P9-DUS-701

A DIARY
of the
PLAGUE
YEAR

A DIARY
of the
PLAGUE
YEAR

An Illustrated
Chronicle of 2020

ELISE
ENGLER

METROPOLITAN BOOKS

Henry Holt and Company New York

To my parents

Metropolitan Books
Henry Holt and Company
Publishers since 1866
120 Broadway
New York, New York 10271
www.henryholt.com

Metropolitan Books® and ▥® are registered trademarks of
Macmillan Publishing Group, LLC.

Copyright © 2021 by Elise Engler
All rights reserved.
Distributed in Canada by Raincoast Book Distribution Limited

Library of Congress Cataloging-in-Publication Data is available

ISBN: 9781250824691

Our books may be purchased in bulk for promotional, educational, or business use. Please
contact your local bookseller or the Macmillan Corporate and Premium Sales Department at
(800) 221-7945, extension 5442, or by e-mail at MacmillanSpecialMarkets@macmillan.com.

First Edition 2021

Designed by Kelly S. Too

Printed in the United States of America

1 3 5 7 9 10 8 6 4 2

A DIARY
of the
PLAGUE
YEAR

INTRODUCTION

WAS THERE EVER SUCH A YEAR?

A global pandemic with millions dead, half a million Americans among them; a national uprising ignited by police killings of Black Americans; cities shut down, poverty soaring, a president inciting a riot to stop his election defeat, hellish wildfires, mass shootings. It was the worst year of our lives, people said, apocalyptic, unprecedented, biblical in the scale of its disasters.

Throughout 2020 and into 2021, I painted the day's headlines, making a picture of the first few news items I heard emitting from my wooden bedside radio when I woke up each morning. Viewed together here, these daily paintings, which include ordinary events along with the historic ones, ended up forming an unusual visual record of an epic, momentous year.

I did not set out to document this extraordinary time. The project that became this book began five years earlier. On November 22, 2015, I started painting a portrait of an ordinary year in American life. It would be an illustrated series called *Diary of a Radio Junkie*, and the idea was to do a small gouache or watercolor picture illustrating the lead headline I heard on WNYC at the start of each day. After the planned twelve months of making the paintings, I would stop and exhibit this portrait of a year.

For decades, my art had been about depicting the mundane or ordinary to create

a big picture, working from the small and intimate to arrive at a greater whole. I had drawn the contents of seventy women's pocketbooks to give an intimate portrait of women who varied by race, ethnicity, class, and age. My series *TaxOnomies* displayed thousands of items purchased by tax dollars, from the everyday (elementary school chairs, everything on a fire truck) to the extreme (billion-dollar war planes), as a view into US government policy. I'd recently finished a project showing all 252 blocks of Broadway in Manhattan, drawn on-site, day by day, block by block over a one-year period. My diary of daily headlines would be another similar assemblage, again taking place over the course of a single year.

I was not expecting to chronicle a drama. Yes, we were gearing up for a particularly belligerent presidential election, but Barack Obama had a little more than a year left in office and all seemed to be business as usual. Then Donald Trump was elected president, and I quickly realized this was not the time to stop my drawing. His would be a presidency like no other, and I wanted to continue to document it, day by day. So for the next five years, I carried on, rising at the crack of dawn to catch the morning's radio news.

Once Trump took office, there were too many outlandish and urgent headlines to be able to choose just one. Curating the news became increasingly challenging, as every day was jam-packed with possibilities. I had started with my single headline but increased that to as many as six, and I would cover local, national, and international news. I'd begin at 5:00 a.m. with WNYC's twice-hourly newsbreaks and then move on to *Democracy Now* at 8:00 a.m. I'd take notes as I listened and then choose my items: the most significant, the most underreported, and the most pictorial (sometimes one headline took care of two or three items). The same painting could include the Georgia governor's race, a global Google work stoppage, and a rare species of duck in Central Park. Assembling an image from disparate parts was a compositional feat. My pencils and brushes worked to make all these pieces fit inside a small rectangular piece of paper along with the embedded headlines.

As the Trump presidency cut its operatic path through the first, second, and third years, I made portraits of the revolving-door cabinet, of world despots and dictators cavorting on the golf course, and of Trump's tweets—an oft-featured motif. There were the many faces of the Me Too movement, and the appearance of machine guns and shotguns in the tragic stories of mass shootings. I drew children in tears as they were separated from their families at the border, natural and unnatural disasters, midterm elections, impeachment hearings. Fleeting events were depicted alongside the momentous: on the day Trump insulted the venerable African American congressman John

Lewis, Barnum & Bailey announced that it was closing the circus after 127 years—what a juxtaposition, those circus elephants and that chaotic White House.

By the end of 2019, my work formed a record of one of the most turbulent periods in our history. I didn't know that the coming year would top it.

The plague entered my drawings quietly. On January 20, 2020, COVID-19 appeared in a small portion of a pencil drawing. The rest of that day's page featured the *New York Times* endorsement of Elizabeth Warren and Amy Klobuchar for president, as well as protests in Iraq and a flooded New York subway station. In the right-hand corner, a medically masked woman stood beneath a sign that read, in English and Chinese, "Wuhan Medical," and the newspaper's headline read, "Coronavirus in China, cases triple as infection spreads to Beijing and Shanghai."

But it was events such as the death of basketball player Kobe Bryant, the 2020 primaries, and Democratic efforts to call witnesses in Trump's impeachment trial that drew my attention, although the coronavirus started making more regular appearances. It was on the news every few days, and then, soon, every day. On January 27, there were 2,700 cases in Wuhan, and eighty people reported dead. Now there were five cases in the United States. In early February, Trump dedicated twenty seconds to the coronavirus in his State of the Union address, but House Speaker Nancy Pelosi tearing up his speech in a dramatic show of distaste was the focus, the story that appeared over and over. The picture of masked workers producing masks was not.

After that, events moved quickly. The virus was approaching the United States, we heard; there were reports of a cruise ship with infected passengers on board being turned away by one country after another. (On the day it was finally able to dock, one of my stories was Attorney General William Barr saying, "Trump's tweets make it impossible to do my job.") Only five days later, my painting showed a map of the United States with twenty-eight states painted yellow for the virus: it was spreading up and down the East Coast. The headlines on my March 12 painting read: "Trump suspends all travel from Europe to combat COVID-19 (for 30 days), also announces economic measures; New York Governor Cuomo shuts down CUNY and SUNY, will institute online learning; NBA cancels season; WHO declares pandemic; Seattle closes public schools; Italy death toll jumps 30%; Iran has 10,000 cases; Harvey Weinstein sentenced to 23 years for rape and sexual assault; Supreme Court allows "remain in Mexico" program to continue; Bernie Sanders will stay in pres. race."

Journalist Amy Goodman soon started every broadcast of *Democracy Now* "from the epicenter of the pandemic." New York City shut down its offices, schools, and all indoor public spaces. Journalists broadcast from closets converted into soundproofed

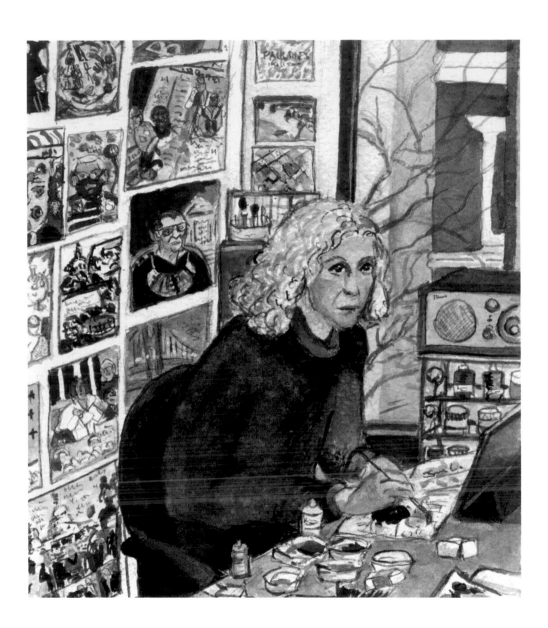

studios. They described the weather by looking out their apartment windows. Students learned from screens, white-collar workers worked on screens, shopping was done on screens. Hospitals and graveyards overflowed.

I felt my pages changing. For four years, most of what I'd drawn was done from a distance; I was an observer. Often the images were constructed with a cool gridded format, almost like newspaper columns. Now I was part of the story, and being in the epicenter changed the compositions. They were more urgent and tumultuous, with swirling forms that reflected the country's sense of chaos and anxiety.

Now I painted rows of emergency vehicles. I painted the tent hospital set up in Central Park, just a few minutes' walk from my apartment. On April 3, I made a double self-portrait in home-sewn masks, one from half of an old bra, the other from a bandanna. We all became the story. COVID-19 was the story.

On May 25, with 98,000 Americans dead from the virus, COVID-19 was displaced as the seismic event of the year when we witnessed the gruesome murder of a Black man, George Floyd, by a Minneapolis cop. Thousands of multiracial protests called to defund the police, statues of Confederate leaders were toppled from their pedestals. I painted statues being defaced and Confederate flags being removed. Then, in the fall, the Black Lives Matter protests gave way to electoral politics and the incendiary Republican Convention, which raged while massive wildfires burned nine million acres in the West. We mourned the death of Ruth Bader Ginsburg; we were subjected to a thuggish brawl of a presidential debate; we watched as COVID-19 occupied the White House.

Even after all this, 2020 was still not done with us: we lived through the November 3 election and Trump's defeat, his campaign to overturn the result, and the live-streamed invasion of the Capitol Building by Trumpist rioters—all of it unprecedented and unimaginable.

The paintings themselves changed again throughout the course of the year: at the start of the virus, most of my images were of interiors; in May I switched to depicting the streets, with masses of masked people carrying signs and police in riot gear. When politics dominated the news, my drawings featured more talking heads, and the wildfires brought me to landscapes before the scenes shifted to Washington, DC, the White House, and finally the Capitol.

I didn't know where my relentless listening was going to take me, waking up every morning, turning on the radio, and then heading to my drawing table. I couldn't have foreseen the earth-shaking events that would change my paintings from an idiosyncratic chronicle to a record of a year like no other.

This diary covers the period from January 20, 2020, when COVID-19 made its first

appearance in my drawings, to January 21, 2021, the day after President Joe Biden's inauguration. (Almost all of the daily illustrations of that period are included here; a few were left out due to space constraints.) The paintings chronicle a time scarred by fecklessness, devastation, rage, injustice, illness, and death. Their immediacy, created in real time, conveys what it felt like to live through a plague that did not have to be so deadly. They recall the texture and context that we might not otherwise remember: the sentencing of Harvey Weinstein; the 27,000 tons of exploded aluminum nitrate that destroyed Beirut; the Arctic ice melt from the record-high summer temperatures; the stolen election in Belarus.

The extraordinary and tragic events may remain vivid in our memories, but the daily details and lesser stories of the year will be mostly forgotten—negotiations with the Taliban, the death of designer Milton Glaser, the publication of Michael Cohen's book. Here, though, the large and the small are preserved, side by side, in paintings that serve as a time capsule of the turmoil that befell us in the United States in 2020. I hope they help honor and commemorate those days of grief and disbelief. I hope they remind us of whom we lost, what we witnessed, how we felt, and how we managed to carry on.

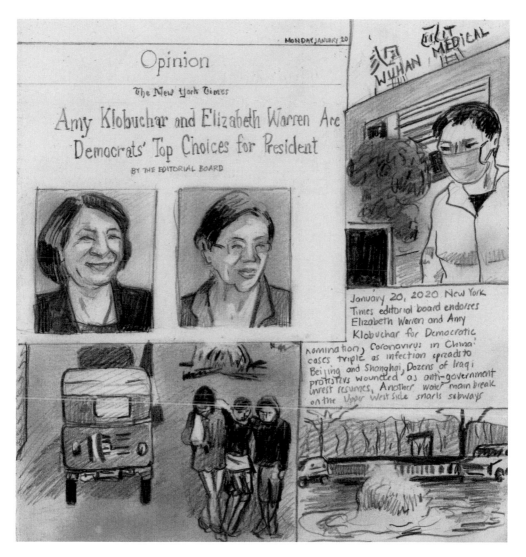

January 20, 2020

New York Times editorial board endorses Elizabeth Warren and Amy Klobuchar for Democratic nomination; Coronavirus in China: cases triple as infection spreads to Beijing and Shanghai; Dozens of Iraqi protesters wounded as anti-government unrest resumes; Another water main break on the Upper West Side snarls subways.

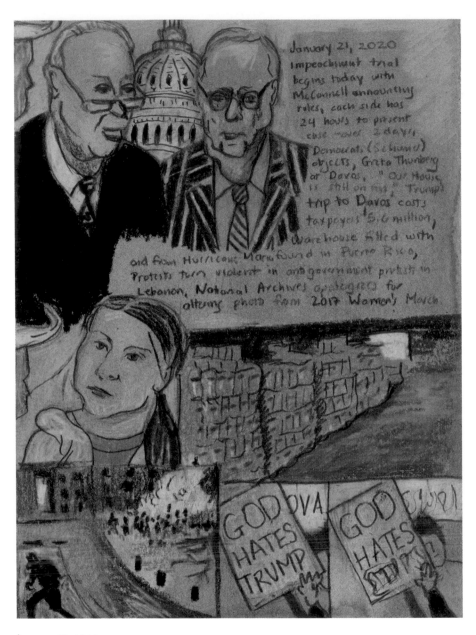

January 21, 2020

Impeachment trial begins today with McConnell announcing rules, each side has 24 hours to present a case over 2 days, Democrats (Schumer) object; Greta Thunberg at Davos, "Our house is still on fire," Trump trip to Davos costs taxpayers $5.6 million; Warehouse filled with aid from Hurricane Maria found in Puerto Rico; Protests turn violent in anti-government protests in Lebanon; National Archives apologizes for altering photo from 2017 Women's March.

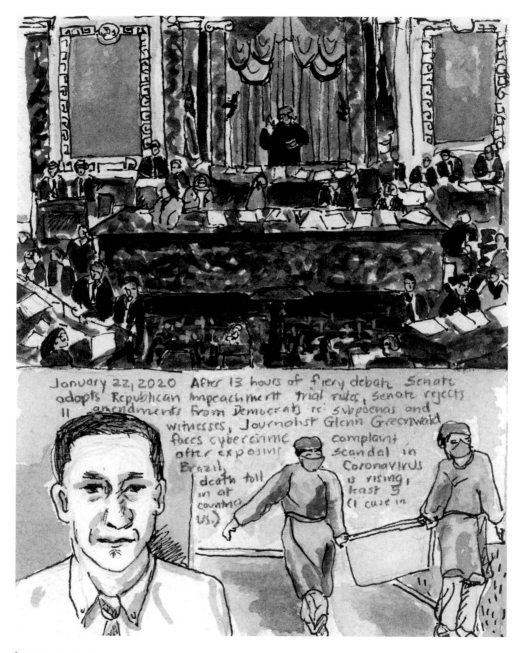

January 22, 2020

After 13 hours of fiery debate, Senate adopts Republican impeachment trial rules, Senate rejects 11 amendments from Democrats re: subpoenas and witnesses; Journalist Glenn Greenwald faces cyber-crime complaint after exposing scandal in Brazil; Coronavirus death toll is rising in at least 5 countries (1 case in US).

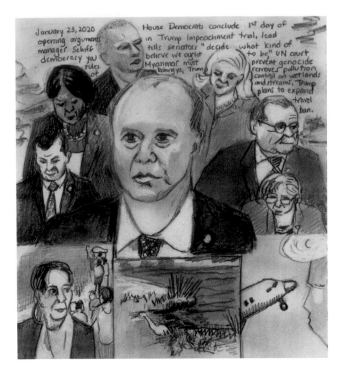

January 23, 2020

House Democrats conclude 1st day of opening arguments in Trump impeachment trial, lead manager Schiff tells senators "decide what kind of democracy you believe we ought to be"; UN court rules Myanmar must prevent genocide of Rohingya; Trump removes pollution control on wetlands and streams; Trump plans to expand travel ban.

January 25, 2020

Trump impeachment: Dems say remove Trump or risk more lawlessness, Trump's legal defense begins, Parnas says he has recording of Trump calling for Yovanovitch firing; At least 22 dead in Turkey earthquake; Coronavirus spreading rapidly, at least 41 dead.

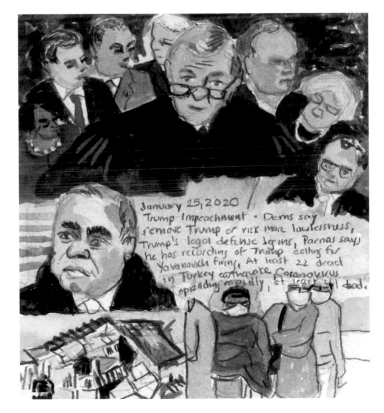

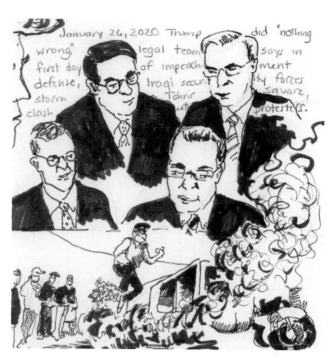

January 26, 2020

Trump did "nothing wrong," legal team says in first day of impeachment defense; Iraqi security forces storm Tahrir Square, clash with protesters.

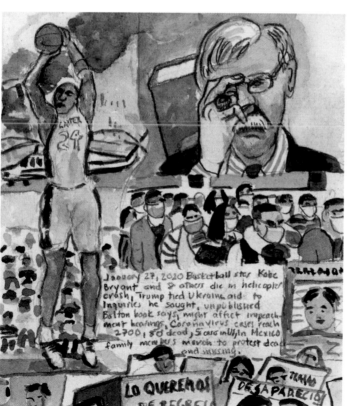

January 27, 2020

Basketball star Kobe Bryant and 8 others die in helicopter crash; Trump tied Ukraine aid to inquiries he sought, unpublished Bolton book says, might affect impeachment hearings; Coronavirus cases reach 2,700, 80 dead, 5 cases in US; In Mexico family members march to protest dead and missing.

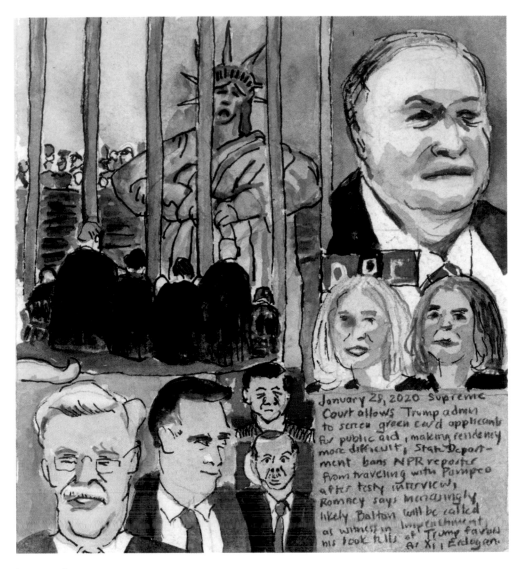

January 28, 2020

Supreme Court allows Trump admin to screen green card applicants for public aid, making residency more difficult; State Department bans NPR reporter from traveling with Pompeo after testy interview; Romney says increasingly likely Bolton will be called as witness in impeachment, his book tells of Trump favors for Xi, Erdoğan.

January 29, 2020

Defense rests in impeachment trial, question phase begins; Trump presents "Middle East Peace Plan," no Palestinian consultation, protests in Palestine; Syrians flee Idlib as Syrian military advances.

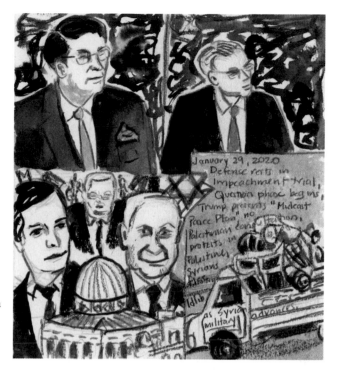

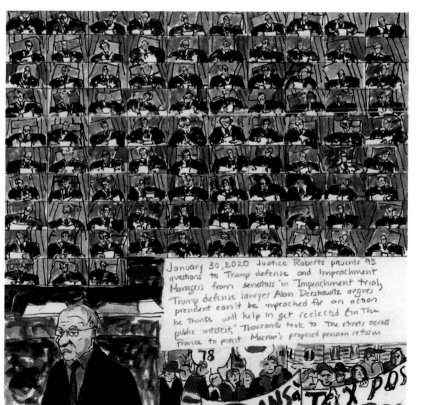

January 30, 2020

Justice Roberts presents 93 questions to Trump's defense and impeachment managers from senators in impeachment trial; Trump's defense lawyer Alan Dershowitz argues president can't be impeached for an action he thinks will help in getting reelected ("in the public interest"); Thousands took to the streets across France to protest Macron's proposed pension reform.

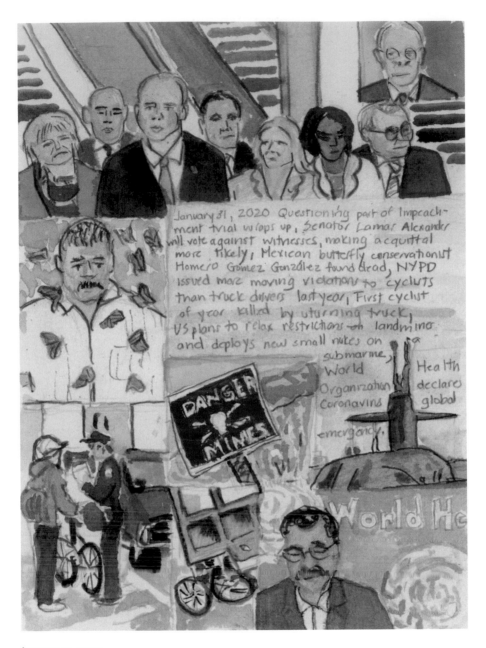

January 31, 2020

Questioning part of impeachment trial wraps up, Senator Lamar Alexander will vote against witnesses, making acquittal more likely; Mexican butterfly conservationist Homero Gómez Gonzalez found dead; NYPD issued more moving violations to cyclists than truck drivers last year; First cyclist of year killed by U-turning truck; US plans to relax restrictions on landmines and deploys new small nukes on a submarine; World Health Organization declares coronavirus global emergency.

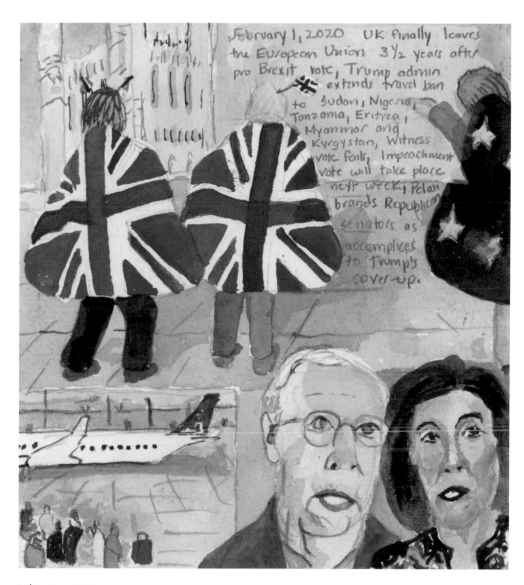

February 1, 2020

UK finally leaves the European Union 3 1/2 years after pro-Brexit vote; Trump admin extends travel ban to Sudan, Nigeria, Tanzania, Eritrea, Myanmar, and Kyrgyzstan; Witness vote fails, impeachment vote will take place next week; Pelosi brands Republican senators as accomplices to Trump's cover-up.

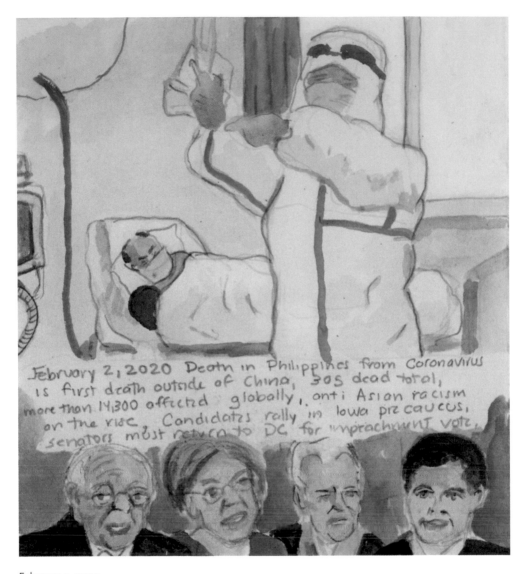

February 2, 2020

Death in Philippines from coronavirus is first death outside of China; 305 dead total, more than 14,300 affected globally; anti-Asian racism on the right; Candidates rally in Iowa pre-caucus, senators must return to DC for impeachment vote.

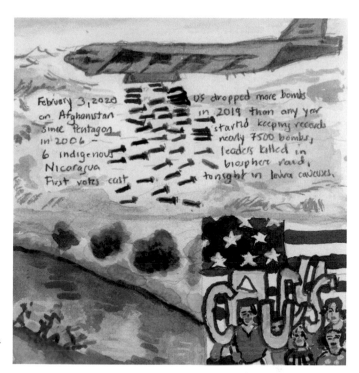

February 3, 2020

US dropped more bombs on Afghanistan in 2019 than any year since Pentagon started keeping records in 2006, nearly 7,500 bombs; 6 indigenous leaders killed in Nicaragua biosphere raid; First votes cast tonight in Iowa caucuses.

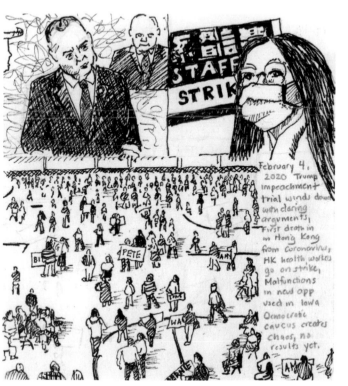

February 4, 2020

Trump impeachment trial winds down with closing arguments; First death in Hong Kong from coronavirus, HK health workers go on strike; Malfunctions in new app used in Iowa Democratic caucus creates chaos, no results yet.

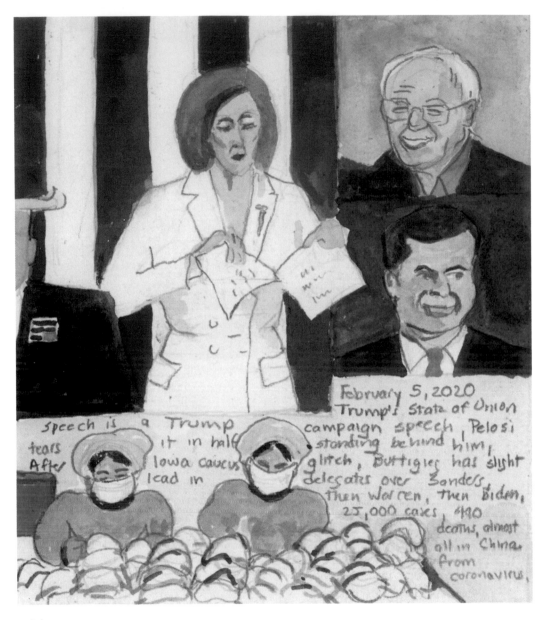

February 5, 2020

Trump's State of Union speech is a Trump campaign speech, Pelosi tears it in half standing behind him; After Iowa caucus glitch, Buttigieg has slight lead in delegates over Sanders, then Warren, then Biden; 25,000 cases, 490 deaths, almost all in China, from coronavirus.

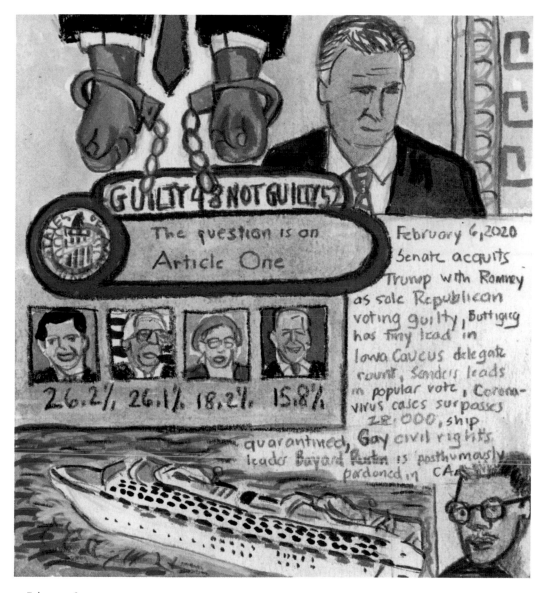

February 6, 2020

Senate acquits Trump with Romney as sole Republican voting guilty; Buttigieg has tiny lead in Iowa caucus delegate count, Sanders leads in popular vote; Coronavirus cases surpass 28,000, ship quarantined; Gay civil rights leader Bayard Rustin is posthumously pardoned in CA.

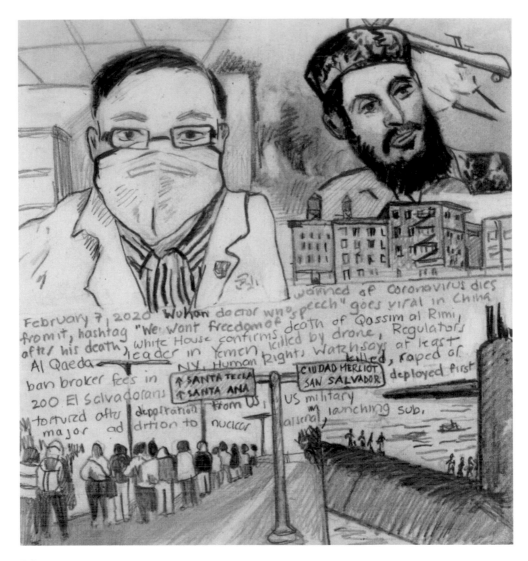

February 7, 2020

Wuhan doctor who warned of coronavirus dies from it, hashtag "We Want Freedom of Speech" goes viral in China after his death; White House confirms death of Qassim al-Rimi, al Qaeda leader in Yemen killed by drone; Regulators ban broker fees in NY; Human Rights Watch says at least 200 El Salvadorans were killed, raped, or tortured after deportation from US; US military deployed first major addition to nuclear arsenal, launching sub.

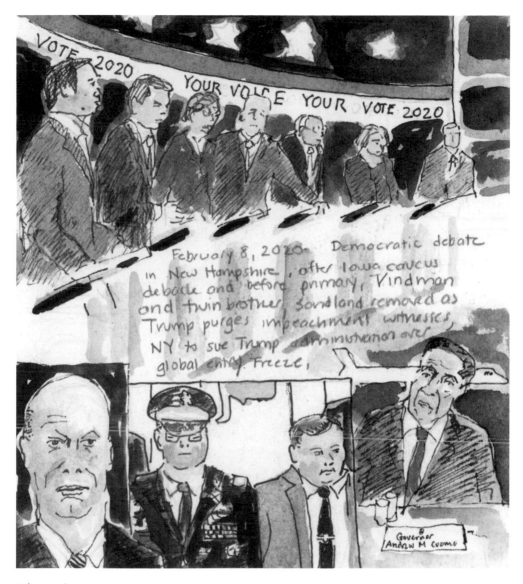

February 8, 2020

Democratic debate in New Hampshire, after Iowa caucus debacle and before primary; Vindman and twin brother, Sondland removed as Trump purges impeachment witnesses; NY to sue Trump administration over global entry freeze.

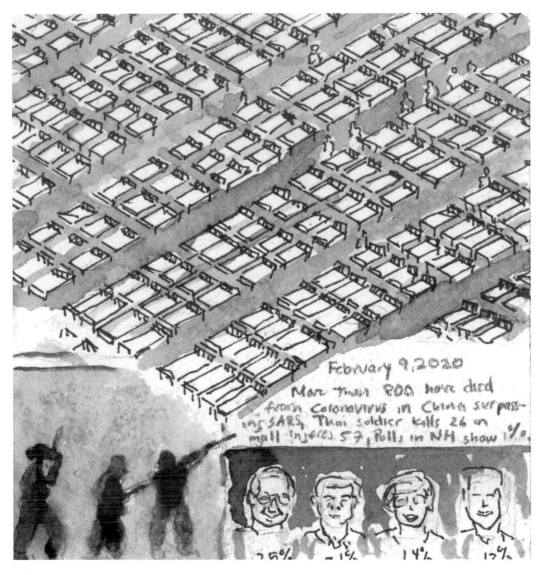

February 9, 2020

More than 800 have died from coronavirus in China, surpassing SARS; Thai soldier kills 26 in mall, injures 57; Polls in NH show percentage.

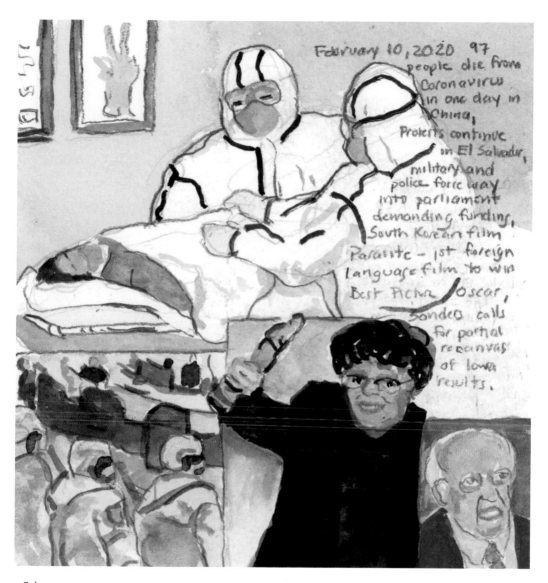

February 10, 2020

97 people die from coronavirus in one day in China; Protests continue in El Salvador, military and police force way into parliament demanding funding; South Korean film *Parasite* 1st foreign-language film to win Best Picture Oscar; Sanders calls for partial recanvass of Iowa results.

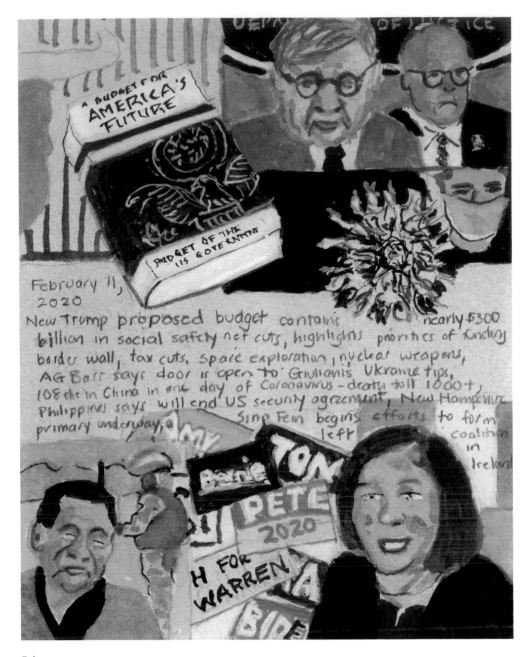

February 11, 2020

New Trump proposed budget contains nearly $300 billion in social safety net cuts, highlights priorities of funding border wall, tax cuts, space exploration, nuclear weapons; AG Barr says door is open to Giuliani's Ukraine tips; 108 die in China in one day of coronavirus—death toll 1,000+; Philippines says it will end US security agreement; New Hampshire primary underway; Sinn Féin begins efforts to form left coalition in Ireland.

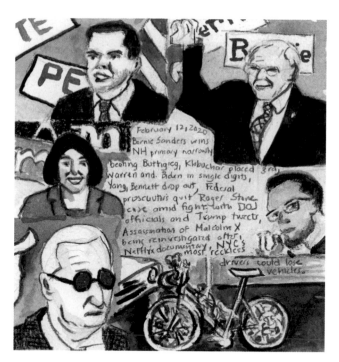

February 12, 2020

Bernie Sanders wins NH primary narrowly beating Buttigieg, Klobuchar placed 3rd, Warren and Biden in single digits, Yang, Bennett drop out; Federal prosecutors quit Roger Stone case amid fight with DOJ officials and Trump tweets; Assassination of Malcolm X being reinvestigated after Netflix documentary; NYC's most reckless drivers could lose vehicles.

February 13, 2020

Defense will make final arguments in Harvey Weinstein rape case; AG Barr will testify before House Judiciary Committee on 3/31 regarding Roger Stone interference; Indigenous pipeline blockades spark Canada-wide protests; New way of diagnosing coronavirus leads to huge jump in number of deaths and confirmed cases.

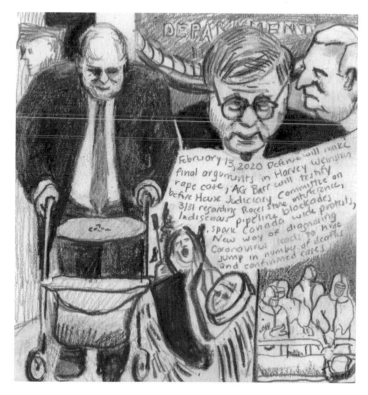

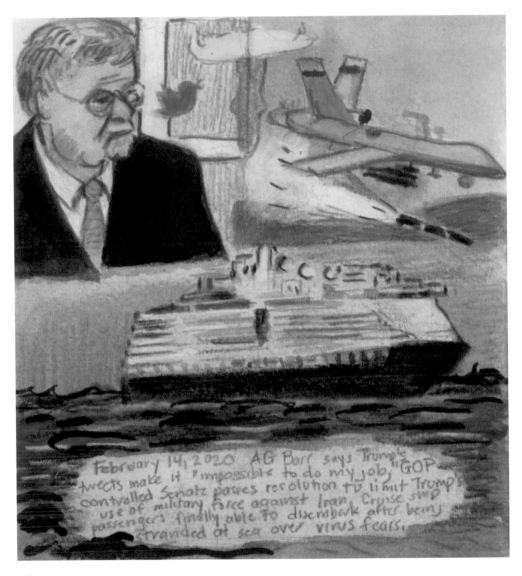

February 14, 2020

AG Barr says Trump's tweets make it "impossible to do my job"; GOP-controlled Senate passes a resolution to limit Trump's use of military force against Iran; Cruise ship passengers finally able to disembark after being stranded at sea over virus fears.

February 15, 2020

US defense chief says Taliban deal looks promising, "but not without risk," in Afghanistan; US to evacuate Americans on cruise ship quarantined in Japan; Missouri farm wins $265 million in dicamba damage case.

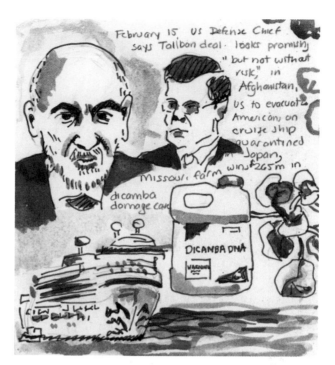

February 16, 2020

China reports over 68,000 cases of coronavirus including over 1,700 health workers; At Munich security conference Zuckerberg calls for more online regulation pre-US elections; Storm Dennis triggers massive floods in UK.

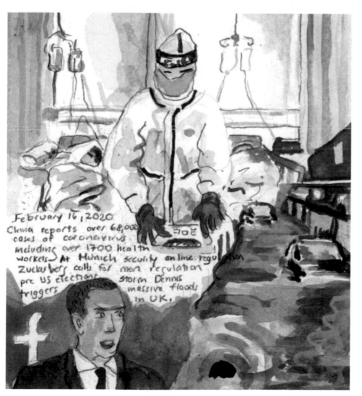

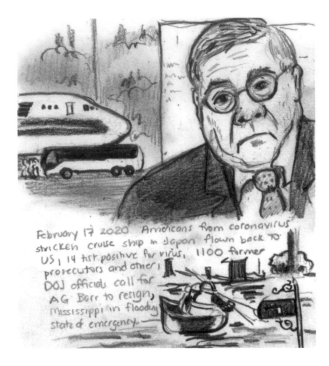

February 17 2020 Americans from coronavirus stricken cruise ship in Japan flown back to US, 14 test positive for virus, 1100 former prosecutors and other DOJ officials call for AG Barr to resign, Mississippi in flooding state of emergency.

February 17, 2020

Americans from coronavirus-stricken cruise ship in Japan flown back to US, 14 test positive for virus; 1,100 former prosecutors and other DOJ officials call for AG Barr to resign; Mississippi in flooding state of emergency.

February 18, 2020

Facing a wave of sex abuse claims Boy Scouts file for bankruptcy; Bloomberg surges in poll, qualifies for Las Vegas debate; In Idlib, Syria, displacement creating overwhelming relief effort; Over 150 million Chinese in coronavirus lockdown.

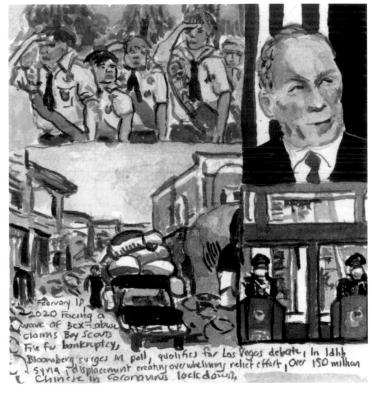

February 18 2020 Facing a wave of sex-abuse claims Boy Scouts File for bankruptcy, Bloomberg surges in poll, qualifies for Las Vegas debate, In Idlib Syria, displacement creating overwhelming relief effort, Over 150 million Chinese in coronavirus lockdown.

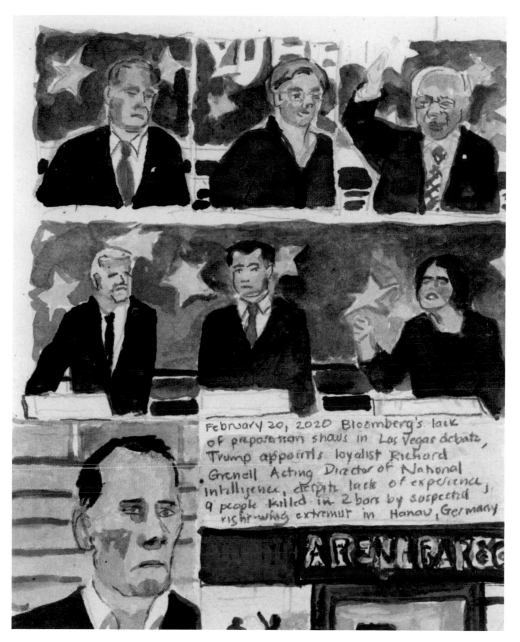

February 20, 2020

Bloomberg's lack of preparation shows in Las Vegas debate; Trump appoints loyalist Richard Grenell Acting Director of National Intelligence, despite lack of experience; 9 people killed in 2 bars by suspected right-wing extremist in Hanau, Germany.

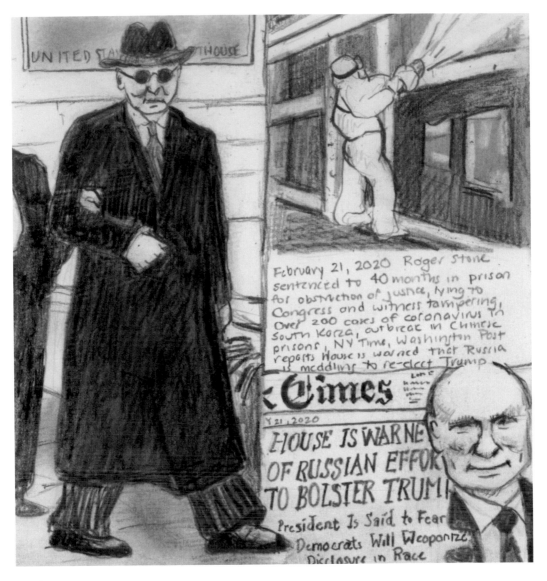

February 21, 2020

Roger Stone sentenced to 40 months in prison for obstruction of justice, lying to Congress, and witness tampering; Over 200 cases of coronavirus in South Korea, outbreak in Chinese prisons; *NY Times, Washington Post* report House is warned that Russia is meddling to reelect Trump.

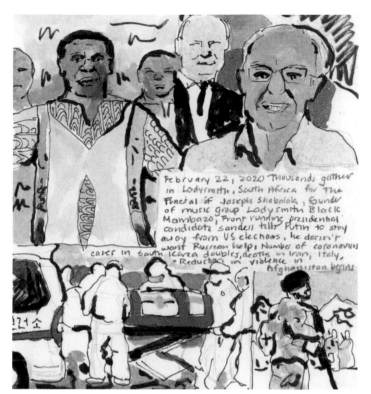

February 22, 2020 Thousands gather in Ladysmith, South Africa for The Funeral of Joseph Shabalala, founder of music group Ladysmith Black Mambazo, Front-running presidential candidate Sanders tells Putin to stay away from US elections, he doesn't want Russian help; Number of coronavirus cases in South Korea doubles, deaths in Iran, Italy, "Reduction in violence in Afghanistan begins

February 22, 2020

Thousands gather in Ladysmith, South Africa, for the funeral of Joseph Shabalala, founder of music group Ladysmith Black Mambazo; Front-running presidential candidate Sanders tells Putin to stay away from US elections, he doesn't want Russian help; Number of coronavirus cases in South Korea doubles, deaths in Iran and Italy; "Reduction in violence" in Afghanistan begins.

February 23, 2020

Bernie Sanders wins Nevada caucuses, takes national Democratic lead; Coronavirus—132 cases in Italy, towns in lockdown, over 600 in South Korea.

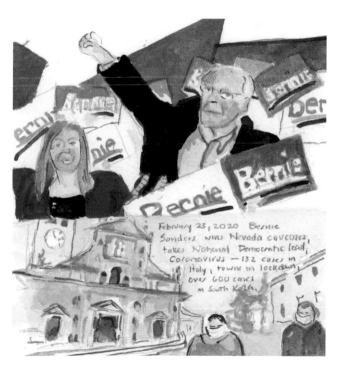

February 23, 2020 Bernie Sanders wins Nevada caucuses, takes National Democratic lead, Coronavirus — 132 cases in Italy, towns in lockdown, over 600 cases in South Korea.

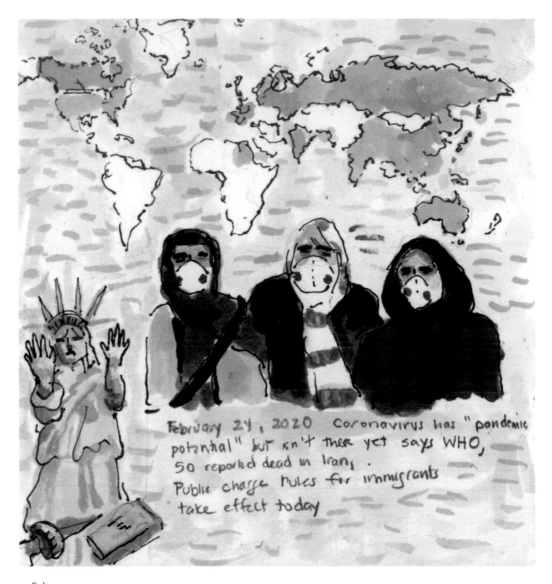

February 24, 2020

Coronavirus has "pandemic potential" but isn't there yet says WHO; 50 reported dead in Iran; Public charge rules for immigrants take effect today.

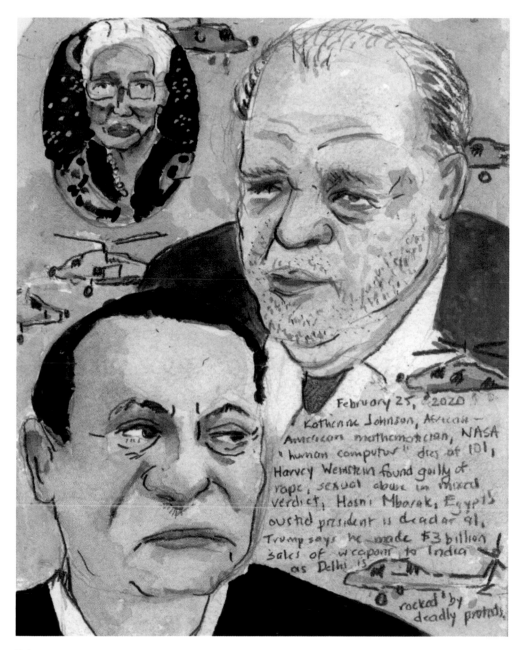

Within the image: February 25, 2020. Katherine Johnson, African-American mathematician, NASA "human computer" dies at 101, Harvey Weinstein found guilty of rape, sexual abuse in mixed verdict, Hosni Mbarak, Egypt's ousted president is dead at 91, Trump says he made $3 billion sales of weapons to India as Delhi is rocked by deadly protests.

February 25, 2020

Katherine Johnson, African American mathematician, NASA "human computer," dies at 101; Harvey Weinstein found guilty of rape and sexual abuse in mixed verdict; Hosni Mubarak, Egypt's ousted president, is dead at 91; Trump says he made $3 billion in sales of weapons to India, as Delhi is rocked by deadly protests.

February 26, 2020

Sanders as front-runner took the heat in South Carolina Democratic debate; Health officials warn—coronavirus is coming; Supreme Court rules border patrol agents who shoot foreign nationals can't be sued.

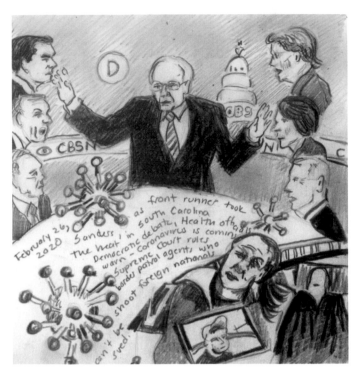

February 27, 2020

Trump puts Pence as head of coronavirus protection; Trump cancels funds for NYC seawall; House passes law to make lynching a federal hate crime; Molson Coors employee shoots 5 and then himself in Milwaukee; 34 dead in anti-Muslim riots in Delhi, India.

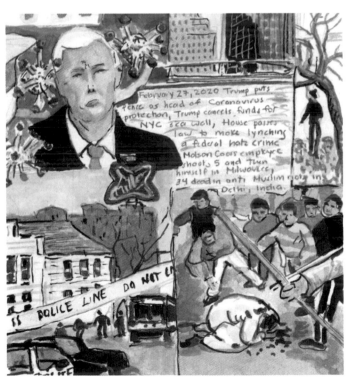

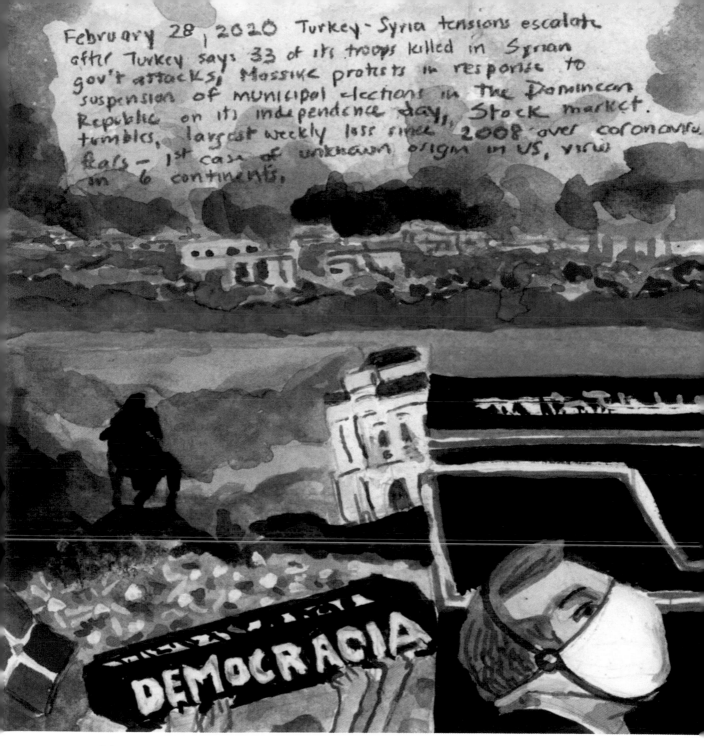

February 28, 2020

Turkey-Syria tensions escalate after Turkey says 33 of its troops killed in Syrian government attacks; Massive protests in response to suspension of municipal elections in the Dominican Republic on its independence day; Stock market tumbles, largest weekly loss since 2008 over coronavirus fears—1st case of unknown origin in US, virus in 6 continents.

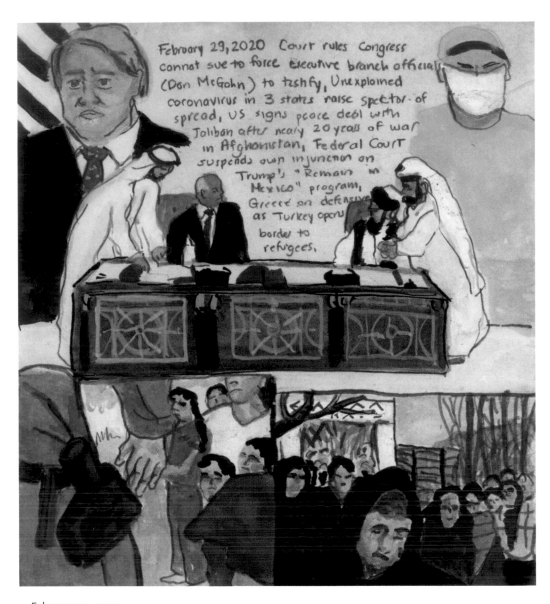

February 29, 2020

Court rules Congress cannot sue to force executive branch officials (Don McGahn) to testify; Unexplained coronavirus in 3 states raise specter of spread; US signs peace deal with Taliban after nearly 20 years of war in Afghanistan; Federal court suspends own injunction on Trump's "Remain in Mexico" program; Greece on defensive as Turkey opens border to refugees.

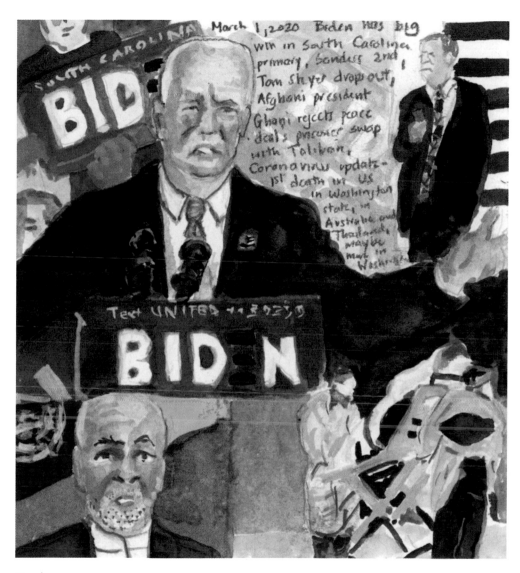

March 1, 2020

Biden has big win in South Carolina primary, Sanders 2nd, Tom Steyer drops out; Afghani president Ghani rejects peace deal, prisoner swap with Taliban; Coronavirus update—1st death in US in Washington State, in Australia and in Thailand, maybe more in Washington.

March 2, 2020

Pete Buttigieg drops out of Democratic presidential race; Coronavirus—1,700 cases in Italy, over 1,500 in Iran with 66 deaths, 2nd death in the US, 1st case in NYC, 89,000+ worldwide with 3,040 deaths; Plastic bag ban in 2nd day in NY State; Judge says Ken Cuccinelli was appointed unlawfully to top immigration post, several asylum rules now must be set aside.

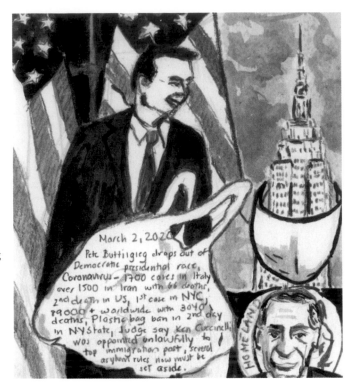

March 3, 2020

Tornadoes in Tenn. kill at least 19 and cause widespread damage in Nashville; Super Tuesday— after Klobuchar and Buttigieg drop out of race they endorse Biden; Israeli election gives "edge" to Netanyahu; Coronavirus—2 NY cases, 6 die in Washington State.

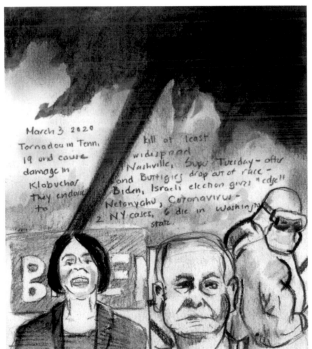

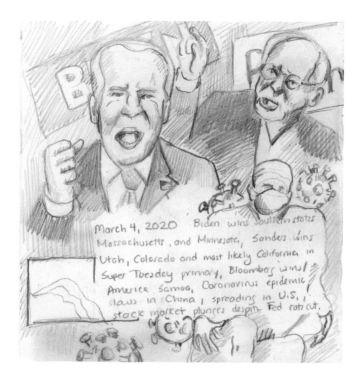

March 4, 2020

Biden wins Southern states, Massachusetts, and Minnesota, Sanders wins Utah, Colorado, and most likely California in Super Tuesday primary; Bloomberg wins American Samoa; Coronavirus epidemic slows in China, spreading in US; Stock market plunges despite Fed rate cut.

March 5, 2020

Elizabeth Warren will reportedly drop out of presidential primary race; Governor Newsom declares California a state of emergency, with one death, awaiting contaminated cruise ship from coronavirus, as NY now has 13 cases; Thousands of migrants and refugees at Greece/Turkey border desperate to get in EU; Bloomberg dropped out of race, spent hundreds of billions.

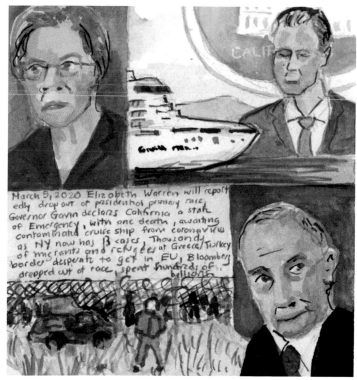

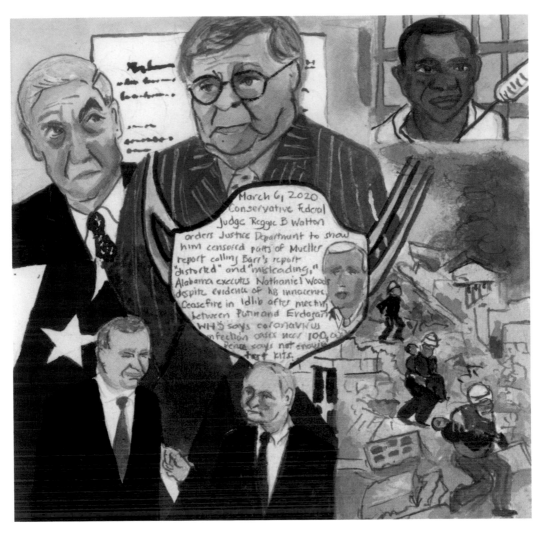

March 6, 2020

Conservative federal judge Reggie B. Walton orders Justice Department to show him censored parts of Mueller report, calling Barr's report "distorted" and "misleading"; Alabama executes Nathaniel Woods despite evidence of his innocence; Cease-fire in Idlib after meeting between Putin and Erdoğan; WHO says coronavirus infection cases near 100,000, Pence says not enough test kits.

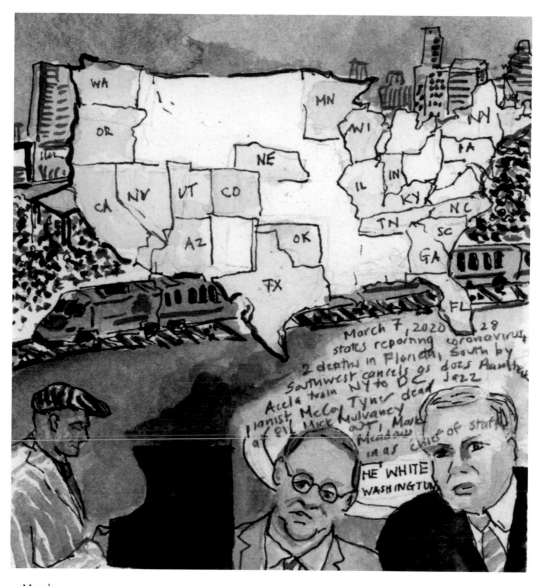

March 7, 2020

28 states reporting coronavirus, 2 deaths in Florida; South by Southwest cancels as does Amtrak Acela train NY to DC; Jazz pianist McCoy Tyner dead at 81; Mick Mulvaney out, Mark Meadows in as chief of staff.

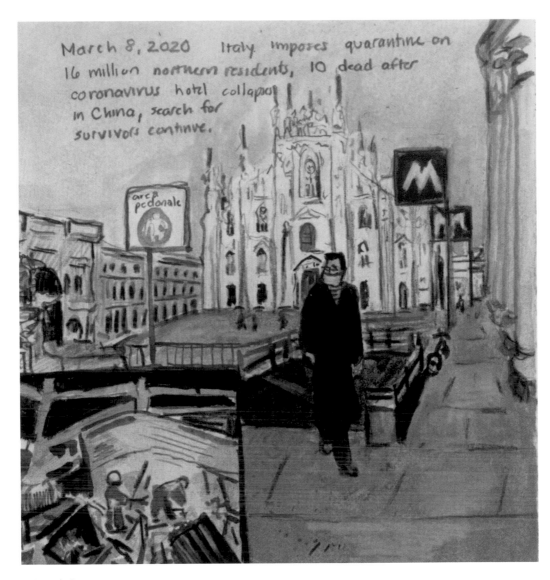

March 8, 2020

Italy imposes quarantine on 16 million northern residents; 10 dead after coronavirus hotel collapses in China, search for survivors continues.

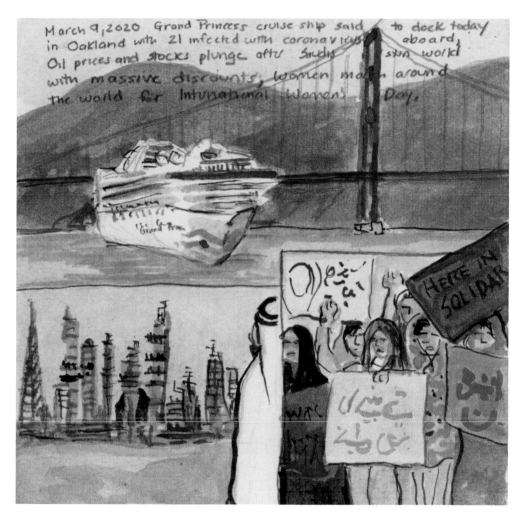

March 9, 2020

Grand Princess cruise ship said to dock today in Oakland with 21 infected with coronavirus aboard; Oil prices and stocks plunge after Saudis stun world with massive discounts; Women march around the world for International Women's Day.

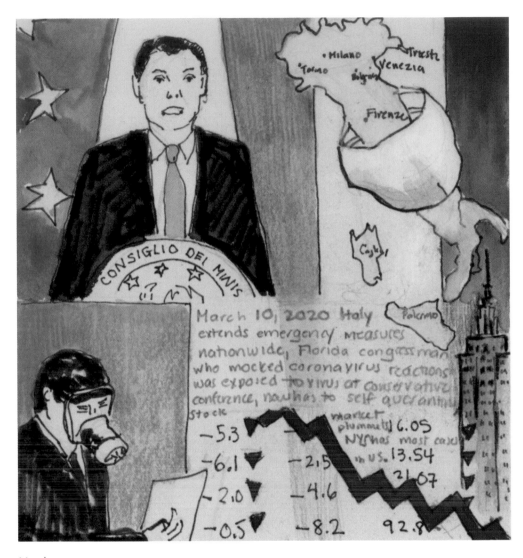

March 10, 2020

Italy extends emergency measures nationwide; Florida congressman who mocked coronavirus reactions was exposed to a virus at conservative conference, now has to self-quarantine; Stock market plummets; NY State has most cases in US.

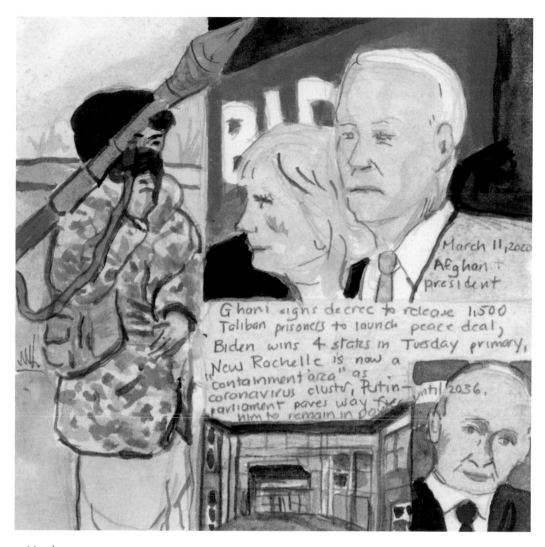

March 11, 2020

Afghan president Ghani signs decree to release 1,500 Taliban prisoners to launch peace deal; Biden wins 4 states in Tuesday primary; New Rochelle is now a "containment area" as coronavirus cluster; Putin—Parliament paves the way for him to remain in power until 2036.

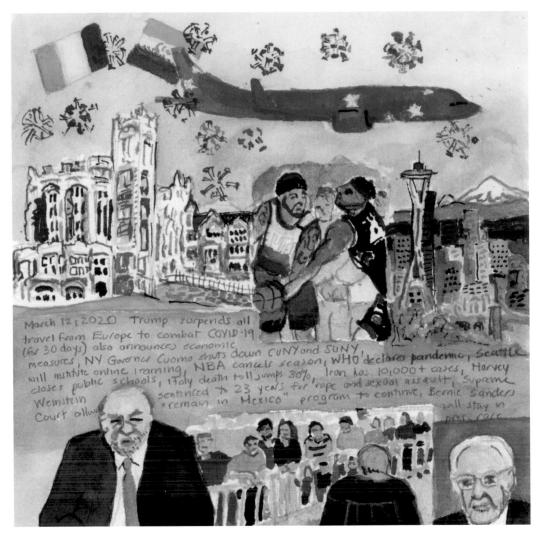

March 12, 2020*

Trump suspends all travel from Europe to combat COVID-19 (for 30 days), also announces economic measures; New York governor Cuomo shuts down CUNY and SUNY, will institute online learning; NBA cancels season; WHO declares pandemic; Seattle closes public schools; Italy death toll jumps 30%; Iran has 10,000 cases; Harvey Weinstein sentenced to 23 years for rape and sexual assault; Supreme Court allows "remain in Mexico" program to continue; Bernie Sanders will stay in pres. race.

* For reasons I'd rather not go into, there are no illustrations for March 13 through 16.

March 17, 2020

17-year-old Seattle resident Avi Schiffman develops coronavirus tracker viewed by 35,000,000+—ncov2019.live; 6 San Francisco districts order "shelter in place"; Ohio primary election called off, 3 states go on; Spain reports 368 coronavirus deaths in 24 hours; In NYC Saint Patrick's Day parade called off, 1st time in more than 250 years, bars, restaurants closed.

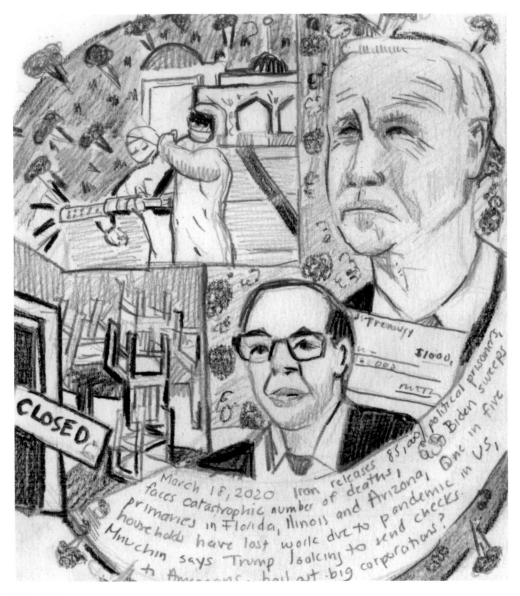

March 18, 2020

Iran releases 85,000 political prisoners, faces catastrophic number of deaths; Biden sweeps primaries in Florida, Illinois, and Arizona; One in five households have lost work due to pandemic in US; Mnuchin says Trump looking to send checks to Americans, bail out big corporations?

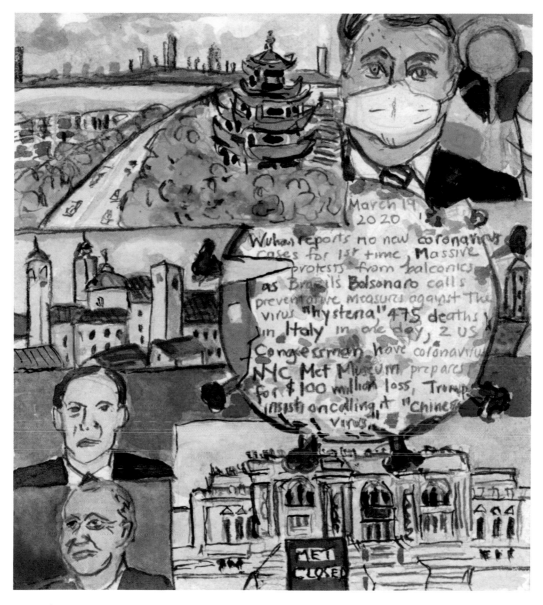

March 19, 2020

Wuhan reports no new coronavirus cases for 1st time; Massive protests from balconies as Brazil's Bolsonaro calls preventative measures against virus "hysteria"; 475 deaths in Italy in one day; 2 US congressmen have coronavirus; NYC Met Museum prepares for $100 million loss; Trump insists on calling it "Chinese virus."

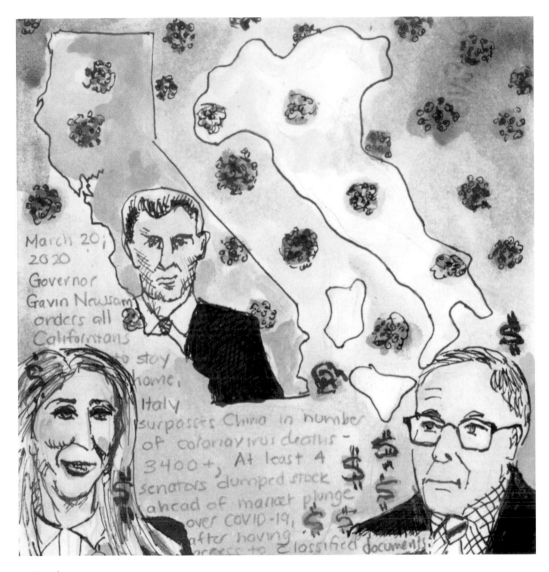

March 20, 2020

Governor Gavin Newsom orders all Californians to stay home; Italy surpasses China in number of coronavirus deaths—3,400+; At least 4 senators dumped stock ahead of market plunge over COVID-19, after having access to classified documents.

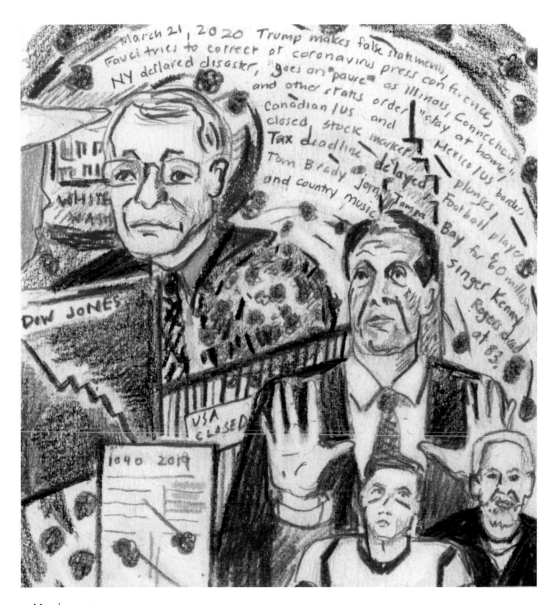

March 21, 2020

Trump makes false statements, Fauci tries to correct at coronavirus press conference; New York declared disaster, goes on "pause" as Illinois, Connecticut, and other states order "stay at home"; Canada/US and Mexico/US borders closed; Stock market plunges; Tax deadline delayed; Tom Brady joins Tampa Bay for $60 million; Country music singer Kenny Rogers dead at 83.

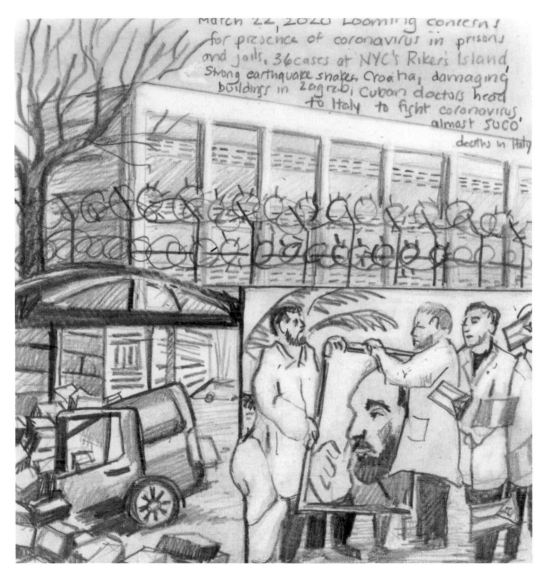

March 22, 2020

Looming concerns for presence of coronavirus in prisons and jails, 36 cases at NYC's Rikers Island; Strong earthquake shakes Croatia, damaging buildings in Zagreb; Cuban doctors head to Italy to fight coronavirus, almost 5,000 deaths in Italy.

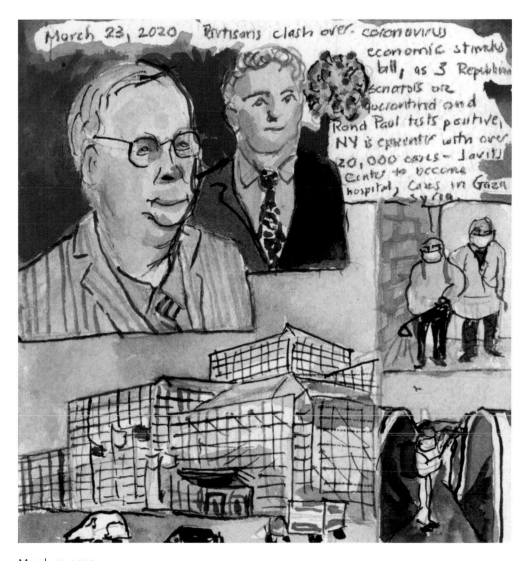

March 23, 2020

Partisans clash over coronavirus economic stimulus bill, as 3 Republican senators are quarantined and Rand Paul tests positive; New York is epicenter with over 20,000 cases—Javits Center to become hospital; Cases in Gaza, Syria.

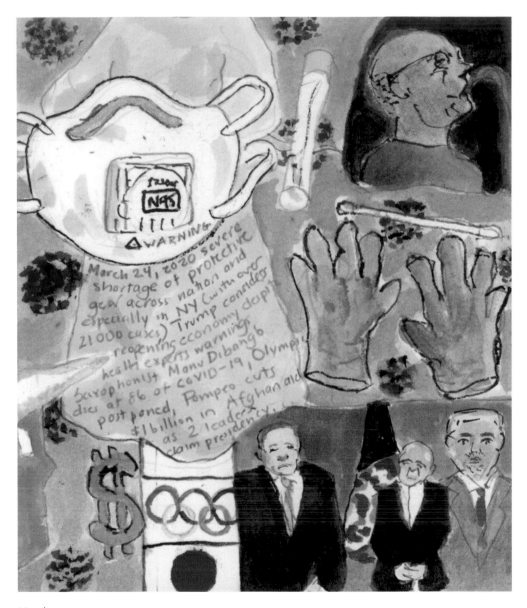

March 24, 2020

Severe shortage of protective gear across the nation and especially in New York (with over 21,000 cases); Trump considers reopening economy despite health experts' warnings; Saxophonist Manu Dibango dies at 86 of COVID-19; Olympics postponed; Pompeo cuts $1 billion in Afghan aid as 2 leaders claim presidency.

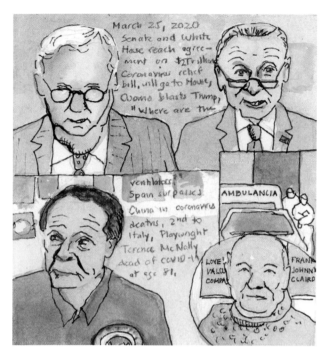

March 25, 2020

Senate and White House reach agreement on $2 trillion coronavirus relief bill, will go to House; Cuomo blasts Trump, "Where are the ventilators?"; Spain surpasses China in coronavirus deaths, 2nd to Italy; Playwright Terrence McNally dead of COVID-19 at age 81.

March 26, 2020

At least 280 have died from coronavirus in NYC with 88 recorded on Wednesday, 20,011 confirmed cases, hospital facilities overwhelmed; Record shattering 3.3 million Americans file for unemployment as coronavirus rips through economy; PM Modi tells over 1 billion Indians to lock down for 3 weeks; Judge strikes down Dakota Access Pipeline permits.

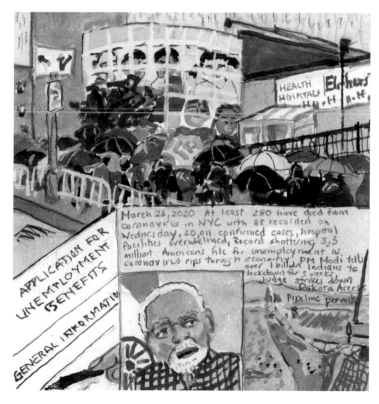

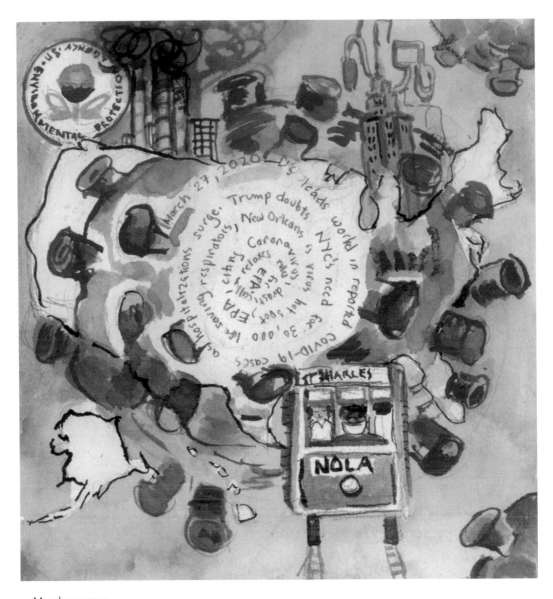

March 27, 2020

US leads world in reported COVID-19 cases as hospitalizations surge; Trump doubts NYC's need for 30,000 life-saving respirators; New Orleans is virus hot spot; EPA, citing coronavirus, drastically reduces rules for EPA.

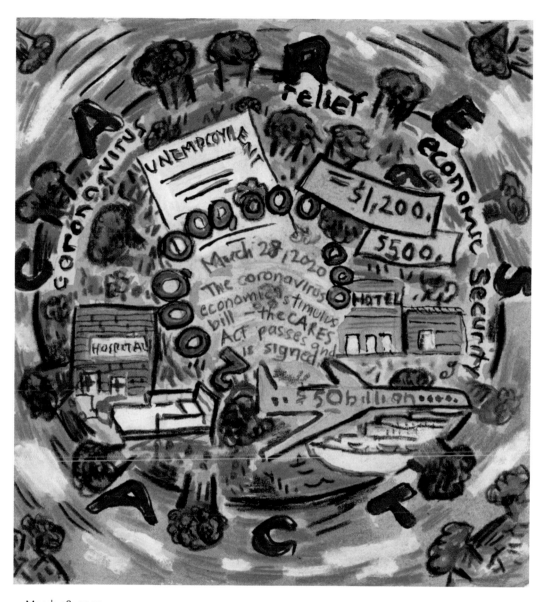

March 28, 2020

The coronavirus economic stimulus bill, the CARES Act, passes and is signed.

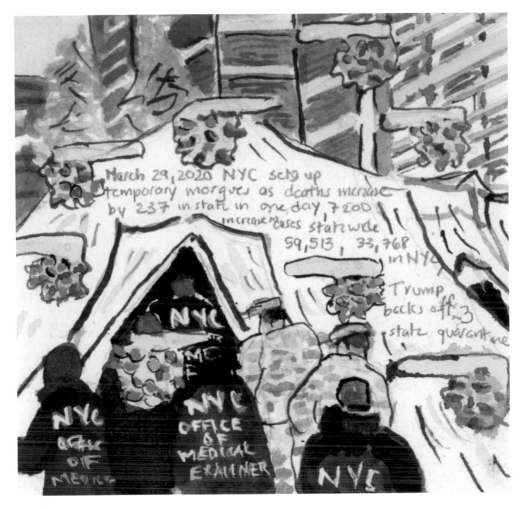

March 29, 2020

NYC sets up temporary morgues as deaths increase by 237 in state in one day, 7,200 increase in cases statewide, 59,513 total in NY State, 33,768 in NYC; Trump backs off 3-state quarantine.

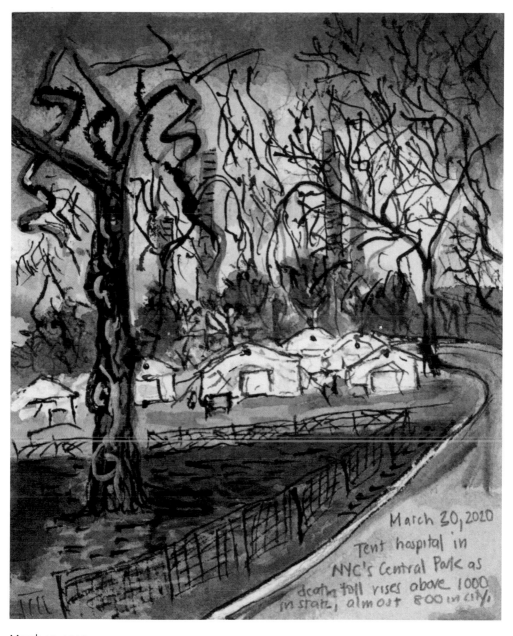

March 30, 2020

Tent hospital in NYC's Central Park as death toll rises above 1,000 in state, almost 800 in city.

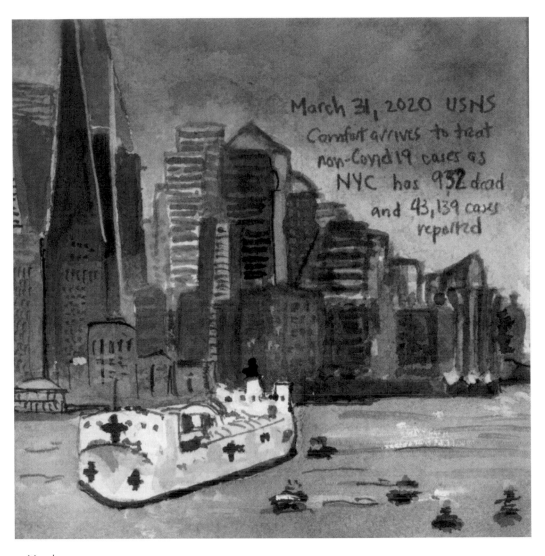

The handwritten text within the image reads:

March 31, 2020 USNS
Comfort arrives to treat
non-Covid 19 cases as
NYC has 932 dead
and 43,139 cases
reported

March 31, 2020

USNS *Comfort* arrives to treat non-COVID-19 cases as NYC has 932 dead and 43,139 cases reported.

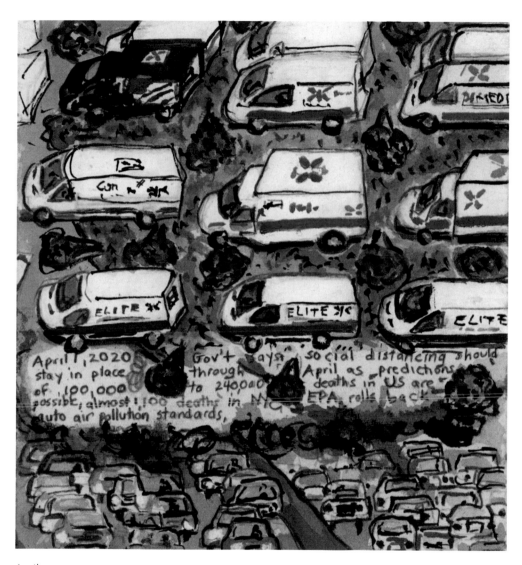

April 1, 2020

Government says social distancing should stay in place through April as predictions of 100,000 to 240,000 deaths in the US are possible; Almost 1,100 deaths in NYC; EPA rolls back auto air pollution standards.

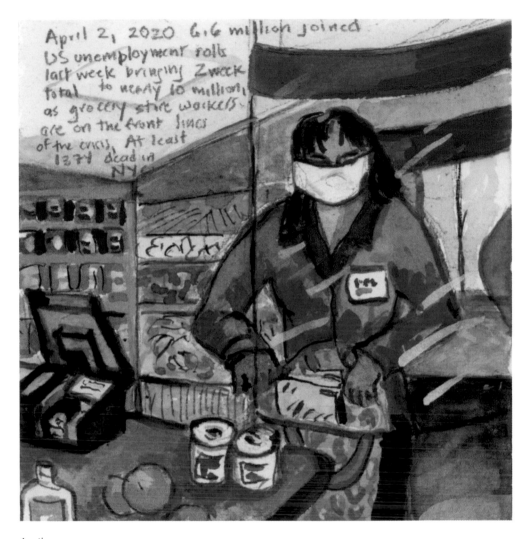

April 2, 2020

6.6 million joined US unemployment rolls last week, bringing 2-week total to nearly 10 million, as grocery workers are on the front lines of the crisis; At least 1,374 dead in NYC.

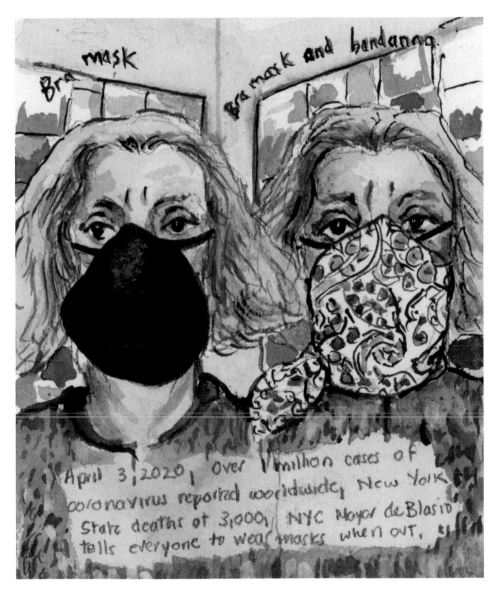

April 3, 2020

Over 1 million cases of coronavirus reported worldwide; New York State deaths at 3,000; NYC mayor de Blasio tells everyone to wear masks when out.

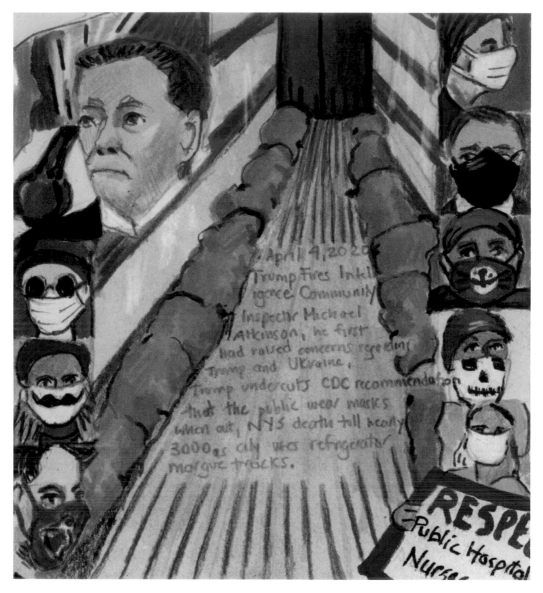

April 4, 2020

Trump fires Intelligence Community Inspector Michael Atkinson, he first had raised concerns regarding Trump and Ukraine; Trump undercuts CDC recommendation that the public wear masks when out; NY State death toll nearly 3,000 as city uses refrigerator morgue trucks.

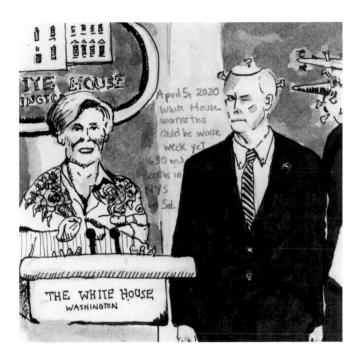

April 5, 2020

White House warns this could be worst week yet; 630 new deaths in NY State on Saturday.

April 6, 2020

Cathedral Church of Saint John the Divine in NYC will open doors to 400 beds for non-COVID-19 patients, working with Christian fundamentalist Samaritan's Purse; Boris Johnson is moved to intensive care with COVID-19; Queen of England tells UK public "We will succeed" in regard to coronavirus; Navy captain who leaked info about COVID-19 on his vessel and was fired tests positive for virus; First prisoner on Rikers Island dies, prisons are reporting rapidly increasing cases; 1st case of human–animal transmission—tiger has COVID at Bronx Zoo.

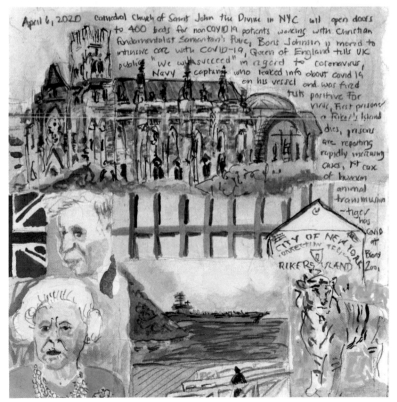

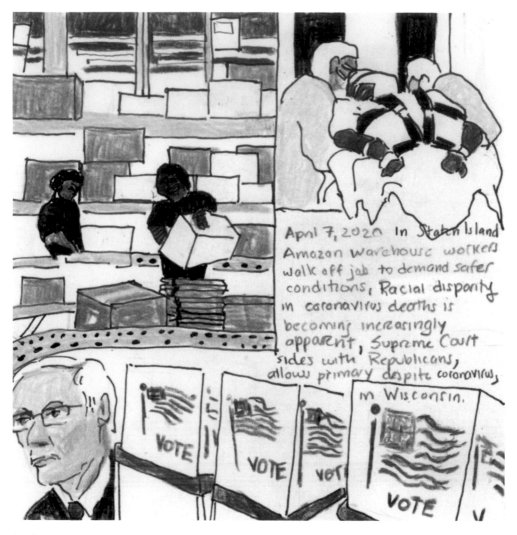

April 7, 2020

In Staten Island, Amazon warehouse workers walk off job to demand safer conditions; Racial disparity in coronavirus deaths is becoming increasingly apparent; Supreme Court sides with Republicans, allows primary, despite coronavirus, in Wisconsin.

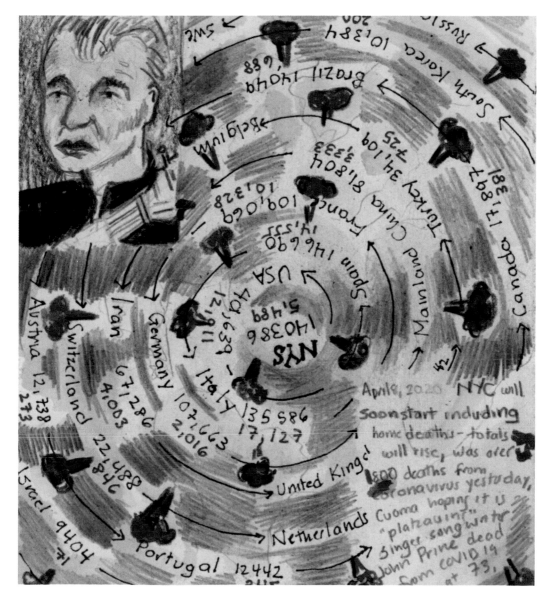

April 8, 2020

NYC will soon start including home deaths—totals will rise, there were over 800 deaths from coronavirus yesterday, Cuomo hoping it is "plateauing"; Singer-songwriter John Prine dead from COVID-19 at 73.

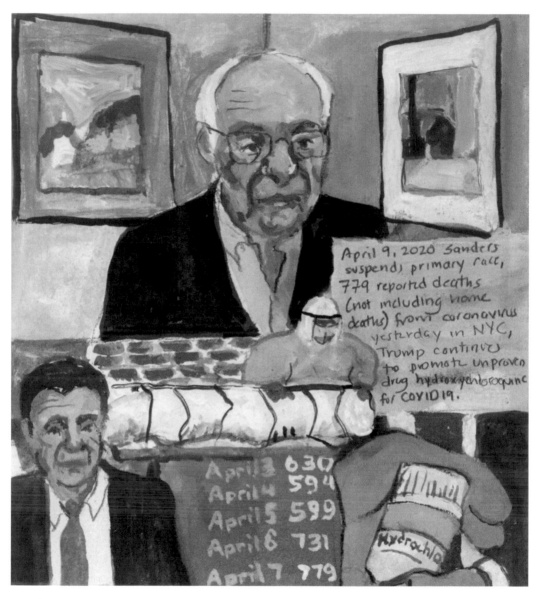

April 9, 2020

Sanders suspends primary race; 779 reported deaths (not including home deaths) from coronavirus yesterday in NYC; Trump continues to promote unproven drug hydroxychloroquine for COVID-19.

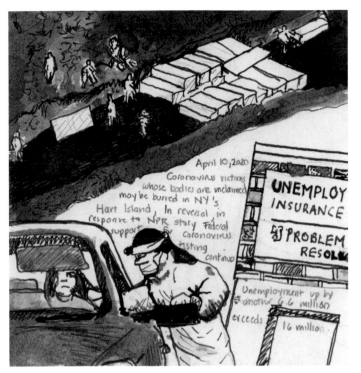

April 10, 2020

Coronavirus victims whose
bodies are unclaimed
may be buried in NY's
Hart Island; In reversal,
in response to NPR
story, federal support
for coronavirus testing
continues; Unemployment
up by another 6.6 million,
exceeds 16 million.

April 11, 2020

The number of
confirmed cases in US
tops 500,000, 18,637
have died with almost
2,000 deaths in one
day from coronavirus,
nursing homes are hit
hard; Biden proposes
lowering Medicare
eligibility to 60.

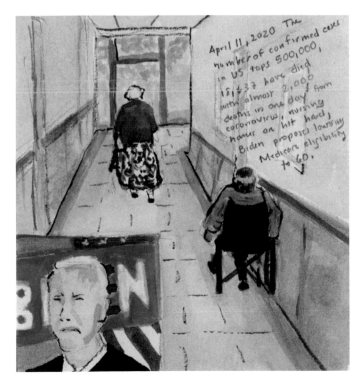

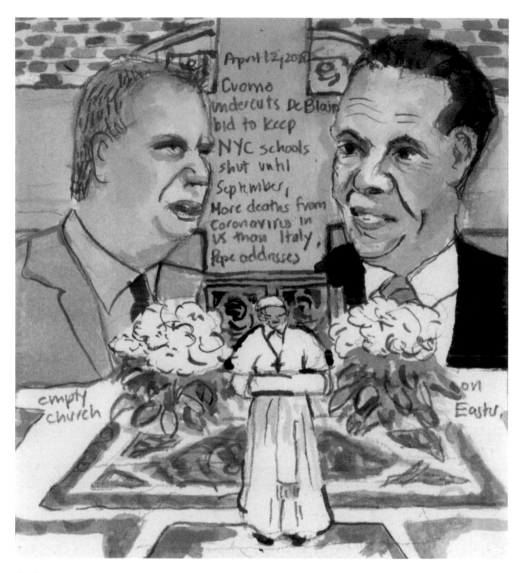

April 12, 2020

Cuomo undercuts de Blasio's bid to keep NYC schools shut until September; More deaths from coronavirus in US than Italy; Pope addresses empty church on Easter.

April 13, 2020

Fatal tornadoes cross South, at least 12 dead; White House wants to lower wages of migrant workers to help farmers; One month after Trump (very belatedly) declares national emergency, Trump retweets call to fire Dr. Fauci; *New York Times* chronicles all of Trump's missteps on coronavirus; OPEC, Russia approve biggest-ever oil cut.

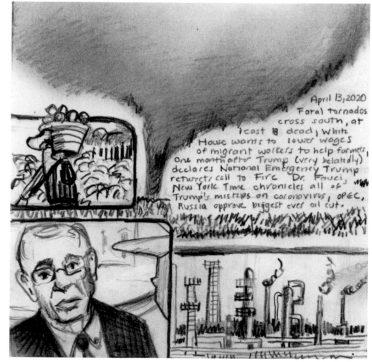

April 14, 2020

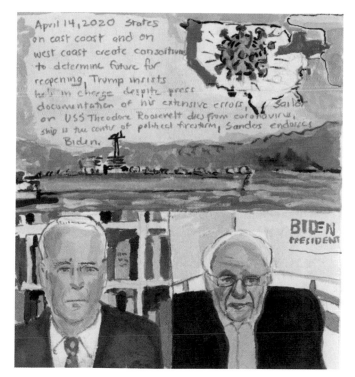

States on East Coast and West Coast create consortium to determine future for reopening; Trump insists he's in charge despite press documentation of his extensive errors; Sailor on USS *Theodore Roosevelt* dies from coronavirus, ship is the center of political firestorm; Sanders endorses Biden.

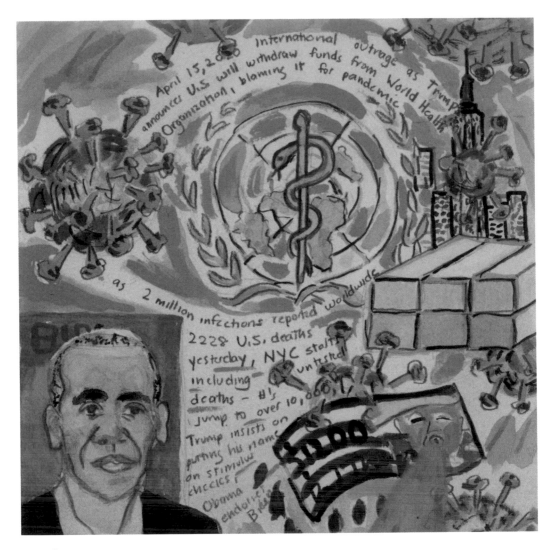

April 15, 2020

International outrage as Trump announces US will withdraw funds from World Health Organization, blaming it for pandemic as 2 million infections reported worldwide, 2,228 US deaths yesterday, NYC starts including untested deaths, numbers jump to over 10,000; Trump insists on putting his name on stimulus checks; Obama endorses Biden.

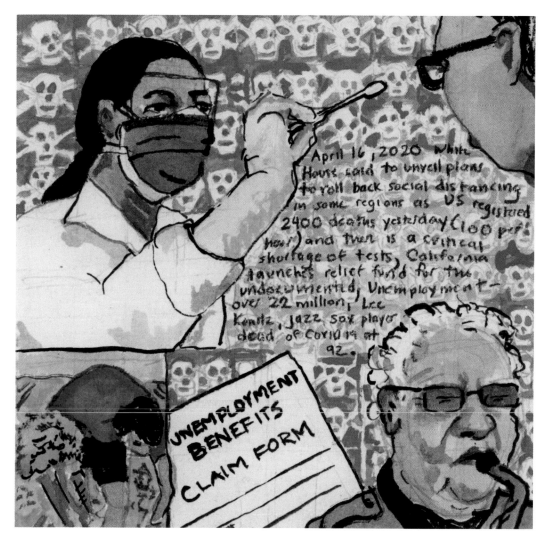

April 16, 2020

White House said to unveil plans to roll back social distancing in some regions as US registered 2,400 deaths yesterday (100 per hour) and there is a critical shortage of tests; California launches relief fund for the undocumented; Unemployment over 22 million; Lee Konitz, jazz sax player, dead of COVID-19 at 92.

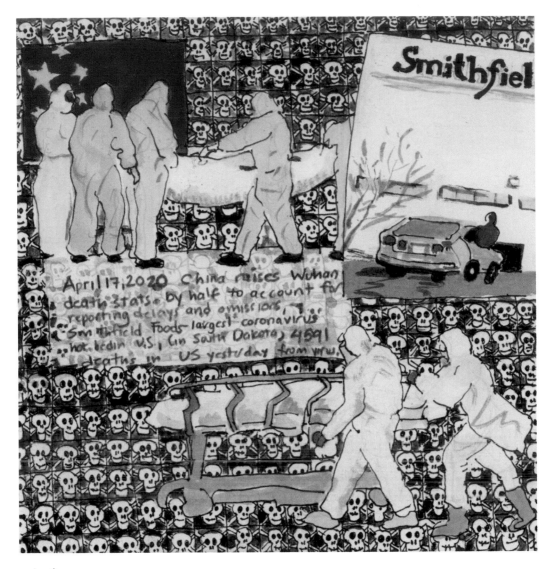

April 17, 2020

China raises Wuhan death stats by half to account for reporting delays and omissions; Smithfield Foods largest coronavirus hotbed in US (in South Dakota); 4,591 deaths in US yesterday from virus.

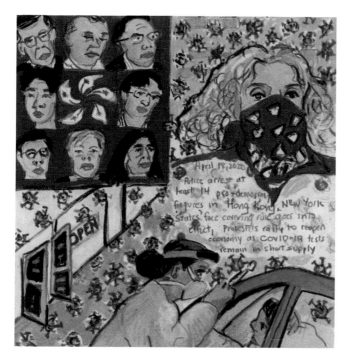

April 18, 2020

Police arrest at least 14 pro-democracy figures in Hong Kong; New York State's face-covering rule goes into effect; Protesters rally to reopen economy as COVID-19 tests remain in short supply.

April 19, 2020

South Korea's new coronavirus cases fall to single digits; 740,000 confirmed COVID-19 cases in US, 40,000 deaths; Cuomo says NY State might be past peak; De Blasio says city needs $7 billion in federal money, budget cuts youth employment, city pools, and more.

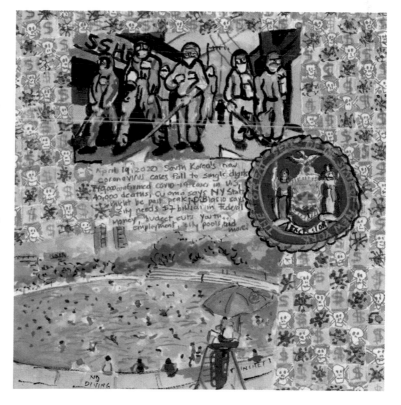

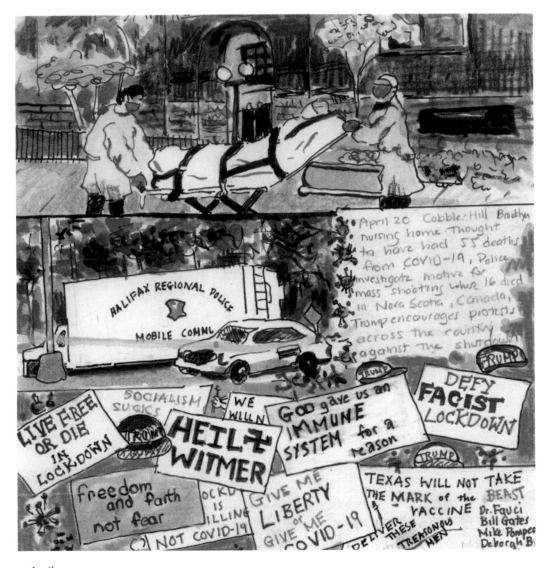

April 20, 2020

Cobble Hill, Brooklyn, nursing home thought to have had 55 deaths from COVID-19; Police investigate motive for mass shooting where 16 died in Nova Scotia, Canada; Trump encourages protests across the country against the shutdown.

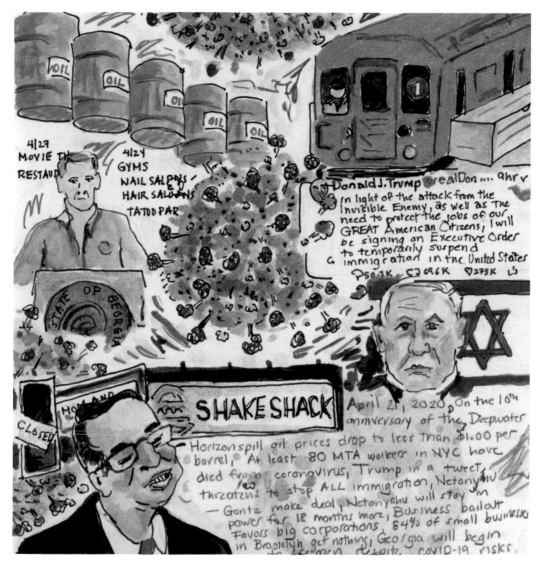

April 21, 2020

On the 10th anniversary of the Deepwater Horizon spill, oil prices drop to less than $1.00 per barrel; At least 80 MTA workers in NYC have died from coronavirus; Trump, in a tweet, threatens to stop *all* immigration; Netanyahu, Gantz make deal, Netanyahu will stay in power for 18 months more; Business bailout favors big corporations, 84% of small businesses in Brooklyn get nothing; Georgia will begin to reopen despite COVID-19 risks.

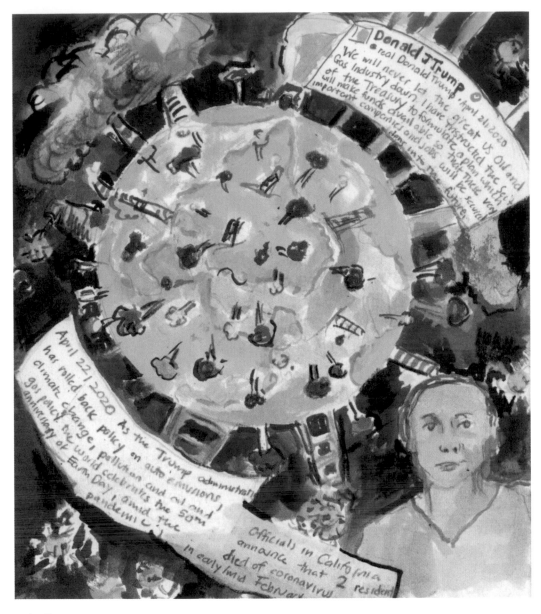

April 22, 2020

As the Trump administration has rolled back policy on auto emissions, climate change, pollution, and oil and gas policy, the world celebrates the 50th anniversary of Earth Day, amid the pandemic; Officials in California announce that 2 residents died of coronavirus in early/mid February.

April 23, 2020

2 New York cats test positive for coronavirus; Another 4.4 million file for unemployment bringing number to over 26 million; Some southern states begin to reopen, even Trump objects to Georgia's plans; Top US vaccine scientist ousted after refusing to tout hydroxychloroquine against coronavirus.

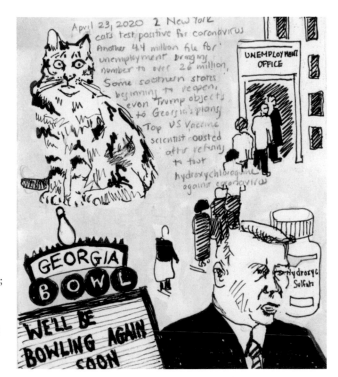

April 24, 2020

Alexandria Ocasio-Cortez is sole Democrat to vote against new $484 billion coronavirus bill, no relief for frontline workers, post office, poor people; Outbreaks in Chicago, Boston, Seattle, San Francisco, coronavirus was there in Jan/Feb; Trump suggests quack cures for COVID-19; 21% of NYC residents test positive for virus antibodies.

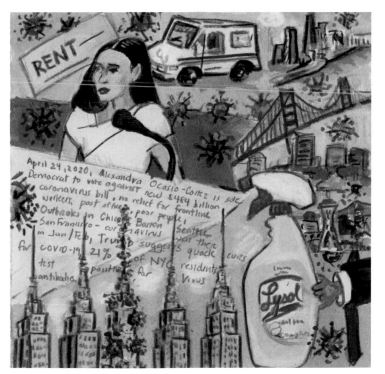

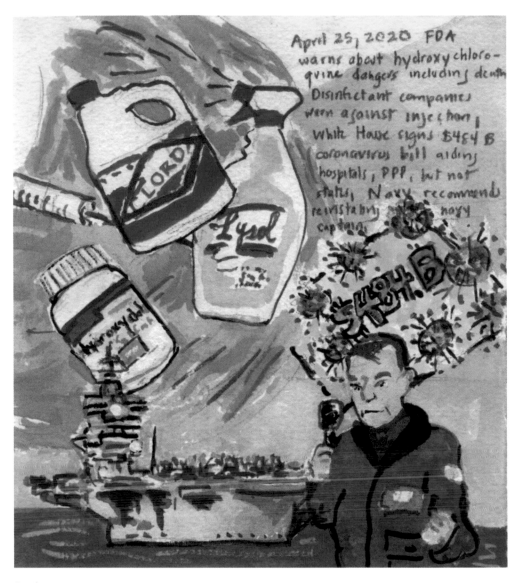

April 25, 2020

FDA warns about hydroxychloroquine dangers including death; Disinfectant companies warn against injection; White House signs $484 billion coronavirus bill aiding hospitals, PPP, but not states; Navy recommends reinstating Navy captain.

April 27, 2020

Republican and Democratic governors and senators object to McConnell telling states to declare bankruptcy; Children in Spain allowed out for first time since quarantine; Dr. Birx says social distancing will be with us through the summer.

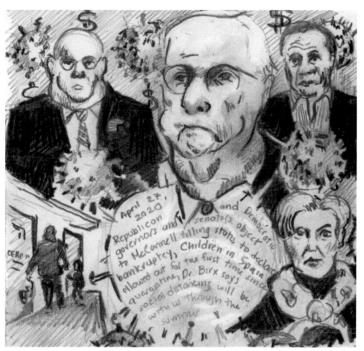

April 28, 2020

The *Washington Post* reports that intelligence agencies warned Trump in January/February of coronavirus, he skipped reading reports; 15,000 deaths in US reported in addition to 56,000 official deaths from virus; New York presidential primaries suspended, Sanders and supporters object; De Blasio, in about-face, will open 40 miles of city streets to pedestrians.

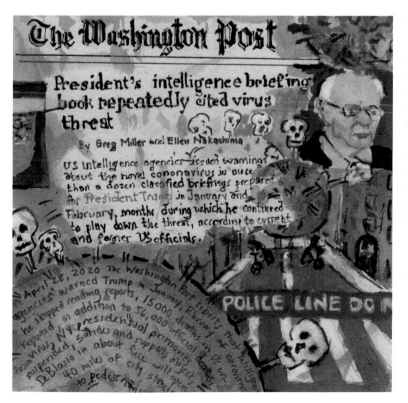

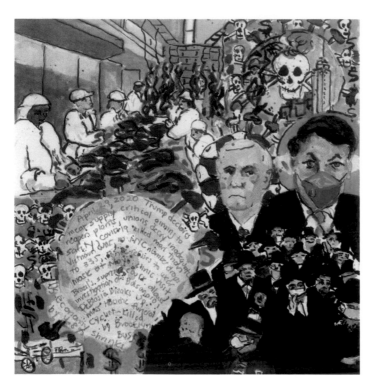

April 29, 2020

Trump declares meat supply critical, aiming to reopen plants, unions decry inadequate safety; COVID-19 killed more than Vietnam War; In NYC number drops to 335; Pence refuses to wear a mask at Mayo Clinic visit; Brazil's supreme court allows investigation of Bolsonaro; De Blasio breaks up mass Hasidic funeral; Cyclist killed by Brooklyn bus; US economy shrinks by 4.8%.

April 30, 2020

Kushner calls US coronavirus story "a great success" with 61,000 dead and many more unreported; Fauci says US could be in for a bad fall and winter if not prepared for second wave; Dozens of bodies found in trucks outside Brooklyn funeral home; Remdesivir shows some promise as anti-COVID-19 drug; 3.8 million more people apply for unemployment, total over 30 million in six weeks; Great Britain has 3rd-highest number of COVID deaths—over 26,000; South Korea has no new cases, 247 dead; Russia 106,000 test positive—worse yet to come; Biden remains silent on sexual assault allegations.

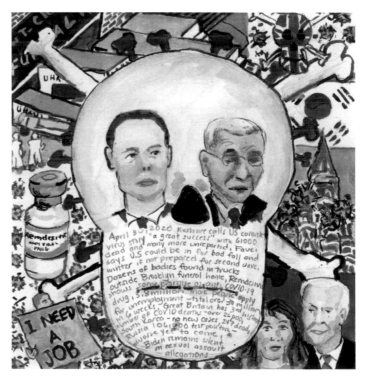

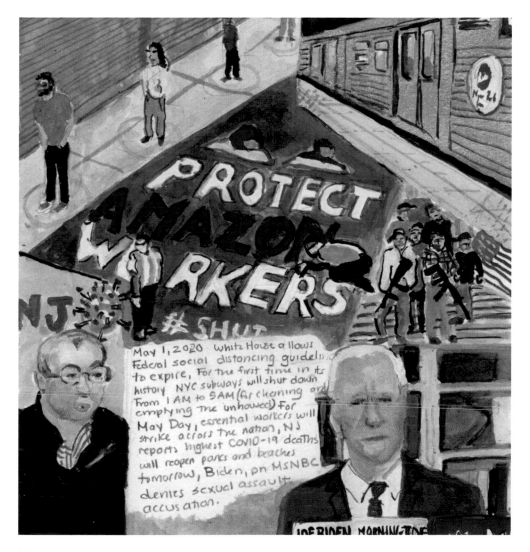

May 1, 2020

White House allows federal social distancing guidelines to expire; For the first time in its history NYC subways will shut down from 1 a.m. to 5 a.m. (for cleaning and emptying the unhoused); For May Day essential workers will strike across the nation; NJ reports highest COVID-19 deaths, will reopen parks and beaches tomorrow; Biden on MSNBC denies sexual assault accusations.

May 2, 2020

US is a patchwork of shutdown endings, some opening now, others not yet decided, Adults in Spain allowed out to exercise after 7 weeks of lockdown; Tenants across the country withhold rent—largest coordinated rent strike in nearly a century; Trump replaces watchdog who reported on hospital shortages with new inspector general Jason Weida; Gilead Sciences, maker of experimental COVID-19 drug remdesivir, spent record $2.45 million lobbying in first quarter.

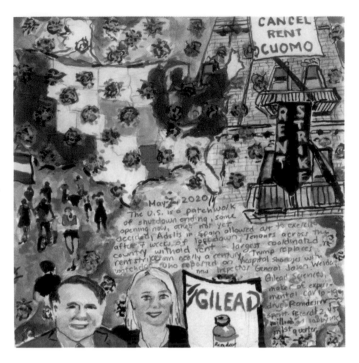

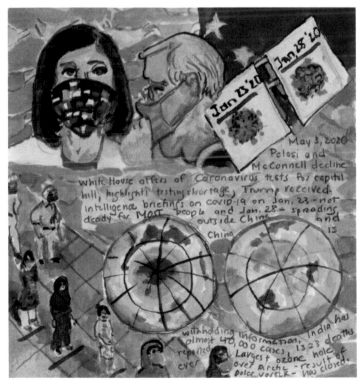

May 3, 2020

Pelosi and McConnell decline White House offers of coronavirus tests for Capitol Hill, highlight testing shortage; Trump received intelligence briefings on COVID-19 on Jan. 23—not deadly for *most* people, and Jan. 28—spreading outside China and China is withholding information; India has almost 40,000 cases, 1,323 deaths reported; Largest ozone hole ever over Arctic, result of polar vortex, has closed.

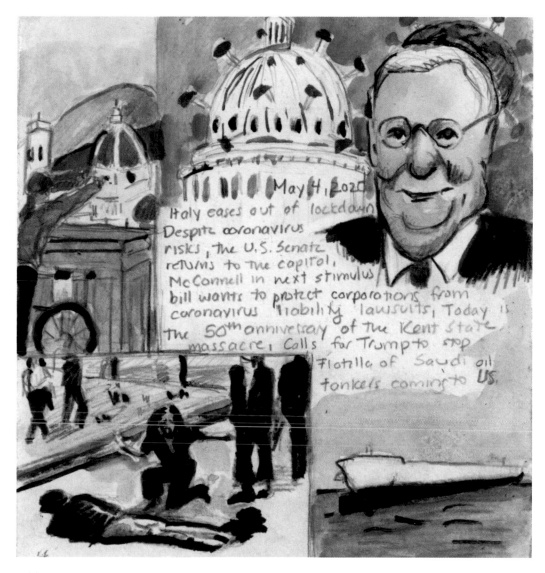

May 4, 2020

Italy eases out of lockdown; Despite coronavirus risks, the US Senate returns to the Capitol; McConnell, in next stimulus bill, wants to protect corporations from coronavirus liability lawsuits; Today is the 50th anniversary of the Kent State massacre; Calls for Trump to stop flotilla of Saudi oil tankers coming to US.

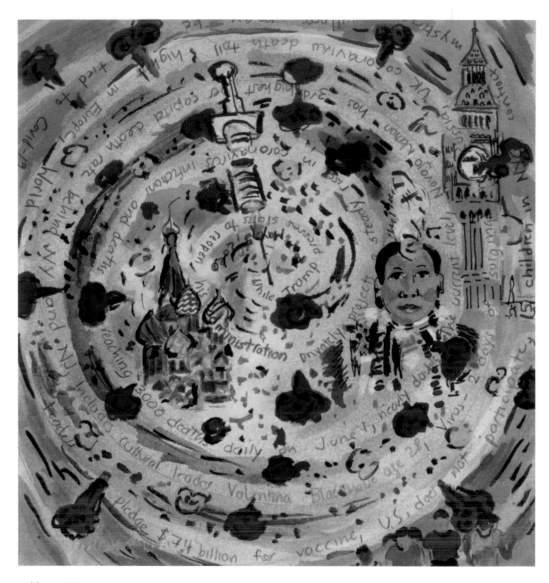

May 5, 2020

While Trump presses states to reopen, his administration privately projects a steady rise in coronavirus infections and deaths reaching 3,000 deaths daily on June 1, nearly double the current level; Navajo Nation has 3rd-highest per capita death rate behind NY and NJ, includes cultural leader Valentina Blackhorse, age 28; Virus—2 days of surges in Russia; UK coronavirus death toll highest in Europe; World leaders pledge $7.4 billion for vaccine, US does not participate; 15 children in NYC contract mysterious illness, may be tied to COVID-19.

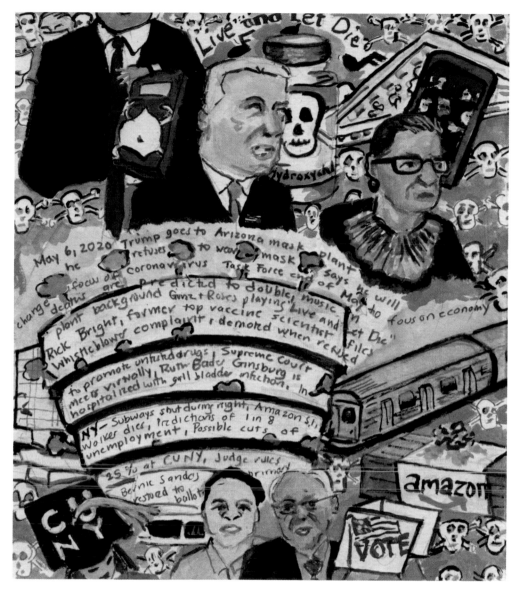

May 6, 2020

Trump goes to Arizona mask plant, he refuses to wear a mask, says he will change focus of coronavirus task force end of May to focus on economy as deaths are predicted to double, music in plant background Guns N' Roses playing "Live and Let Die"; Rick Bright, former top vaccine scientist, files whistleblower complaint, demoted when refused to promote untested drugs; Supreme Court meets virtually, Ruth Bader Ginsburg is hospitalized with gallbladder infection; In NYC, subways shut down during night; Amazon Staten Island worker dies; Predictions of 1 in 8 unemployment; Possible cuts of 25% at CUNY; Judge rules Bernie Sanders primary restored to ballot.

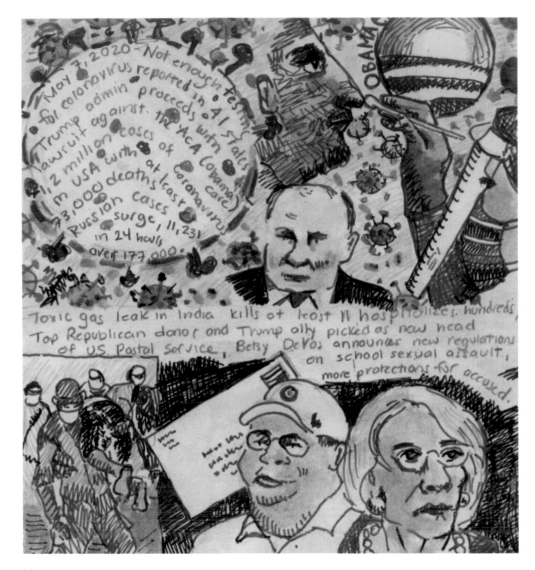

May 7, 2020

Not enough testing for coronavirus reported in 41 states; Trump admin proceeds with lawsuit against the ACA (Obamacare); 1.2 million cases of coronavirus in USA with at least 73,000 deaths; Russian cases surge 11,231 in 24 hours, over 177,000; Toxic gas leak in India kills at least 11, has hospitalized hundreds; Top Republican donor and Trump ally picked as new head of US Postal Service; Betsy DeVos announces new regulations on school sexual assault, more protections for the accused.

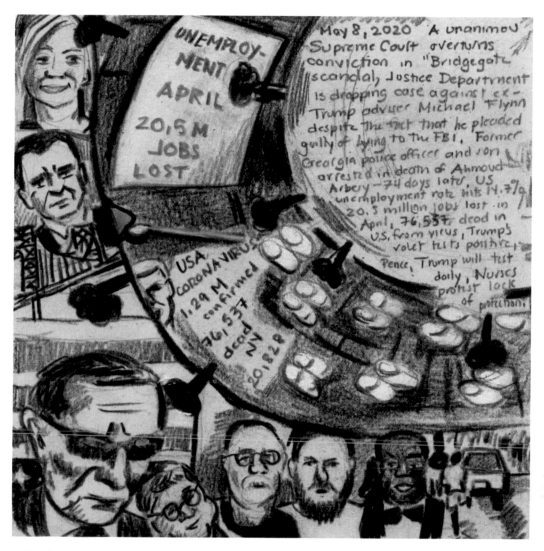

May 8, 2020

A unanimous Supreme Court overturns conviction in "Bridgegate" scandal; Justice Department is dropping case against ex–Trump adviser Michael Flynn, despite the fact that he pleaded guilty of lying to the FBI; Former Georgia police officer and son arrested in death of Ahmaud Arbery—74 days later, US unemployment rate hits 14.7%, 20.5 million jobs lost in April, 76,537 dead in US from virus, Trump's valet tests positive, Pence, Trump will test daily; Nurses protest lack of protection.

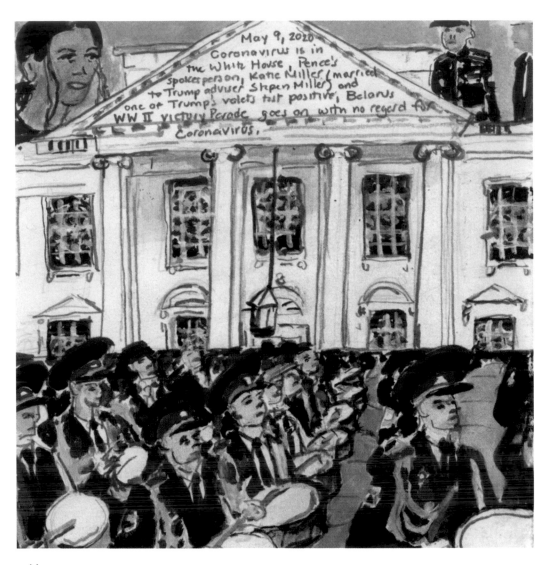

May 9, 2020

Coronavirus is in the White House, Pence's spokesperson Katie Miller (married to Trump advisor Stephen Miller) and one of Trump's valets test positive; Belarus World War II victory parade goes on with no regard for coronavirus.

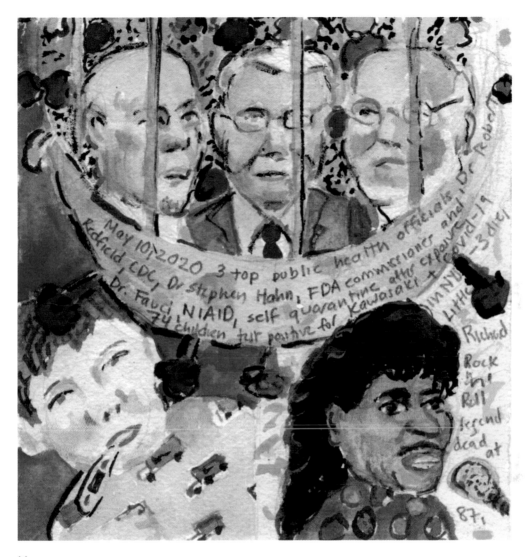

May 10, 2020

3 top public health officials, Dr. Robert Redfield, CDC, Dr. Stephen Hahn, FDA commissioner, and Dr. Fauci, NIAID, self-quarantine after exposure; 74 children test positive for Kawasaki and COVID-19 in NY State—3 die; Little Richard, rock 'n' roll legend, dead at 87.

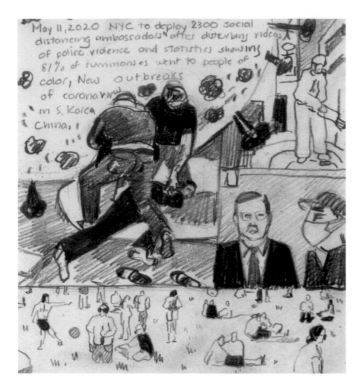

May 11, 2020

NYC to deploy 2,300 "social distancing ambassadors" after disturbing videos of police violence and statistics showing 81% of summonses went to people of color; New outbreaks of coronavirus in South Korea and China.

May 12, 2020

Fauci will testify in front of Senate, said to warn of needless suffering and death if states open too soon; CDC report says NYC coronavirus death toll may be much higher; US death toll tops 80,000; New York Public Library gets Martha Graham archive.

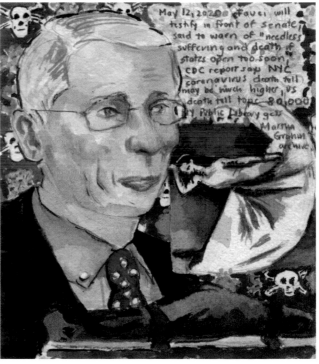

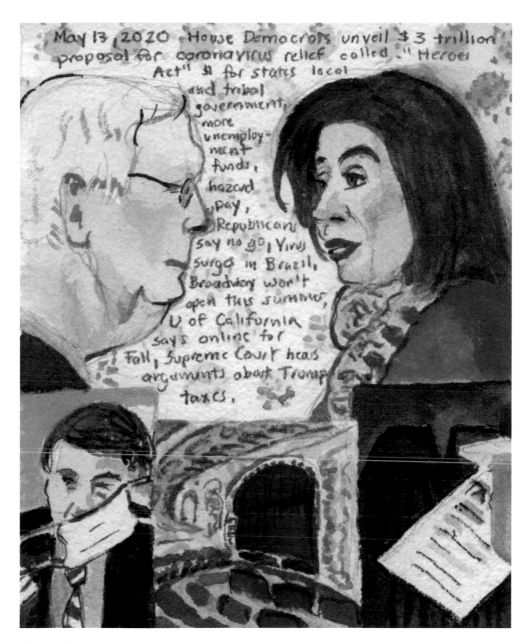

May 13, 2020

House Democrats unveil $3 trillion proposal for coronavirus relief called "Heroes Act," money for state, local, and tribal government, more unemployment funds, hazard pay, Republicans say no go; Virus surges in Brazil; Broadway won't open this summer; U of California says onlinc for fall; Supreme Court hears arguments about Trump taxes.

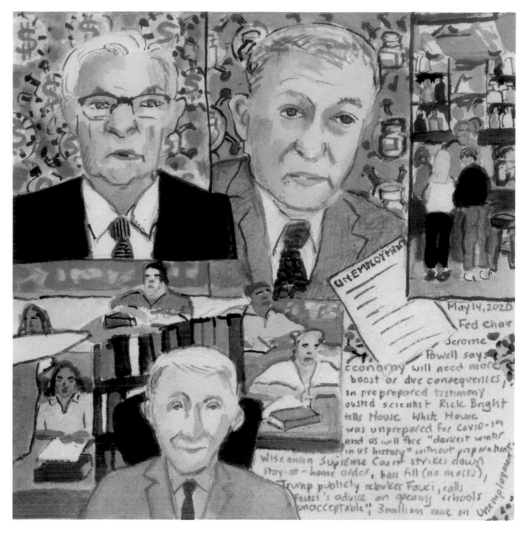

May 14, 2020

Fed Chair Jerome Powell says economy will need more boost or dire consequences; In prepared testimony, ousted scientist Rick Bright tells House White House was unprepared for COVID-19 and US will face "darkest winter in US history" without preparation; Wisconsin Supreme Court strikes down stay-at-home order, bars fill (no masks); Trump publicly rebukes Fauci, calls Fauci's advice on opening schools "unacceptable"; 3 million more on unemployment.

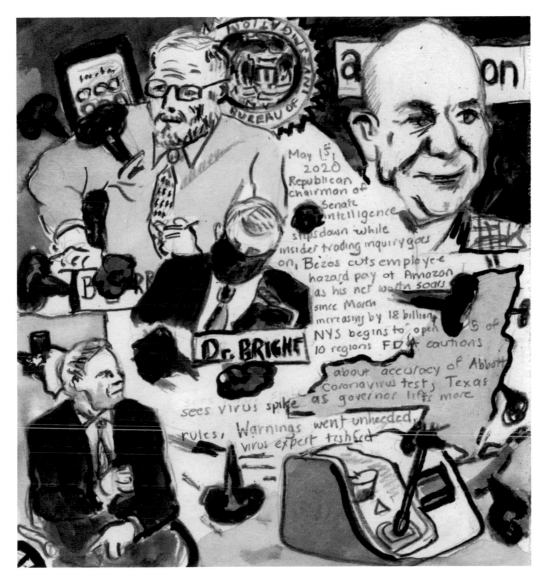

May 15, 2020

Republican chairman of Senate intelligence steps down while insider trading inquiry goes on; Bezos cuts employee hazard pay at Amazon as his net worth soars, since March increasing by $18 billion; NY State begins to open 5 of 10 regions; FDA cautions about accuracy of Abbott coronavirus test; Texas sees virus spike as governor lifts more rules; Warnings went unheeded, virus expert testifies.

May 16, 2020

Trump removes State Department Inspector General Steve Linick over Pompeo investigation; JCPenney files for bankruptcy; Italy to lift travel restrictions June 3; House passes $3 trillion coronavirus relief bill, Republicans call "wish list"; Texas Supreme Court pauses voting by mail despite coronavirus.

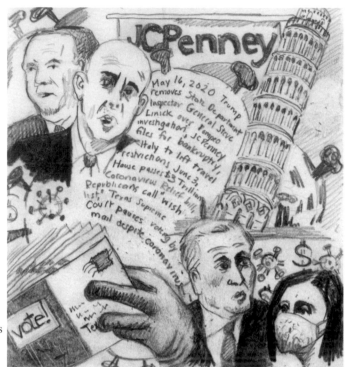

May 17, 2020

Democrats open investigation of Trump's firing of State Department watchdog—said to have been at Pompeo's urging (investigation by watchdog is of Pompeo); Spain has less than 100 COVID-19 deaths in a day; Fire/explosion at hemp oil plant LA.

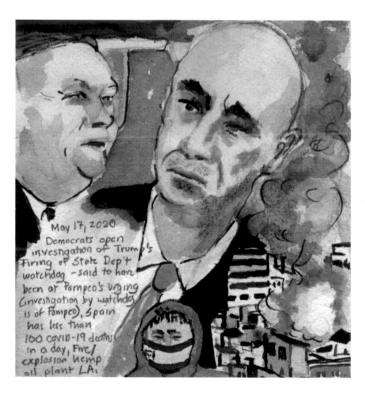

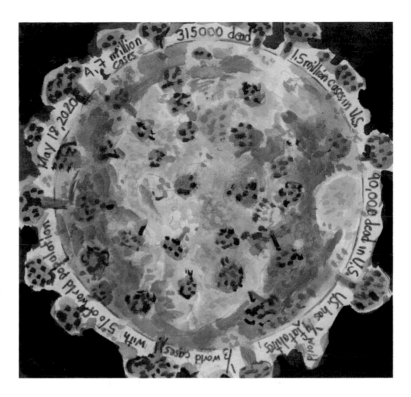

May 18, 2020

4.7 million cases, 315,000 dead, 1.5 million cases in the US, 90,000 dead in US, US has 1/4 world fatalities, 1/3 cases, with 5% population.

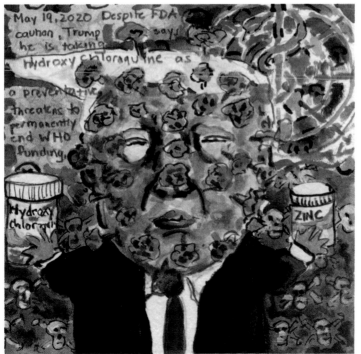

May 19, 2020

Despite FDA caution, Trump says he is taking hydroxychloroquine as a preventative, threatens to permanently end WHO funding.

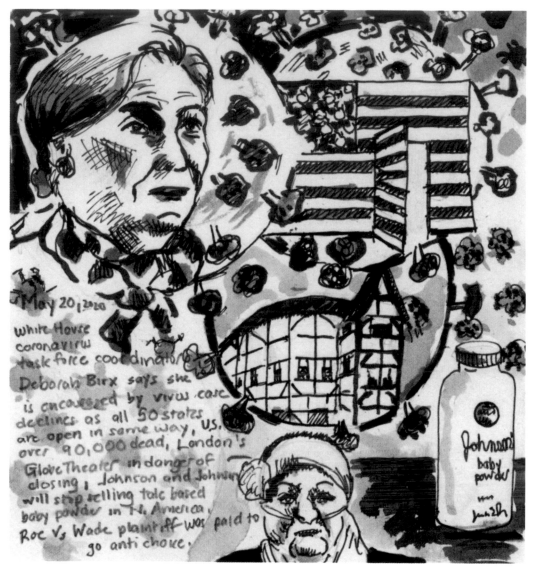

May 20, 2020

White House coronavirus task force coordinator Deborah Birx says she is encouraged by virus case decline as all 50 states are open in some way; US over 90,000 dead; London's Globe Theater in danger of closing; Johnson & Johnson will stop selling talc-based baby powder in N. America; Roe v. Wade plaintiff was paid to go anti-choice.

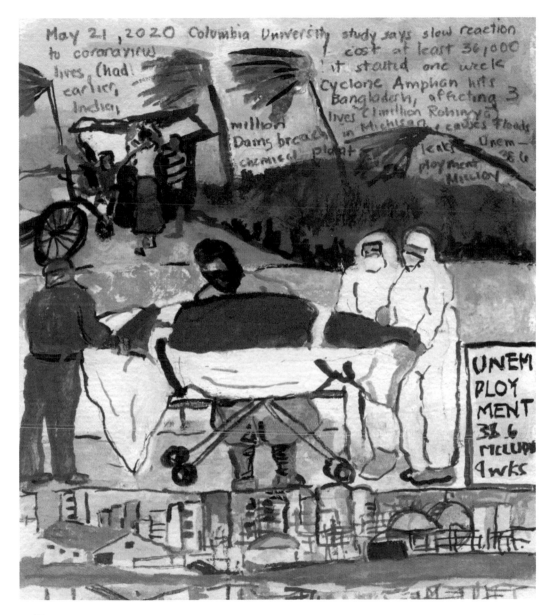

May 21, 2020

Columbia University study says slow reaction to coronavirus cost at least 36,000 lives; Cyclone Amphan hits India, Bangladesh, affecting 3 million lives (1 million Rohingya); Dams breach in Michigan causes floods, chemical plant leaks; Unemployment 38.6 million in 9 weeks.

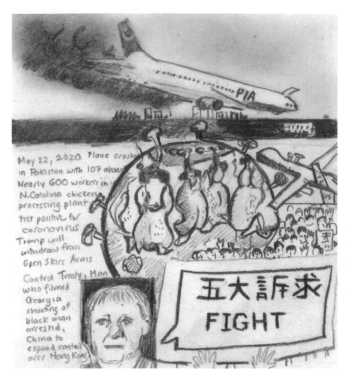

May 22, 2020

Plane crashes in Pakistan with 107 aboard; Nearly 600 workers in N. Carolina chicken processing plant test positive for coronavirus; Trump will withdraw from Open Skies Arms Control Treaty; Man who filmed Georgia shooting of black man arrested; China to expand control over Hong Kong.

May 23, 2020

Trump calls on states to reopen places of worship immediately, calls them essential services; Cuomo, responding to lawsuit, cases rules on gatherings, allows 10 people to convene.

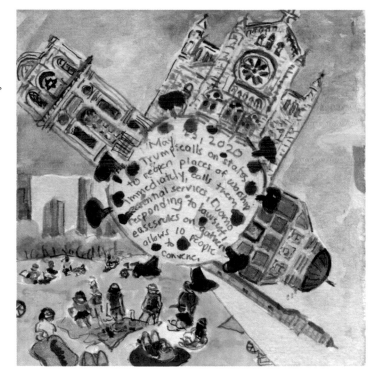

US. DEATHS NEAR 100,000, AN INCALCULABLE LOSS

They Were Not Simply Names on a List, They Were US

May 24, 2020

US approaches 100,000 deaths from coronavirus; Hong Kong protest over proposed national security law met with tear gas; Netanyahu appears in court on corruption charges, first sitting PM ever tried while in office.

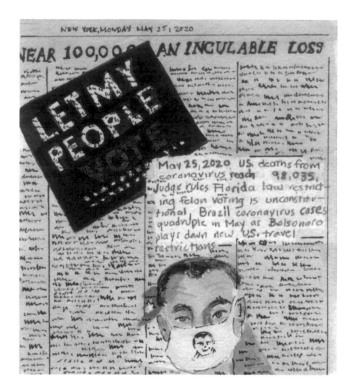

May 25, 2020

US deaths from coronavirus reach 98,035; Judge rules Florida law restricting felon voting is unconstitutional; Brazil coronavirus cases quadruple in May as Bolsonaro plays down new US travel restrictions.

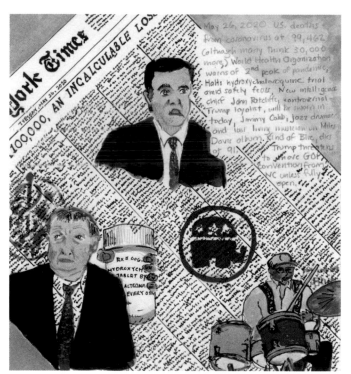

May 26, 2020

US deaths from coronavirus at 99,462 (although many think 30,000 more); World Health Organization warns of 2nd peak of pandemic, halts hydroxychloroquine trial amid safety fears; New Intelligence Chief John Ratcliffe, controversial Trump loyalist, will be sworn in today; Jimmy Cobb, jazz drummer and last living musician on Miles Davis album *Kind of Blue*, dies at 91; Trump threatens to move GOP convention from NC unless fully open.

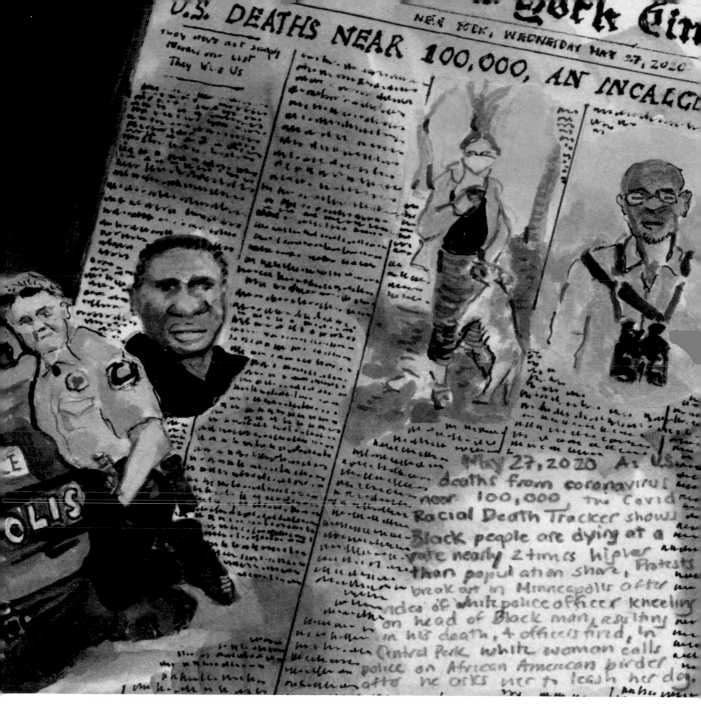

May 27, 2020

As US deaths from coronavirus near 100,000, the COVID Racial Death Tracker shows Black people are dying at a rate nearly 2 times higher than population share; Protests break out in Minneapolis after video of white police officer kneeling on head of Black man, resulting in his death, 4 officers fired; In Central Park, white woman calls police on African American birder after he asks her to leash her dog.

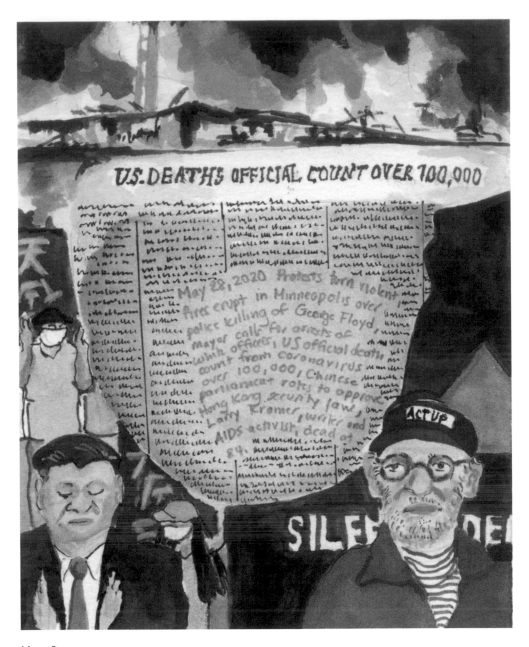

May 28, 2020

Protests turn violent, fires erupt in Minneapolis over police killing of George Floyd, mayor calls for arrests of white officers; US official death count from coronavirus over 100,000; Chinese parliament votes to approve Hong Kong security law; Larry Kramer, writer and AIDS activist, dead at 84.

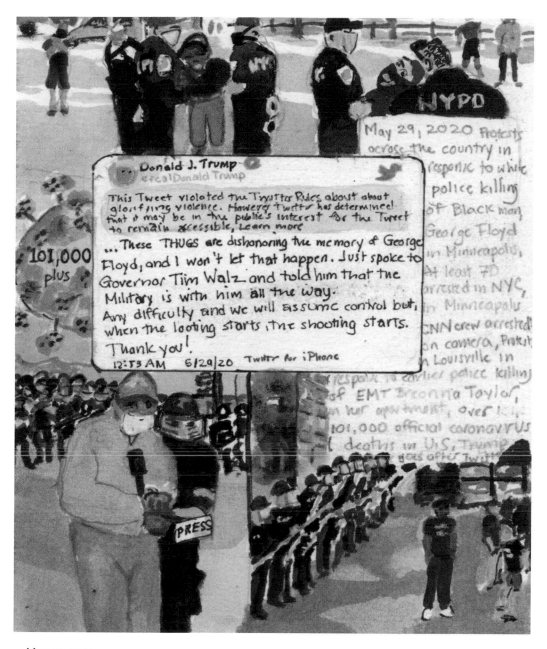

May 29, 2020

Protests across the country in response to white police killing of Black man George Floyd in Minneapolis; At least 70 arrested in NYC; In Minneapolis, CNN crew arrested on camera; Protest in Louisville in response to earlier police killing of EMT Breonna Taylor, at her apartment; Over 101,000 official coronavirus deaths in US; Trump goes after Twitter.

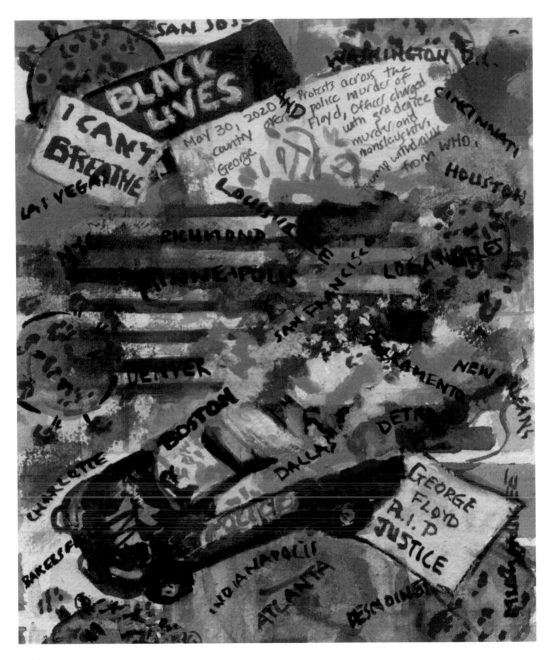

May 30, 2020

Protests across the country over police murder of George Floyd; Officer charged with 3rd degree murder and manslaughter; Trump withdraws from WHO.

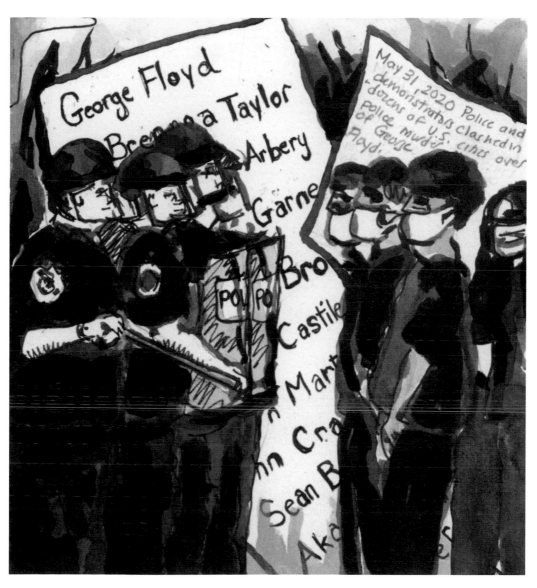

May 31, 2020

Police and demonstrators clash in dozens of US cities over police murder of George Floyd.

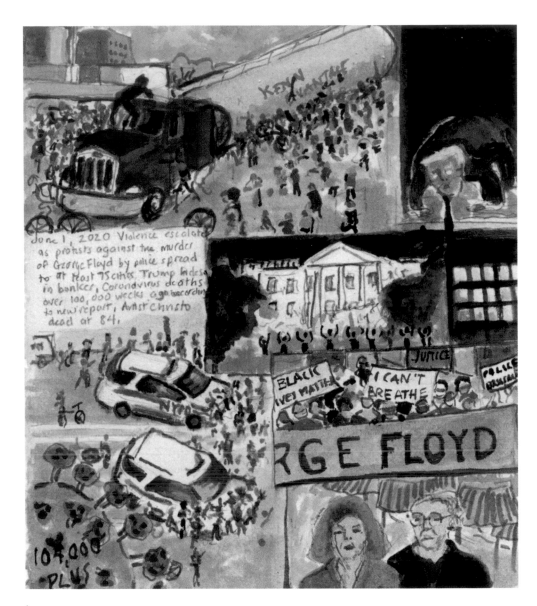

June 1, 2020

Violence escalates as protests against the murder of George Floyd by police spread to at least 75 cities; Trump hides in bunker; Coronavirus deaths over 100,000 weeks ago according to new report; Artist Christo dead at 84.

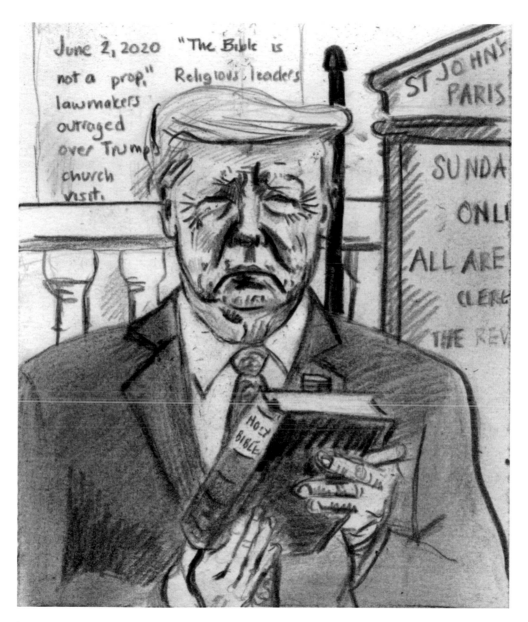

June 2, 2020

"The Bible is not a prop," religious leaders, lawmakers outraged over Trump's church visit.

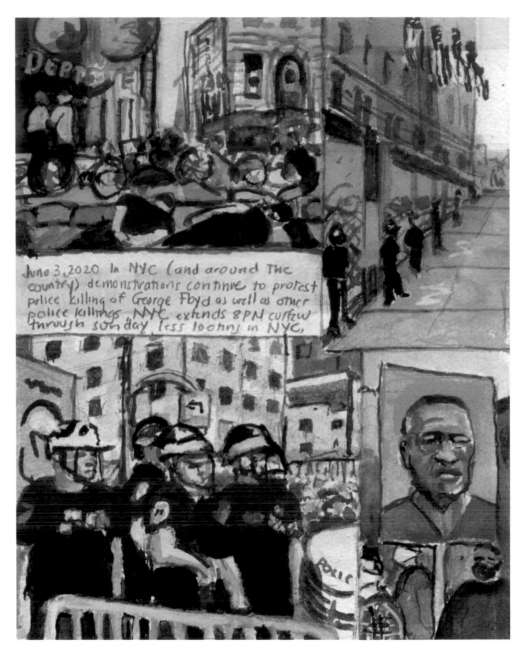

June 3, 2020

In NYC (and around the country) demonstrations continue to protest police killing of George Floyd as well as other police killings; NYC extends 8 p.m. curfew through Sunday, less looting in NYC.

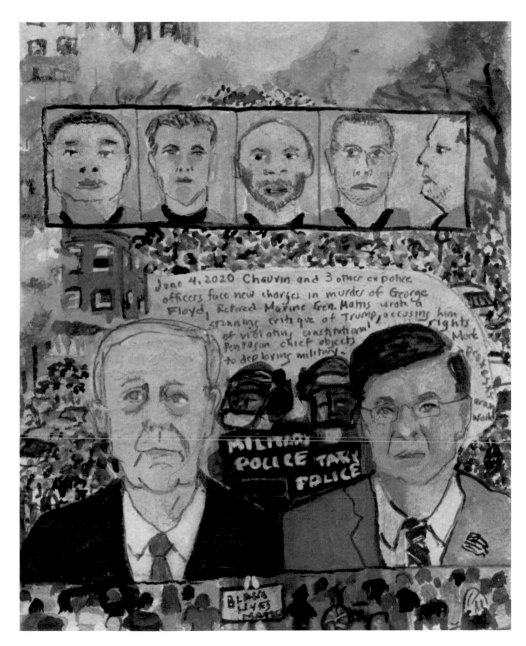

June 4, 2020

Chauvin and 3 other ex-police officers face new charges in murder of George Floyd; Retired Marine Gen. Mattis wrote a stunning critique of Trump, accusing him of violating constitutional rights; Pentagon chief objects to deploying military; More protests around the world.

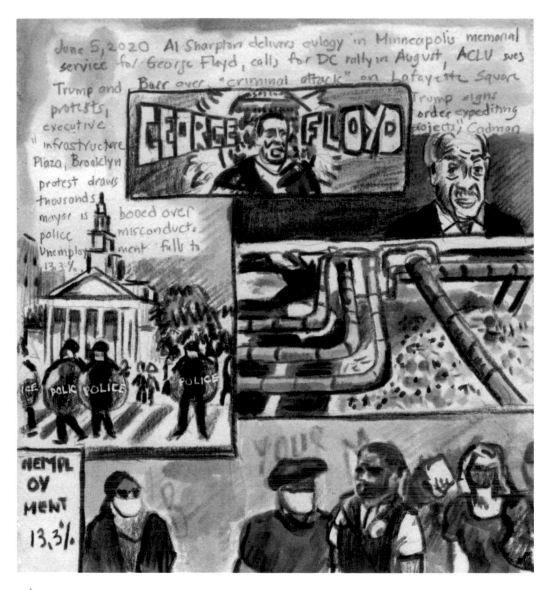

June 5, 2020

Al Sharpton delivers eulogy in Minneapolis memorial service for George Floyd, calls for DC rally in August; ACLU sues Trump and Barr over "criminal attack" on Lafayette Square protests; Trump signs executive order expediting "infrastructure projects"; Cadman Plaza, Brooklyn, protest draws thousands, mayor is booed over police misconduct; Unemployment falls to 13.3%.

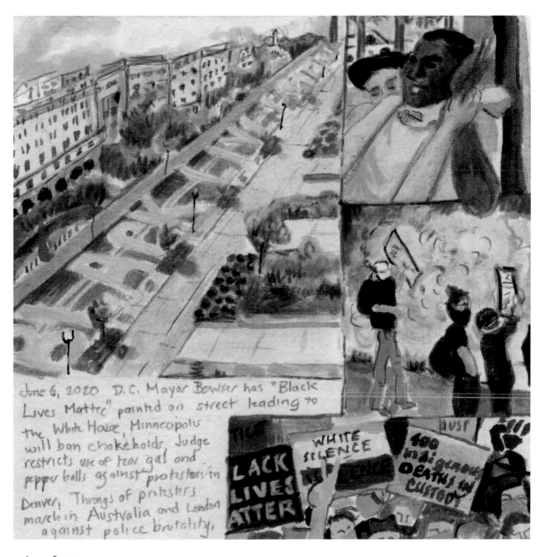

June 6, 2020

DC mayor Bowser has "Black Lives Matter" painted on street leading to the White House; Minneapolis will ban choke holds; Judge restricts use of tear gas and pepper balls against protesters in Denver; Throngs of protesters march in Australia and London against police brutality.

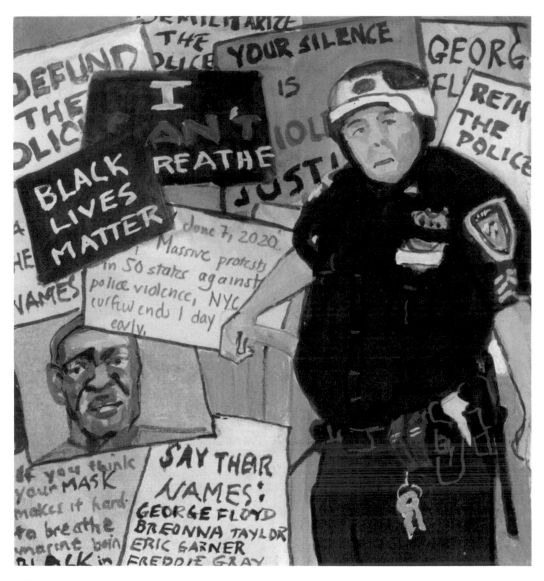

June 7, 2020

Massive protests in 50 states against police violence; NYC curfew ends 1 day early.

June 8, 2020

NYC emerges from coronavirus, enters phase 1 of reopening, construction, retail curbside pickups, after losing 22,000 to virus; Nine members of City Council, Minneapolis, creating a supermajority vote to dismantle city police; More protests in NYC and world over against police brutality.

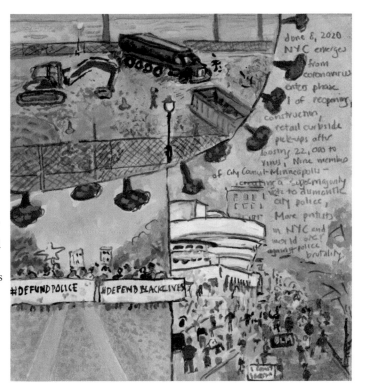

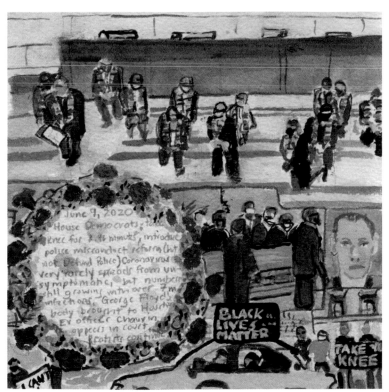

June 9, 2020

House Democrats take knee for 8:46 minutes, introduce police misconduct reform (but not Defund Police); Coronavirus very rarely spreads from asymptomatic, but numbers still growing with over 7 million infections; George Floyd's body brought to Houston; Ex-officer Chauvin appears in court; Protests continue.

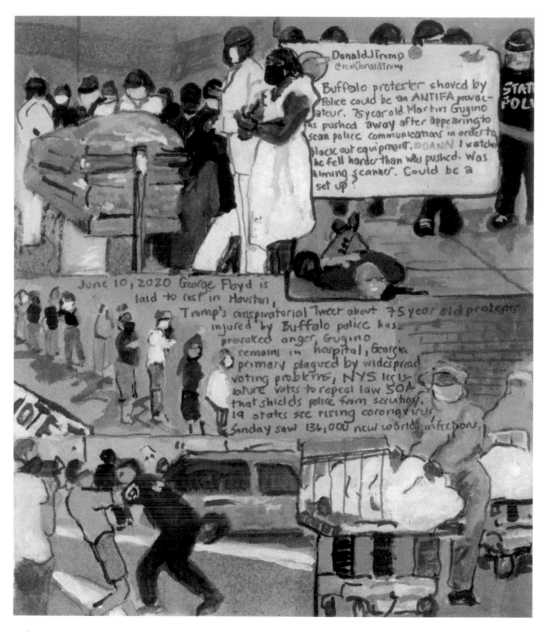

June 10, 2020

George Floyd is laid to rest in Houston; Trump's conspiratorial tweet about 75-year-old protester injured by Buffalo police has provoked anger; Gugino remains in hospital; Georgia primary plagued by widespread voting problems; NY State legislature votes to repeal law 50A that shields police from scrutiny; 19 states see rising coronavirus; Sunday saw 136,000 new world infections.

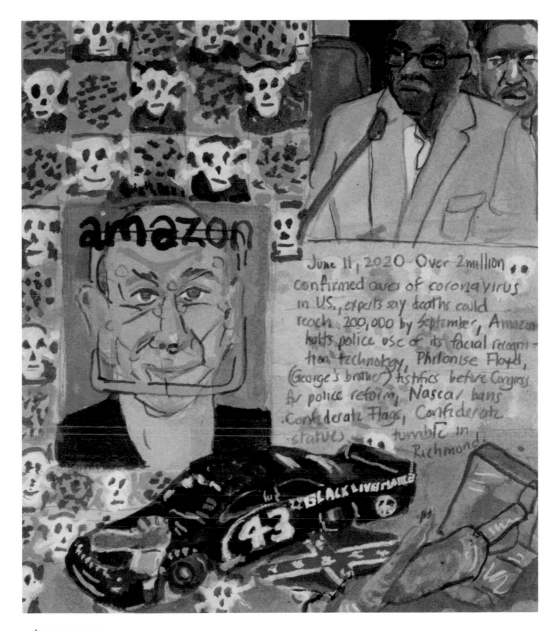

June 11, 2020

Over 2 million confirmed cases of coronavirus in US, experts say deaths could reach 200,000 by September; Amazon halts police use of its facial recognition technology; Philonise Floyd (George's brother) testifies before Congress for police reform; NASCAR bans Confederate flags; Confederate statues tumble in Richmond.

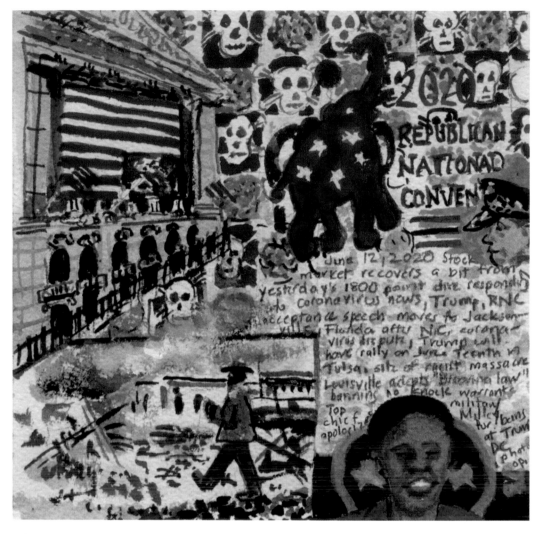

June 12, 2020

Stock market recovers a bit from yesterday's 1,800-point dive responding to coronavirus news; Trump RNC acceptance speech moves to Jacksonville, Florida, after NC coronavirus dispute; Trump will have rally on Juneteenth in Tulsa, site of racist massacre; Louisville adopts Breonna law banning no-knock warrant; Top military chief Milley apologizes for being at Trump DC photo op.

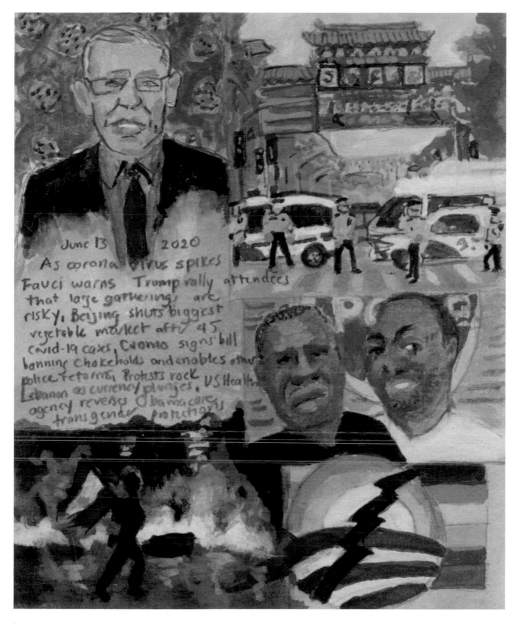

June 13, 2020

As coronavirus spikes, Fauci warns Trump rally attendees that large gatherings are risky; Beijing shuts biggest vegetable market after 45 COVID-19 cases; Cuomo signs bill banning choke hold and enables other police reforms; Protests rock Lebanon as currency plunges; US health agency reverses Obamacare transgender protections.

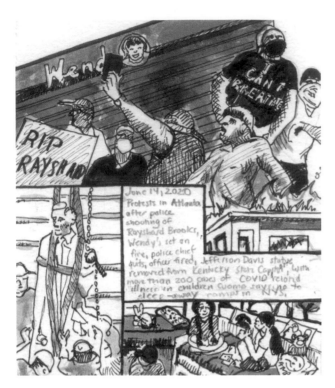

June 14, 2020

Protests in Atlanta after police shooting of Rayshard Brooks, Wendy's set on fire, police chief quits, officer fired; Jefferson Davis statue removed from Kentucky state capitol; With more than 200 cases of COVID-related illness in children; Cuomo says no to sleepaway camps in NY State.

June 15, 2020

Atlanta protesters take to street, video shows Rayshard Brooks being polite, autopsy shows he was shot in the back; Philippine journalist Maria Ressa found guilty of violating cyber libel law; Arizona and 21 other states show increase in coronavirus— Arizona will not pause, Oregon will; Protests continue against police brutality in NYC and across country; "Black Lives Matter" painted on Brooklyn street.

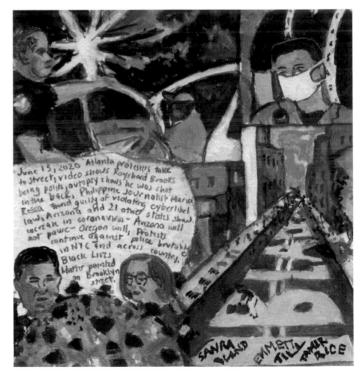

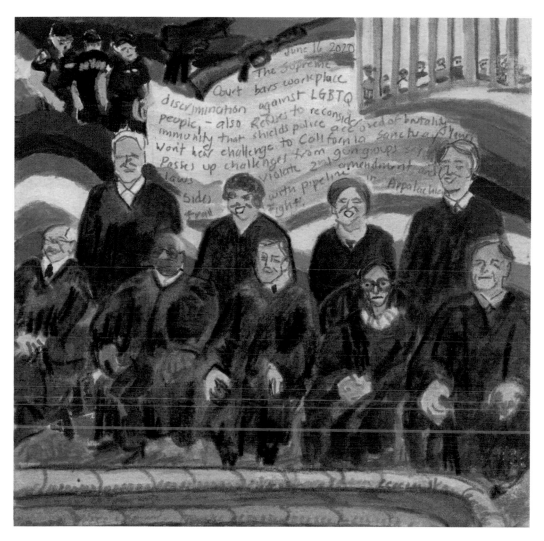

June 16, 2020

The Supreme Court bars workplace discrimination against LGBTQ people, also refuses to reconsider immunity that shields police accused of brutality, won't hear challenge to California sanctuary laws, passes up challenges from gun group saying laws violate Second Amendment, and sides with pipeline on Appalachian Trail fight.

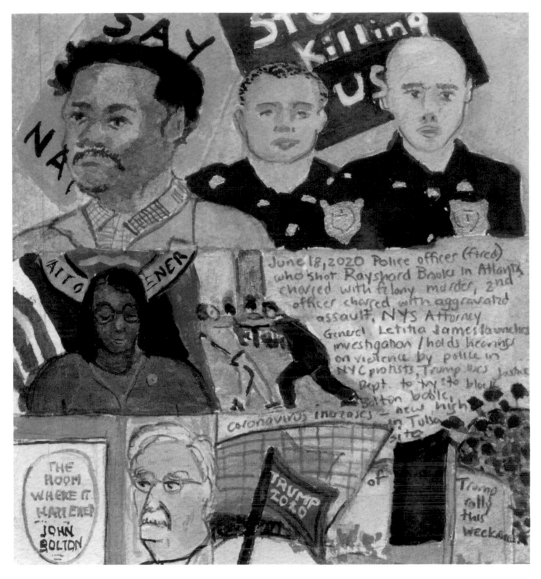

June 18, 2020

Police officer (fired) who shot Rayshard Brooks in Atlanta charged with felony murder, 2nd officer charged with aggravated assault; NY State attorney general Letitia James launches investigation/holds hearings on violence by police in NYC protests; Trump uses Justice Department to try to block Bolton book; Coronavirus increases—new highs in Tulsa, site of Trump rally this weekend.

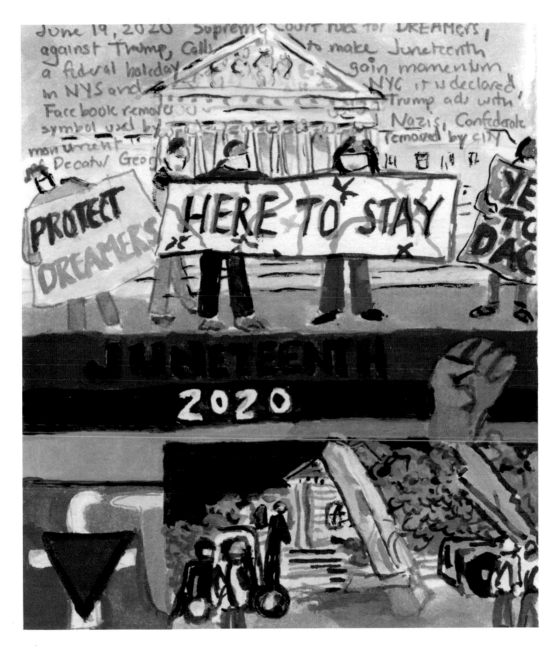

June 19, 2020

Supreme Court rules for DREAMers, against Trump; Calls to make Juneteenth a federal holiday gain momentum in NY State and NYC it is declared; Facebook removes Trump ads with symbol used by Nazis; Confederate monument in Decatur, Georgia, removed by city.

June 20, 2020

Brazil becomes 2nd country to hit 1 million cases of coronavirus, Bolsonaro says some people are going to die, "That's life. That's reality"; Barr announces Geoffrey Berman, US attorney prosecuting Trump allies (Giuliani), is stepping down, Berman says he has no intention; Juneteenth events, protests all over US.

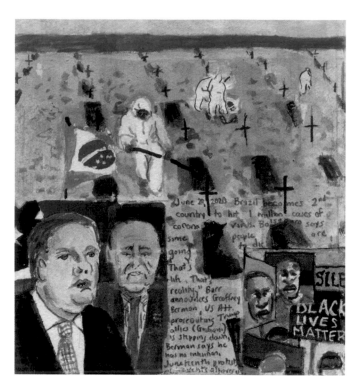

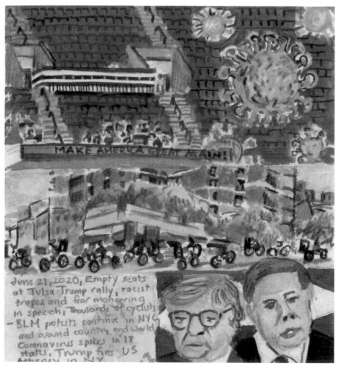

June 21, 2020

Empty seats at Tulsa Trump rally, racist tropes and fearmongering in speech; Thousands of cyclists–BLM protests continue in NYC and around country and world; Coronavirus spikes in 18 states; Trump fires US attorney in NY.

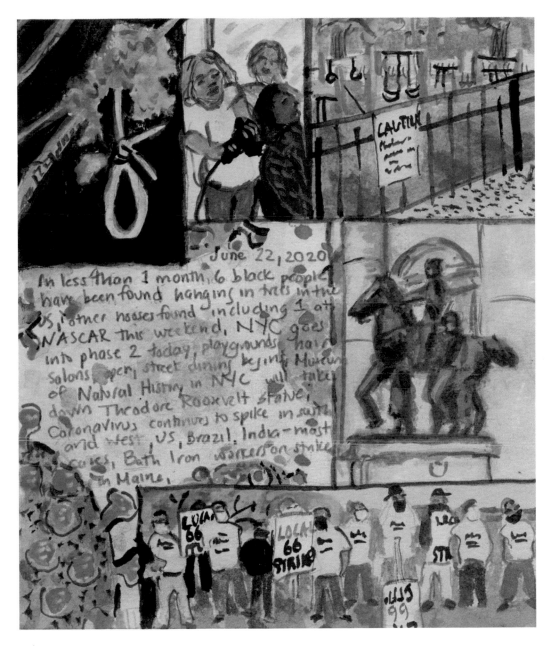

June 22, 2020

In less than 1 month, 6 Black people have been found hanging in trees in the US, other nooses found including 1 at NASCAR this weekend; NYC goes into phase 2 today, playgrounds, hair salons, open street dining begin; Museum of Natural History in NYC will take down Theodore Roosevelt statue; Coronavirus continues to spike in South and West, US, Brazil, India—most cases; Bath Iron workers on strike in Maine.

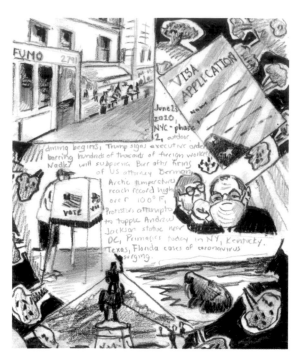

June 23, 2020

NYC—phase 2, outdoor dining begins; Trump signs executive order barring hundreds of thousands of foreign workers; Nadler will subpoena Barr after firing of US attorney Berman; Arctic temperatures reach record highs, over 100°F; Protesters attempt to topple Andrew Jackson statue near DC; Primaries today in NY, Kentucky, Florida, Texas; Coronavirus cases surging.

June 24, 2020

Dr. Fauci testifies in front of House, says next couple of weeks are crucial; Texas reports all-time daily high in coronavirus cases; Washington governor mandates masks; Bolsonaro ordered to wear a mask in Brazil; AOC wins primary, Jamaal Bowman leads Eliot Engel in New York; Whistleblowers testify about politicization of Justice Department; Baseball in July.

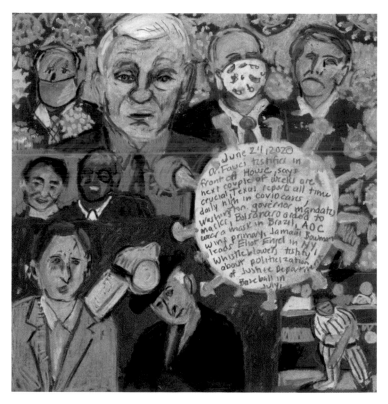

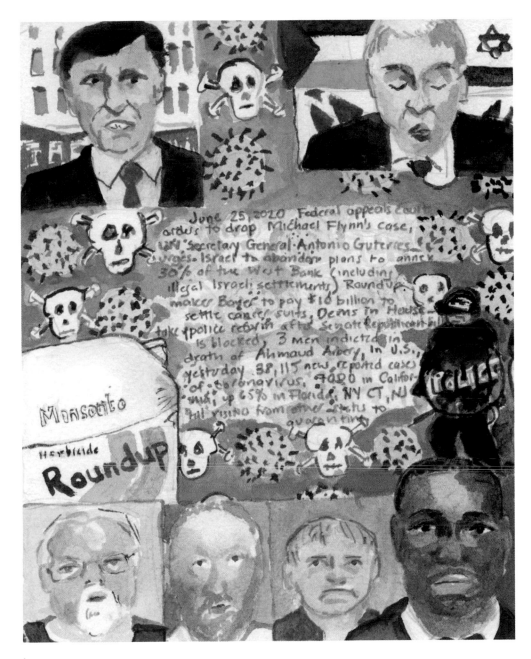

June 25, 2020

Federal appeals court orders to drop Michael Flynn's case; UN Secretary-General Antonio Gutiérrez urges Israel to abandon plans to annex 30% of the West Bank (including illegal Israeli settlements); Roundup maker Bayer to pay $10 billion to settle cancer suits; Dems in the House take up police reform after Senate Republican bill is blocked; 3 men indicted in death of Ahmaud Arbery; In US yesterday 38,115 new reported cases of coronavirus, 7,000 in California, up 65% in Florida; NY, CT, NJ tell visitors from other states to quarantine.

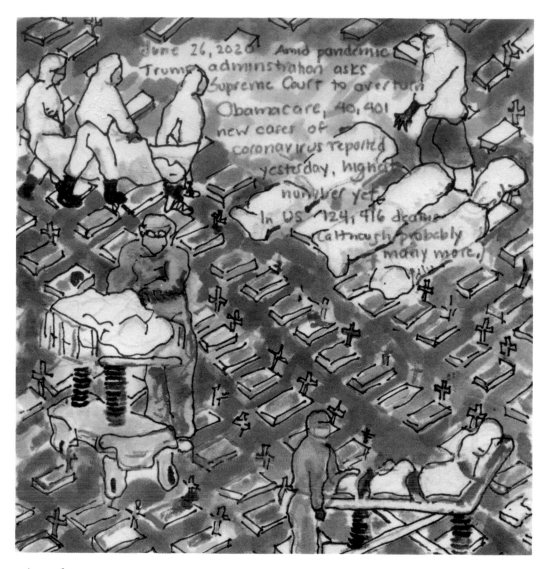

June 26, 2020

Amid pandemic Trump administration asks Supreme Court to overturn Obamacare; 40,401 new cases of coronavirus reported yesterday, highest number yet; In US 124,416 deaths (although probably many more).

June 27, 2020

Facebook will start labeling violent posts from politicians including Trump, as corporations vow to boycott; Milton Glaser, master designer and founder of *New York* magazine dead at 91; Judge rules Trump can't direct military funds to wall; Trump signs executive order to protect monuments; House passes DC statehood; Coronavirus case numbers surging in Florida, Texas, and more.

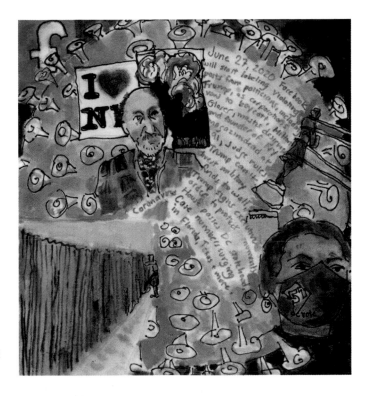

June 28, 2020

US coronavirus cases near 2.5 million, 44,792 new cases yesterday, hospitals in Texas and Arizona admitting record numbers, 65% rise over the last two weeks; Malawi opposition leader Lazarus Chakwara wins historic rerun; Mississippi legislature starts to change state flag; 50 years of Pride parade, this year virtual due to virus.

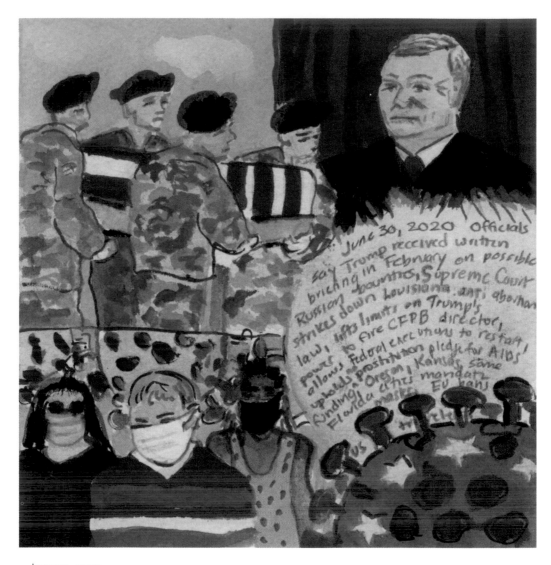

June 30, 2020

Officials say Trump received written briefing in February on possible Russian bounties; Supreme Court strikes down Louisiana anti-abortion law, lifts limits on Trump's power to fire CFPB director, allows federal executions to restart, upholds no prostitution pledge for AIDS funding; Oregon, Kansas, some Florida cities mandate masks; EU bans US travelers.

JULY

July 1, 2020

Williams College will open in fall with major changes, cuts price 15%; Dr. Fauci says 100,000 new cases a day is possible for coronavirus, as US has single day high of 48,000 new cases; NYC passes "heart-wrenching" budget, $1 billion cut from NYPD, protesters not convinced; Amy McGrath wins Kentucky primary, will take on McConnell; Protests in Hong Kong, 300 arrested protesting new security law.

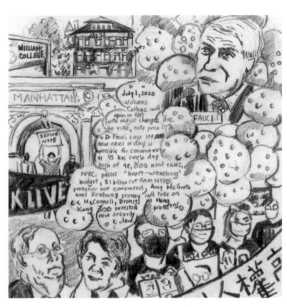

July 2, 2020

52,000 new cases of coronavirus were reported in the US yesterday; Biden outraises Trump in fundraising $141 million in June; Seattle officials shut down police-free zone—CHOP; NY, NJ, and CT are demanding that visitors from 16 states quarantine if visiting; NYC restaurants will not start indoor dining.

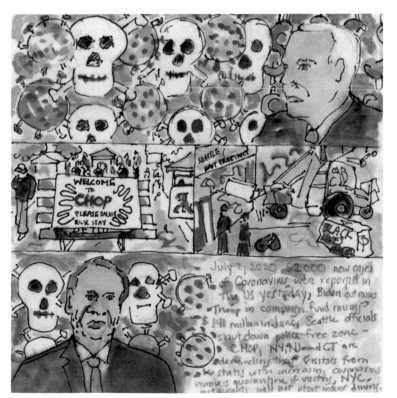

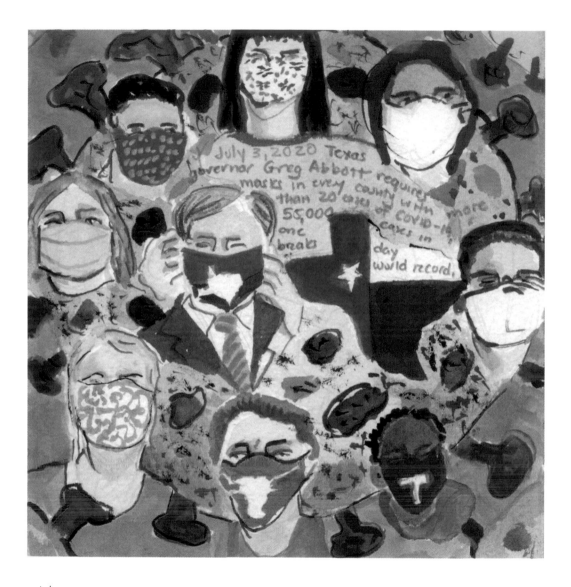

July 3, 2020

Texas governor Greg Abbott requires masks in every county with 20 cases of COVID-19; 55,000 cases in one day breaks world record.

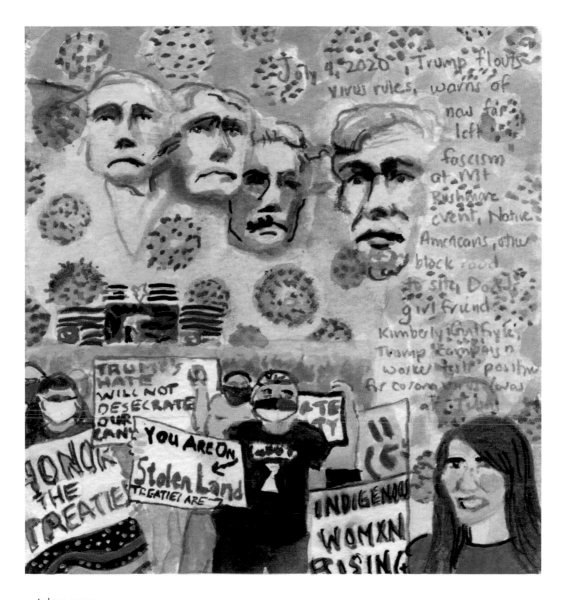

July 4, 2020

Trump flouts virus rules, warns of new "far-left facism" at Mount Rushmore event, Native Americans, others block road to site; Don Jr. girlfriend Kimberly Guilfoyle, Trump campaign worker, tests positive for coronavirus (was at Tulsa).

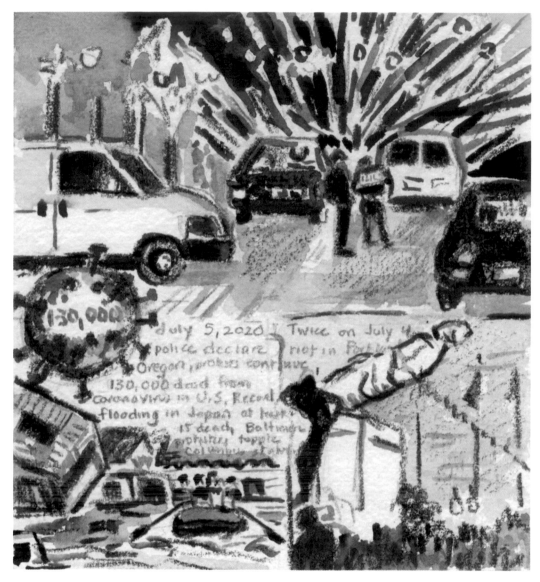

July 5, 2020

Twice on July 4 police declare riot in Portland, Oregon, protests continue; 130,000 dead from coronavirus in US; Record flooding in Japan, at least 15 dead; Baltimore protesters topple Columbus statue.

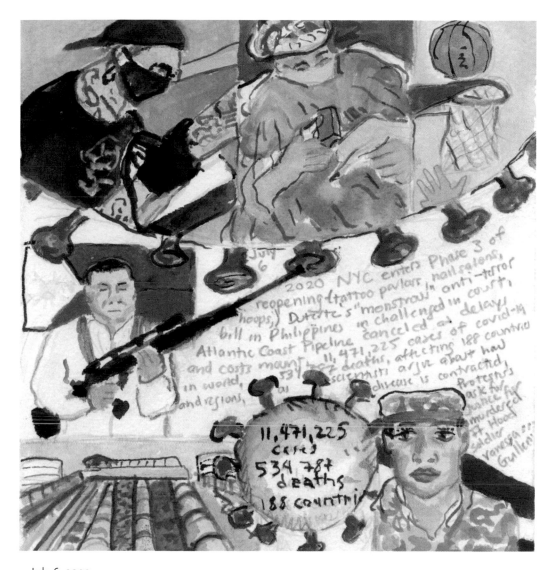

July 6, 2020

NYC enters phase 3 of reopening (tattoo parlors, nail salons, hoops); Duterte's "monstrous" anti-terror bill in Philippines is challenged in court; Atlantic Coast Pipeline canceled as delays and costs mount; 11,471,225 cases of COVID-19 in world, 534,787 deaths, affecting 188 countries and regions, as scientists argue over how disease is contracted; Protesters ask for justice for murdered Fort Hood soldier Vanessa Guillén.

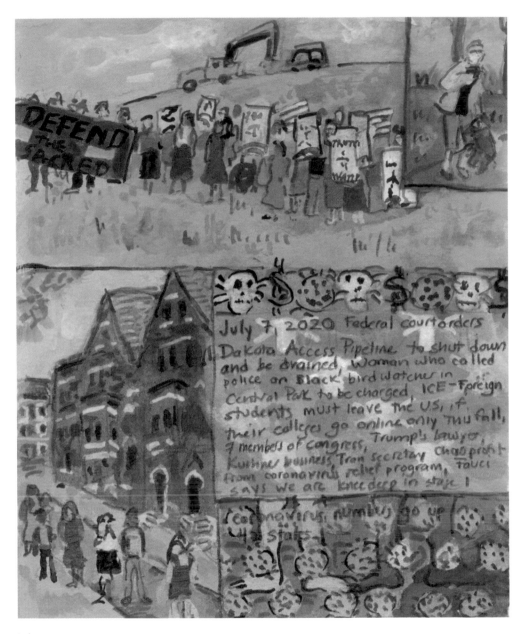

July 7, 2020

Federal court orders Dakota Access Pipeline to shut down and be drained; Woman who called police on Black bird watcher in Central Park to be charged; ICE—Foreign students must leave the US if their colleges go online-only this fall; 7 members of Congress, Trump's lawyer, Kushner business, Trans. Secretary Chao profit from coronavirus relief; Fauci says we are knee-deep in stage 1 coronavirus, numbers go up in 41 states.

July 8, 2020

Brazil's Bolsonaro tests positive for coronavirus, touts hydroxychloroquine; Betsy DeVos, secretary of education, demands schools are fully operational by fall; Trump begins process of withdrawal from WHO; Bill, "new civil rights act," the Breathe Act, introduced in House; Trump's niece's book says Trump paid for SAT cheat.

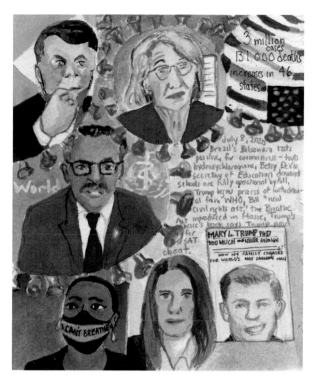

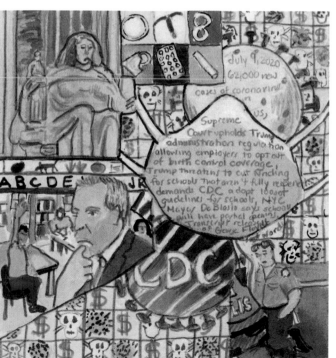

July 9, 2020

62,000 new cases of coronavirus in US; Supreme Court upholds Trump administration regulation allowing employers to opt out of birth control coverage; Trump threatens to cut funding for schools that aren't fully reopened, demands CDC adopt looser guidelines for schools; NYC mayor de Blasio says schools will have partial opening; Transcript released of George Floyd's last words.

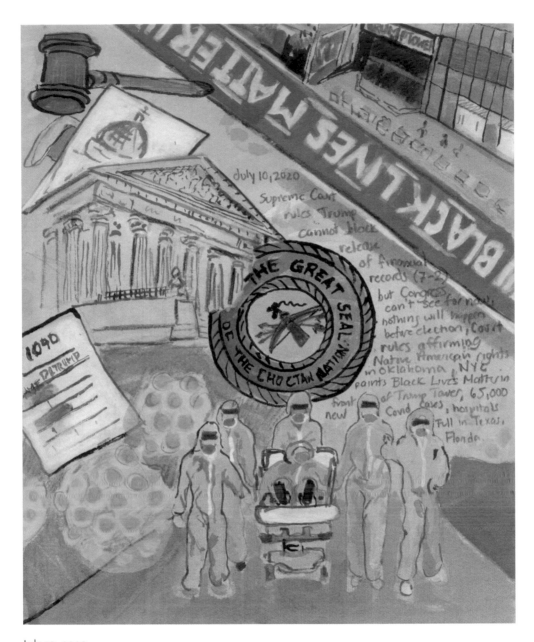

July 10, 2020

Supreme Court rules Trump cannot block release of financial records (7–2) but Congress can't see for now, nothing will happen before election; Court rules affirming Native American rights in Oklahoma; NYC paints "Black Lives Matter" in front of Trump Tower; 65,000 new COVID cases, hospitals full in Texas and Florida.

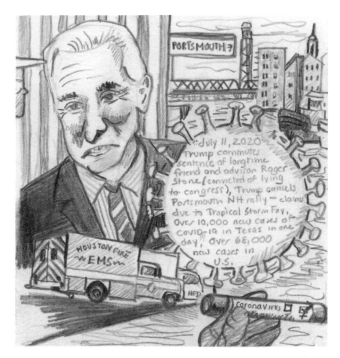

July 11, 2020

Trump commutes sentence of longtime friend and advisor Roger Stone (convicted of lying to Congress); Trump cancels Portsmouth, NH, rally—claims due to Tropical Storm Fay; Over 10,000 new cases of COVID-19 in Texas in one day; Over 68,000 new cases in the US.

July 12, 2020

At the UN Russia forces reduced access for aid to Syria; For first time Trump wears mask in public; Robert Mueller breaks silence, says, "Roger Stone remains a convicted felon and rightly so"; New York sees lowest hospitalizations from COVID-19 since mid-March, Cuomo warns of resurgence coming from other states; Officials order LA Apparel closed after 300 test positive for COVID; US—3.2 million cases, 135,000 deaths.

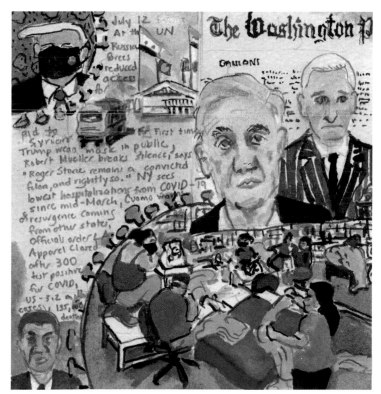

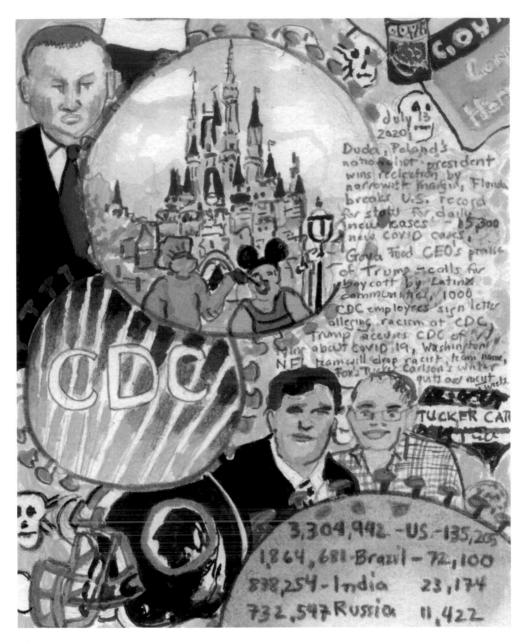

July 13, 2020

Duda, Poland's nationalist president, wins reelection by narrowest margin; Florida breaks US record for states for daily new cases—15,300 new COVID cases; Goya Food CEO's praise of Trump— calls for boycott by Latinx communities; 1,000 CDC employees sign letter alleging racism at CDC; Trump accuses CDC of lying about COVID-19; Washington NFL team will drop racist team name; Fox's Tucker Carlson's writer quits over racist tweets.

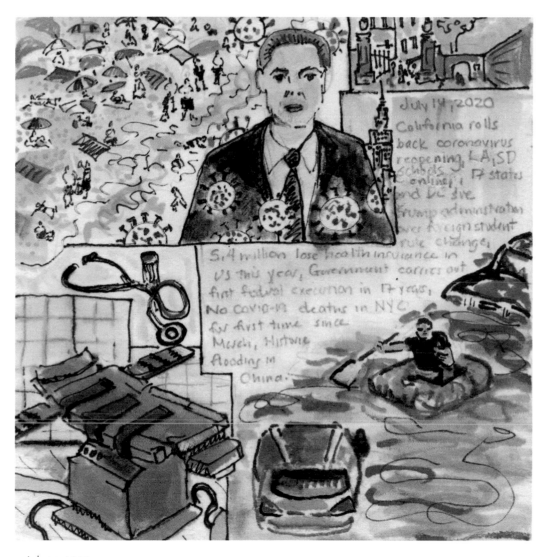

July 14, 2020

California rolls back coronavirus reopening, LA, SD schools online; 17 states and DC sue Trump administration over foreign student rule change; 5.4 million lose health insurance in US this year; Government carries out first federal execution in 17 years; No COVID-19 deaths in NYC for the first time since March; Historic flooding in China.

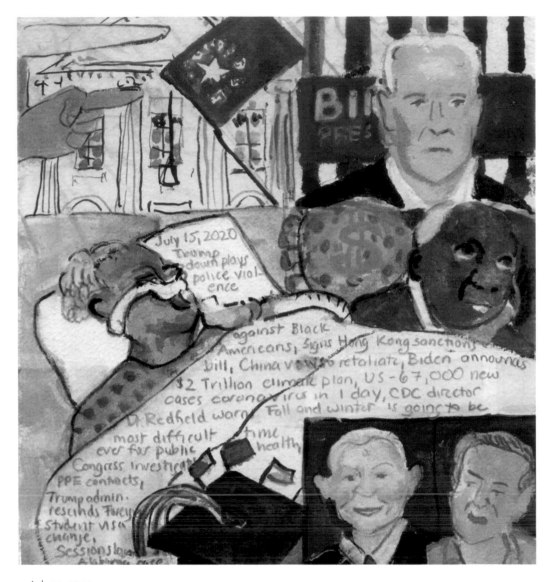

July 15, 2020

Trump downplays police violence against Black Americans, signs Hong Kong sanctions bill, China vows to retaliate; Biden announces $2 trillion climate plan; US—67,000 new cases coronavirus in 1 day; CDC director Dr. Redfield warns fall and winter are going to be most difficult time ever for public health; Congress investigates PPE contracts; Trump admin rescinds foreign student visa change; Sessions loses Alabama race.

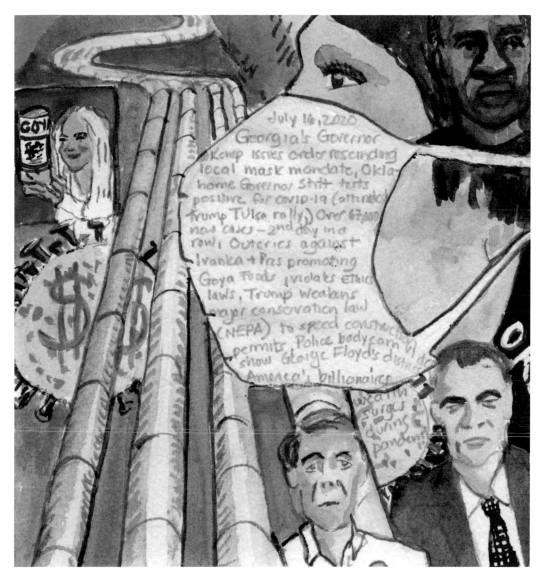

July 16, 2020

Georgia's Governor Kemp issues order rescinding local mask mandate; Oklahoma Governor Stitt tests positive for COVID-19, attended Trump Tulsa rally; Over 67,000 new cases—2nd day in a row; Outcries against Ivanka and Pres. promoting Goya Foods, violates ethics laws; Trump weakens major conservation law (NEPA) to speed construction permits; Police bodycam video shows George Floyd's distress; America's billionaires' wealth surges during pandemic.

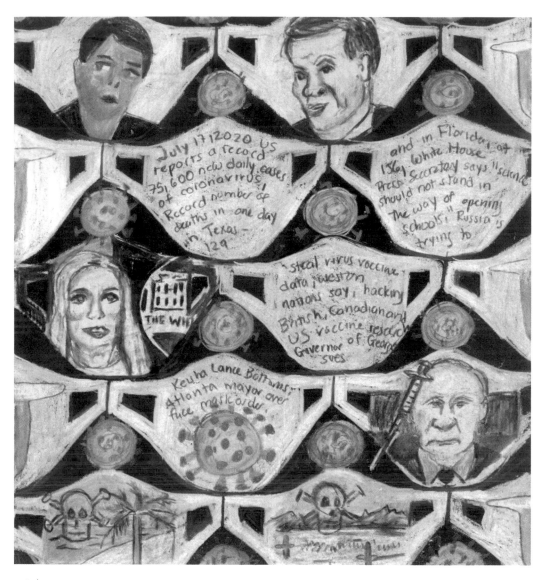

July 17, 2020

US reports a record 75,600 new daily cases of coronavirus; Record number of deaths in Texas—129, and in Florida at 156; White House press secretary says, "Science should not stand in the way of opening schools"; Russia is trying to steal virus vaccine data, Western nations say, hacking British, Canadian, US vaccine research; Governor of Georgia sues Keisha Lance Bottoms, Atlanta mayor, over face mask order.

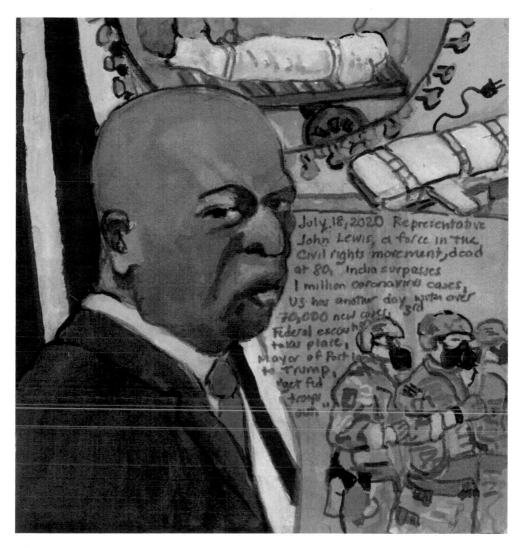

July 18, 2020

Representative John Lewis, a force in the civil rights movement, dead at 80; India surpasses 1 million coronavirus cases; US has another day with over 70,000 new cases; 3rd federal execution takes place; Mayor of Portland to Trump, "Get fed troops out."

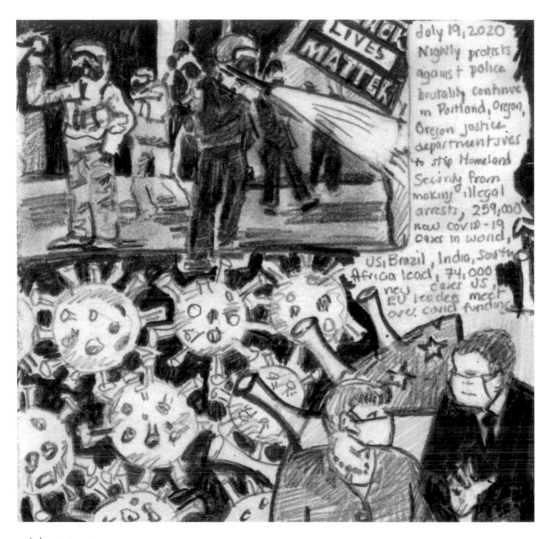

July 19, 2020

Nightly protests against police brutality continue in Portland, Oregon; Oregon Justice Department sues to stop Homeland Security from making illegal arrests; 259,000 new COVID-19 cases in world, US, Brazil, India, South Africa lead, 74,000 new cases US; EU leaders meet over COVID funding.

July 20, 2020

The world continues to mourn the loss of 2 civil rights leaders, Congressman John Lewis and Rev. C. T. Vivian, champion of nonviolent action; Coronavirus world cases—14,508,419, deaths—605,945. US cases—3,773,260, deaths—140,534, 40 states with numbers rising; Trump will reportedly block funding for more testing and tracing.

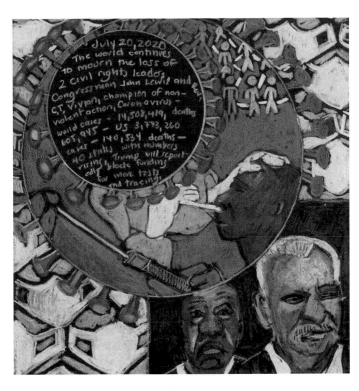

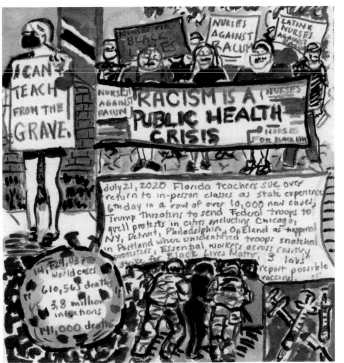

July 21, 2020

Florida teachers sue over return to in-person classes as state experiences 6th day in a row of over 10,000 new cases; Trump threatens to send federal troops to quell protests in cities including Chicago, NY, Detroit, Philadelphia, Oakland, as happened in Portland where unidentified troops snatched protesters; Essential workers across country strike for Black Lives Matter; Three labs report possible vaccines.

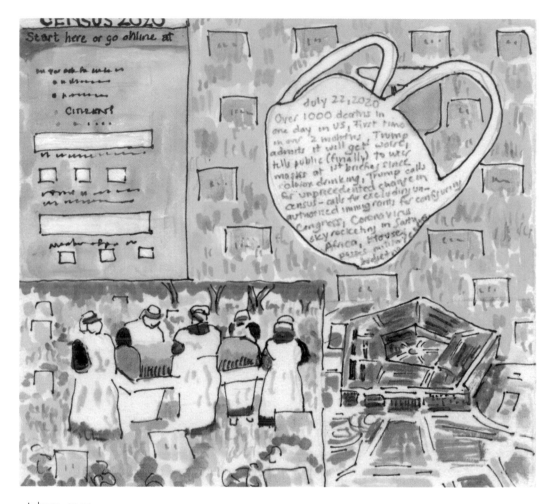

July 22, 2020

Over 1,000 deaths in one day in US, first time in over 2 months; Trump admits it will get worse, tells public (finally) to wear masks at 1st briefing since Clorox drinking; Trump calls for unprecedented change in census—calls for excluding unauthorized immigrants for configuring Congress; Coronavirus skyrocketing in South Africa; House passes military budget, no cuts.

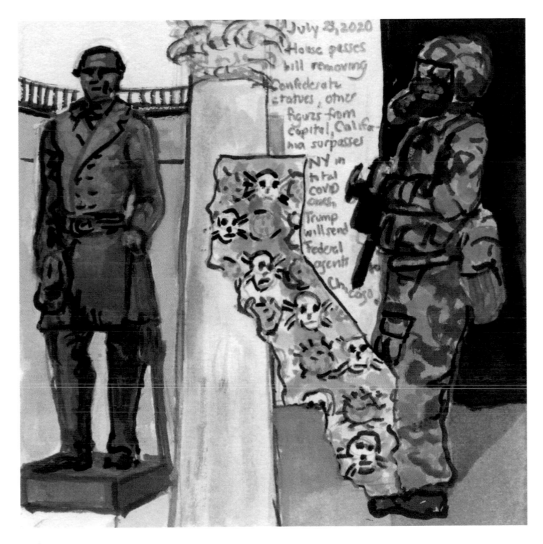

July 23, 2020

House passes bill removing Confederate statues, other figures from Capitol; California surpasses New York in total COVID cases; Trump will send federal agents to Chicago.

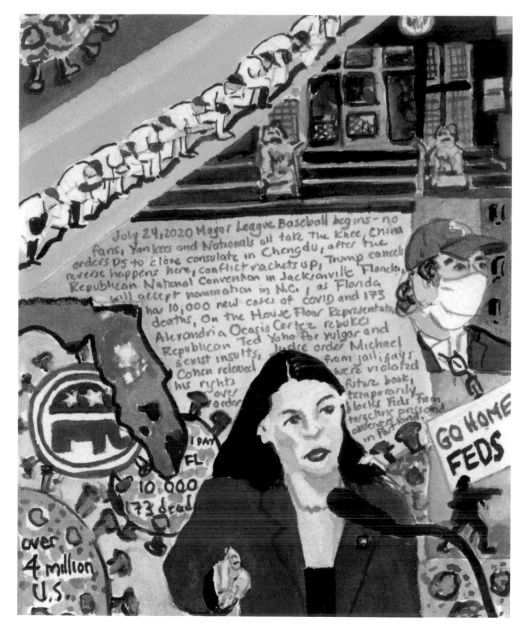

July 24, 2020

Major League Baseball begins—no fans, Yankees and Nationals all take the knee; China orders US to close consulate in Chengdu, after the reverse happens here, conflict ratchets up; Trump cancels Republican National Convention in Jacksonville, Florida, will accept nomination in NC as Florida has 10,000 new cases of COVID and 173 deaths; On the House floor, Representative Alexandria Ocasio-Cortez rebukes Republican Ted Yoho for vulgar and sexist insults; Judge orders Michael Cohen released from jail, says his rights were violated over future book; Order temporarily blocks feds from targeting press and observers in Portland.

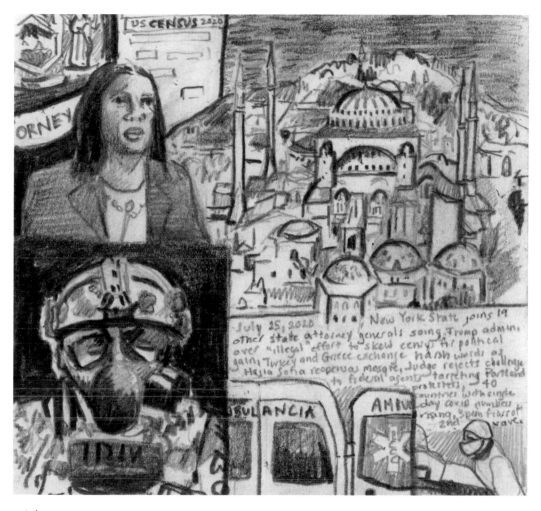

July 25, 2020

New York State joins 19 other state attorneys general suing Trump admin over "illegal" efforts to skew census for political gain; Turkey and Greece exchange harsh words as Hagia Sophia opens mosque; Judge rejects challenge to federal agents targeting Portland protesters; 40 countries with single day COVID numbers rising, Spain fears of 2nd wave.

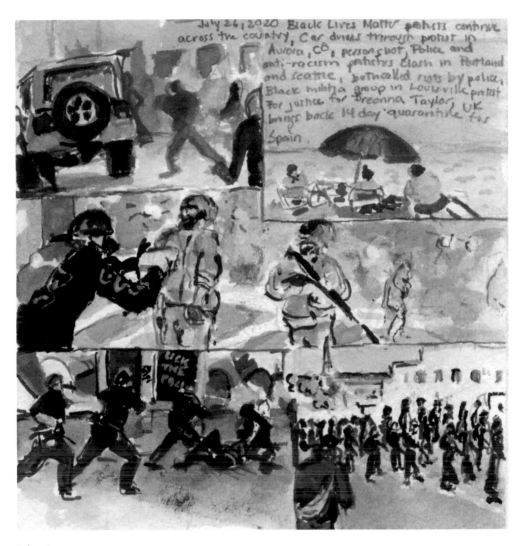

July 26, 2020

Black Lives Matter protests continue across the country; Car drives through protest in Aurora, CO; Police and antiracism protesters clash in Portland and Seattle, both called riots by police; Black militia group in Louisville protests for justice for Breonna Taylor; UK brings back 14-day quarantine for Spain.

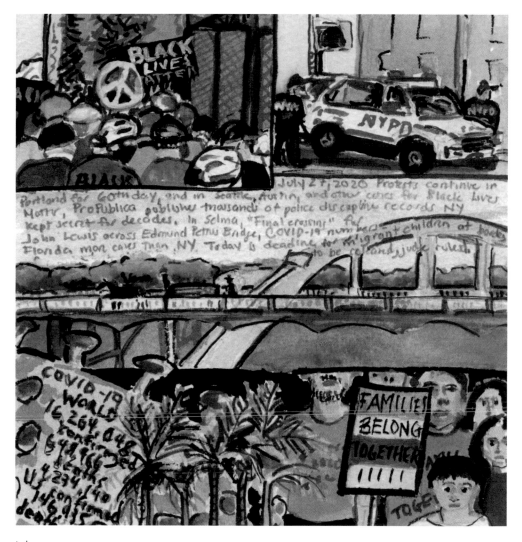

July 27, 2020

Protests continue in Portland for 60th day and in Seattle, Austin, and other cities for Black Lives Matter; ProPublica publishes thousands of police discipline records NY kept secret for decades; In Selma, "final crossing" for John Lewis across Edmund Pettus Bridge; COVID-19 numbers up, Florida more cases than NY; Today is deadline for migrant children on borders to be released, judge rules.

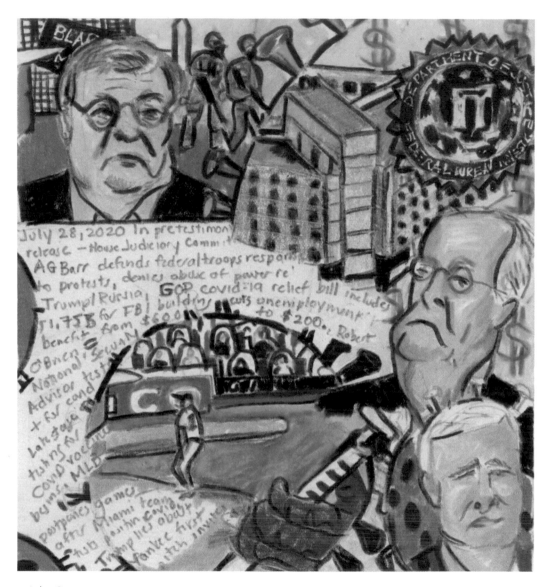

July 28, 2020

In pretestimony release, House Judiciary Committee, AG Barr defends federal troops' response to protests, denies abuse of power re: Trump/Russia; GOP COVID-19 relief bill includes $1.75 billion for FBI building, cuts unemployment benefit from $600 to $200; Robert O'Brien, National Security Advisor, tests positive for COVID-19; Late-stage testing for COVID vaccine begins; MLB postpones games after Miami team tests positive for COVID; Trump lies about Yankee first-pitch invite.

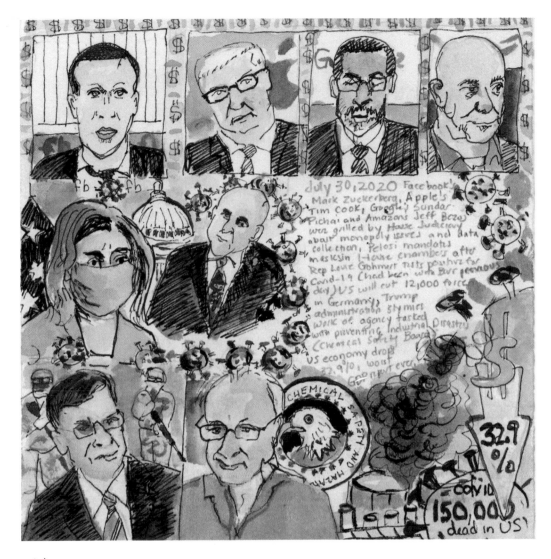

July 30, 2020

Facebook's Mark Zuckerberg, Apple's Tim Cook, Google's Sundar Pichai, and Amazon's Jeff Bezos were grilled by House Judiciary about monopoly issues and data collection; Pelosi mandates masks in House chambers after Rep. Louie Gohmert tests positive for COVID-19 (had been with Barr previous day); US will cut 12,000 forces in Germany; Trump administration stymies work of agency tasked with preventing industrial disasters (Chemical Safety Board); US economy drops 32.9%, worst GDP report ever; 150,000 dead from COVID in US.

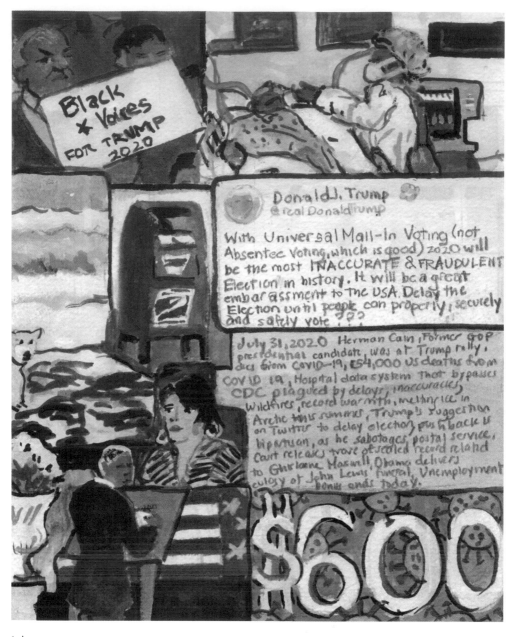

July 31, 2020

Herman Cain, former GOP presidential candidate, was at Trump rally, dies from COVID-19; 154,000 US deaths from COVID-19; Hospital data system that bypasses CDC plagued by delays, inaccuracies; Wildfires, record warmth, melting ice in Arctic this summer; Trump's suggestion on Twitter to delay election, pushback is bipartisan, as he sabotages postal service; Court releases trove of sealed records related to Ghislaine Maxwell; Obama delivers eulogy at John Lewis's funeral; Unemployment bonus ends today.

August 1, 2020

Negotiations continue on COVID benefits; COVID cases rise in New Jersey, linked to parties; Trump says he will ban Chinese app TikTok; Hurricane Isaias slammed Puerto Rico, DR, heading towards Florida.

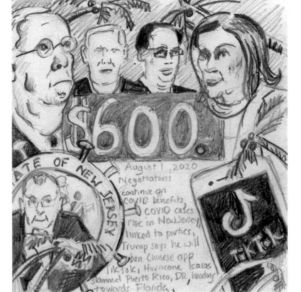

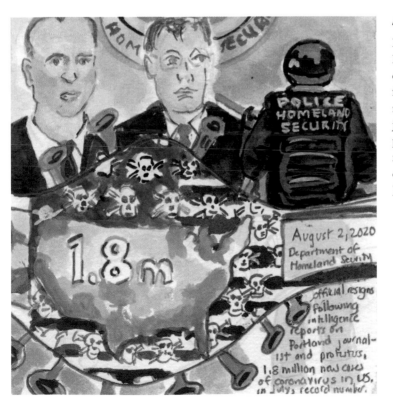

August 2, 2020

Department of Homeland Security official resigns following intelligence reports on Portland journalists and protesters; 1.8 million new cases of coronavirus in US in July, record number.

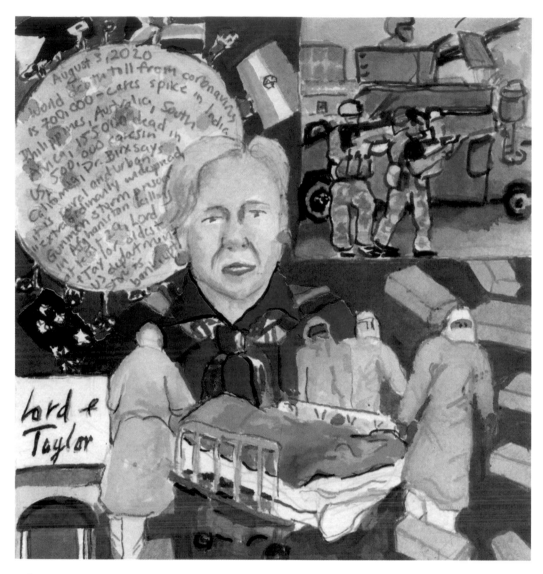

August 3, 2020

World death toll from coronavirus is 700,000—cases spike in India, Philippines, Australia, South Africa; 155,000 dead in US, 500,000 cases in California; Dr. Birx says it is rural and urban, "extraordinarily widespread"; Gunmen storm prison in Afghanistan killing at least 29; Lord & Taylor, oldest US department store, is bankrupt.

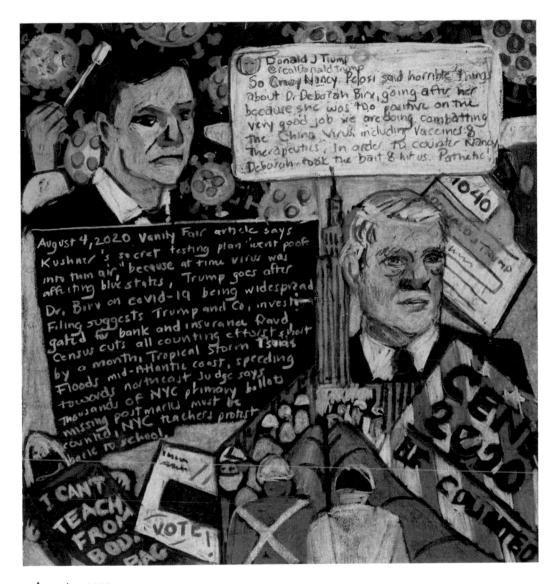

August 4, 2020

Vanity Fair article says Kushner's secret testing plan "went poof into thin air," because at time virus was affecting blue states; Trump goes after Dr. Birx on COVID-19 testing being widespread; Filing suggests Trump and Co. investigated for bank and insurance fraud; Census cuts all counting efforts short by a month; Tropical Storm Isaias floods mid-Atlantic coast, speeding towards Northeast; Judge says thousands of NYC primary ballots missing postmarks must be counted; NYC teachers protest back to school.

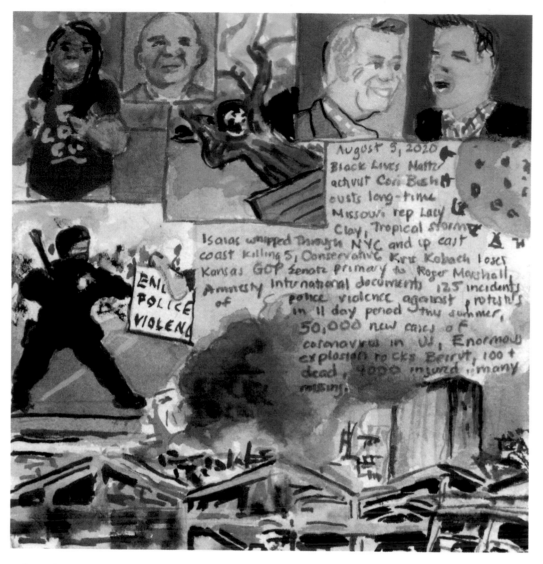

August 5, 2020

Black Lives Matter activist Cori Bush ousts longtime Missouri rep. Lacy Clay; Tropical Storm Isaias whipped through NYC and up East Coast killing 5; Conservative Kris Kobach loses Kansas GOP primary to Roger Marshall; Amnesty International documents 125 incidents of police violence against protesters in 11-day period this summer; 50,000 new cases of coronavirus in US; Enormous explosion rocks Beirut, 100+ dead, 4,000 injured, many missing.

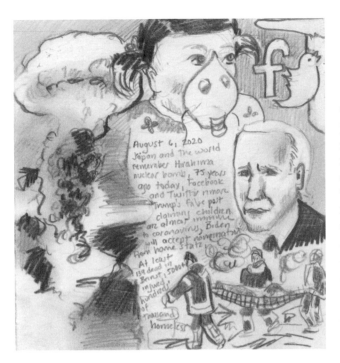

August 6, 2020

Japan and the world remember Hiroshima nuclear bomb, 75 years ago today; Facebook and Twitter remove Trump's false post claiming children are almost immune to coronavirus; Biden will acccept nomination from home state; At least 139 dead in Beirut, 5,000+ injured, hundreds of thousands homeless.

August 7, 2020

Trump signs executive order that will effectively ban use of TikTok and WeChat in the US; New York attorney general files lawsuit to dissolve NRA; India's coronavirus cases top 2 million, more than 62,000 in one day; Over 160,000 dead in US; Elliot Abrams, convicted in Iran-Contra affair, is Trump's envoy to Iran.

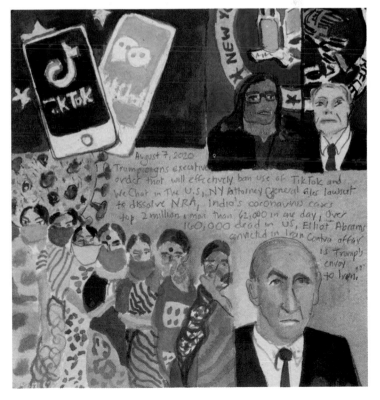

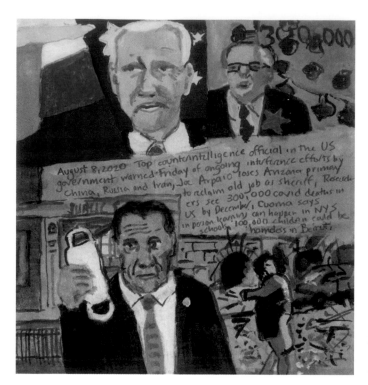

August 8, 2020

Top counterintelligence official in the US government warned Friday of ongoing interference and influence efforts by China, Russia, and Iran; Joe Arpaio loses Arizona primary to reclaim old job as sheriff; Researchers see 300,000 COVID deaths in US by December; Cuomo says in-person learning can take place in NY State; 100,000 children could be homeless in Beirut.

August 9, 2020

US health chief Azar arrives in Taiwan, most senior official to visit since 1979; COVID cases in US approach 5 million (although probably many more); Protests in Beirut, information minister quits, at least 160 dead, 5,000 injured; Trump signs executive order extending unemployment, defers payroll tax.

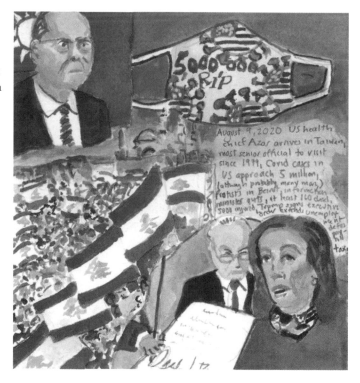

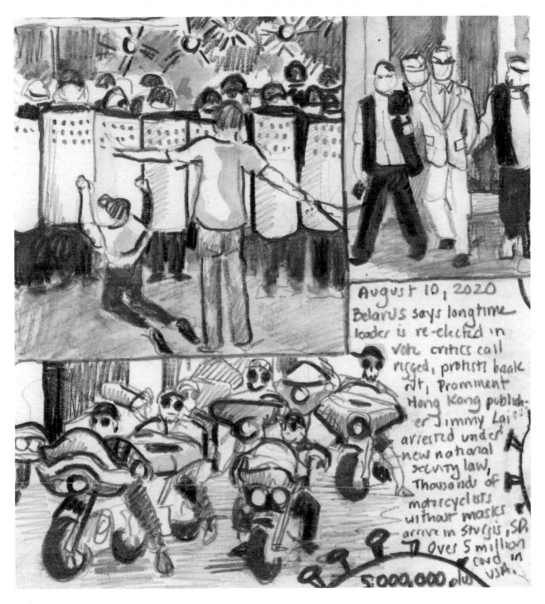

August 10, 2020

Belarus says longtime leader is reelected in vote critics call rigged, protests break out; Prominent Hong Kong publisher Jimmy Lai arrested under new national security law; Thousands of motorcyclists without masks arrive in Sturgis, SD; Over 5 million COVID cases in USA.

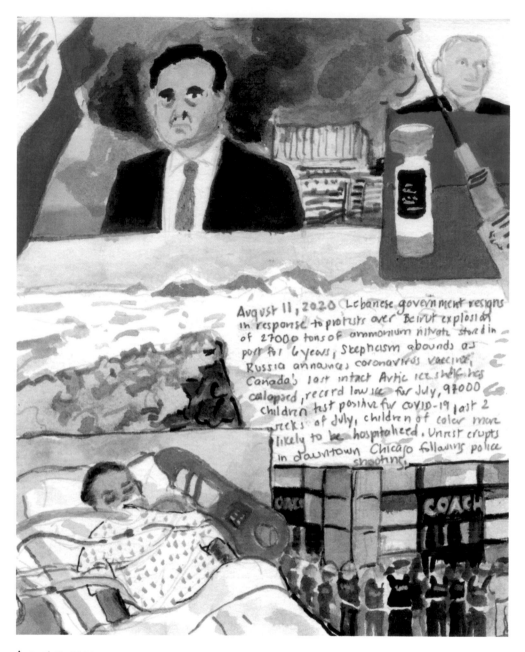

August 11, 2020

Lebanese government resigns in response to protest over Beirut explosion of 27,000 tons of ammonium nitrate stored in port for 6 years; Skepticism abounds as Russia announces coronavirus vaccine; Canada's last intact Arctic ice shelf has collapsed, record low ice for July; 97,000 children test positive for COVID-19 last 2 weeks of July, children of color more likely to be hospitalized; Unrest erupts in downtown Chicago following police shooting.

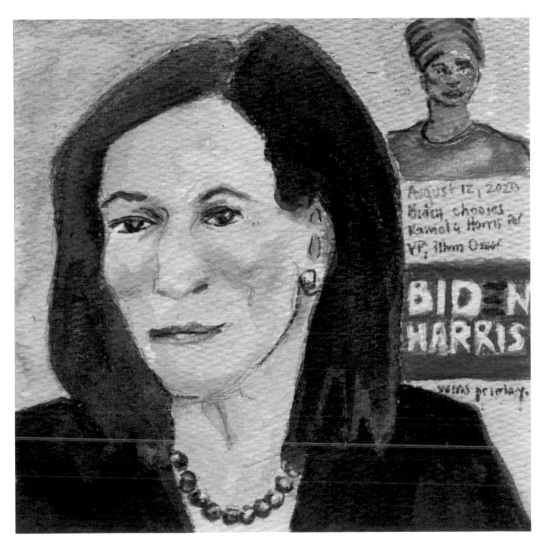

August 12, 2020

Biden chooses Kamala Harris for VP; Ilhan Omar wins primary.

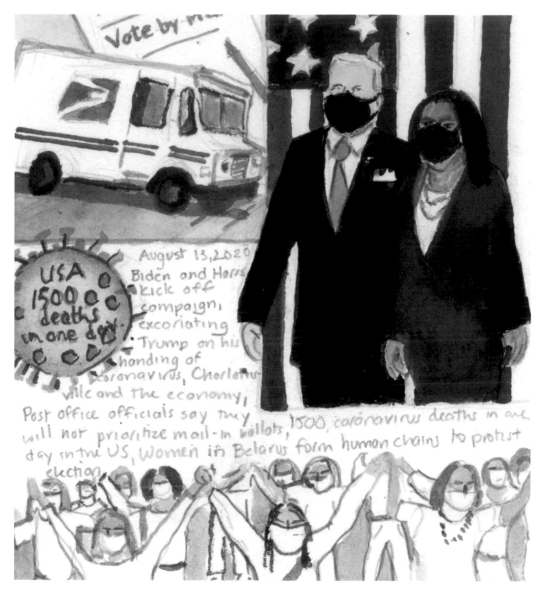

August 13, 2020

Biden and Harris kick off campaign, excoriating Trump on his handling of coronavirus, Charlottesville, and the economy; Post office officials say they will not prioritize mail-in ballots; 1,500 coronavirus deaths in one day in the US; Women in Belarus form human chains to protest election.

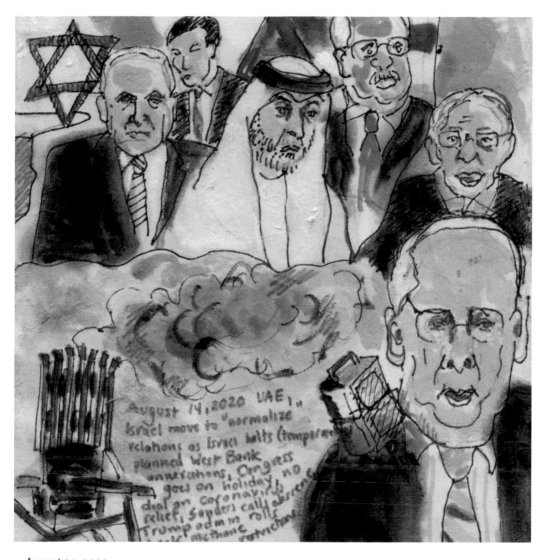

August 14, 2020

UAE, Israel move to "normalize" relations as Israel (temporarily) halts planned West Bank annexations; Congress goes on holiday, no deal on coronavirus relief, Sanders calls it obscene; Trump admin rolls back methane restrictions.

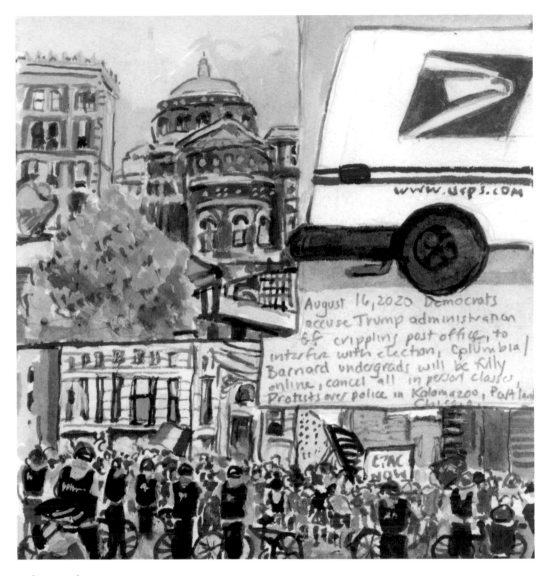

August 16, 2020

Democrats accuse Trump administration of crippling post office to interfere with election; Columbia/ Barnard undergrads will be fully online, cancel all in-person classes; Protests over police in Kalamazoo, Portland, Chicago.

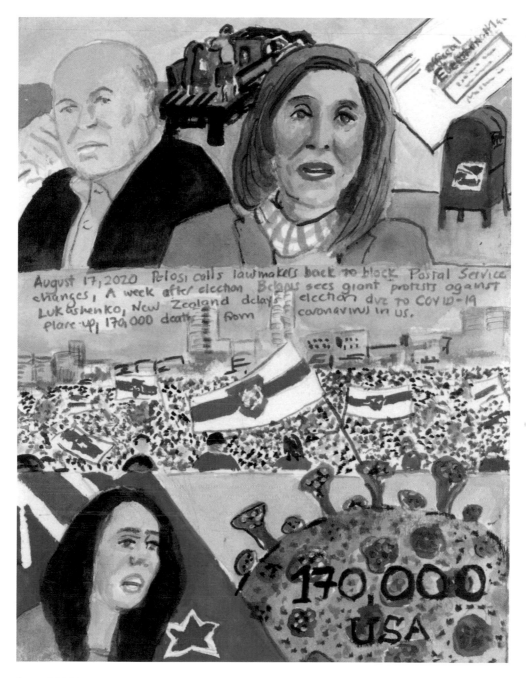

August 17, 2020

Pelosi calls lawmakers back to block Postal Service changes; A week after election Belarus sees giant protests against Lukashenko; New Zealand delays election due to COVID-19 flare-up; 170,000 deaths from coronavirus in US.

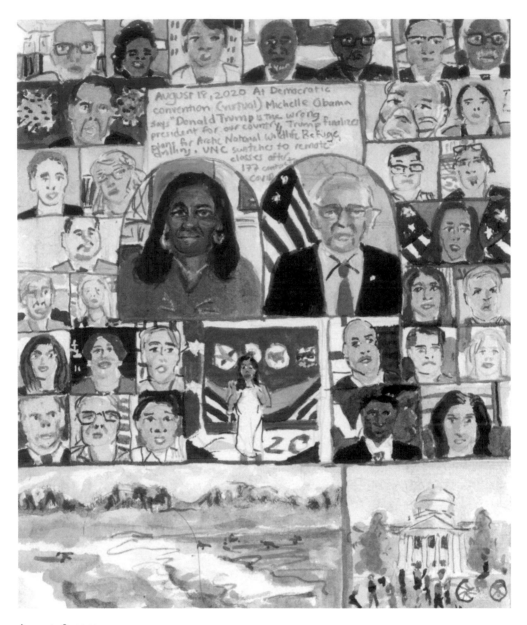

August 18, 2020

At Democratic Convention (virtual) Michelle Obama says, "Donald Trump is the wrong president for our country"; Trump finalizes plans for Arctic National Wildlife Refuge drilling; UNC switches to remote classes after 177 contract COVID.

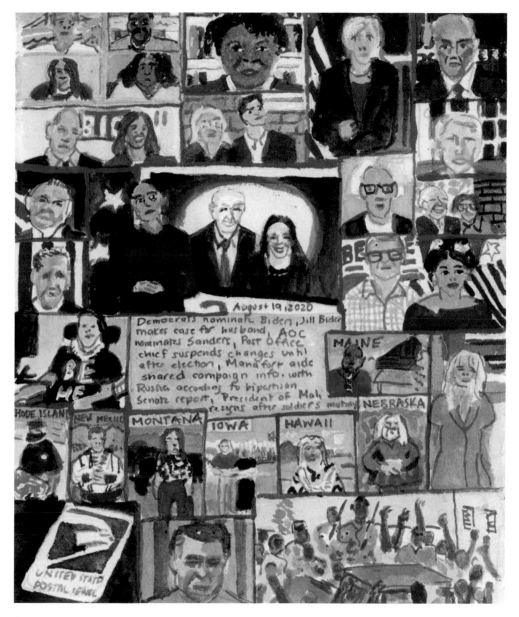

August 19, 2020

Democrats nominate Biden, Jill Biden makes case for her husband, AOC nominates Sanders; Post office chief suspends changes until after election; Manafort aide shared campaign info with Russia according to bipartisan Senate report; President of Mali resigns after soldiers mutiny.

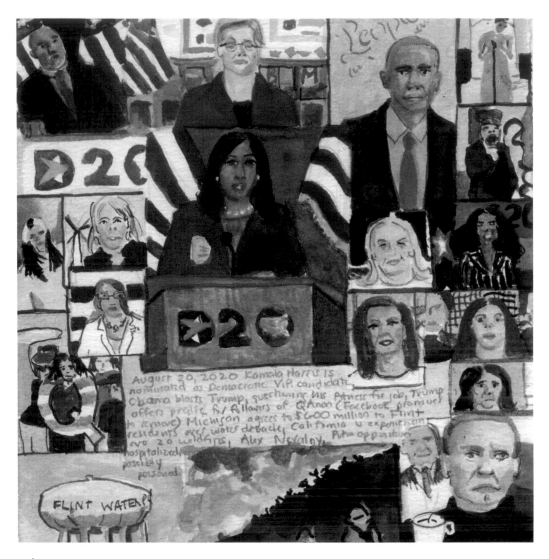

August 20, 2020

Kamala Harris is nominated as Democratic VP candidate; Obama blasts Trump, questioning his fitness for job; Trump offers praise for followers of QAnon (Facebook promises to remove); Michigan agrees to $600 million to Flint residents over water debacle; California is experiencing over 20 wildfires; Alexei Navalny, Putin opposition lawyer, hospitalized, possibly poisoned.

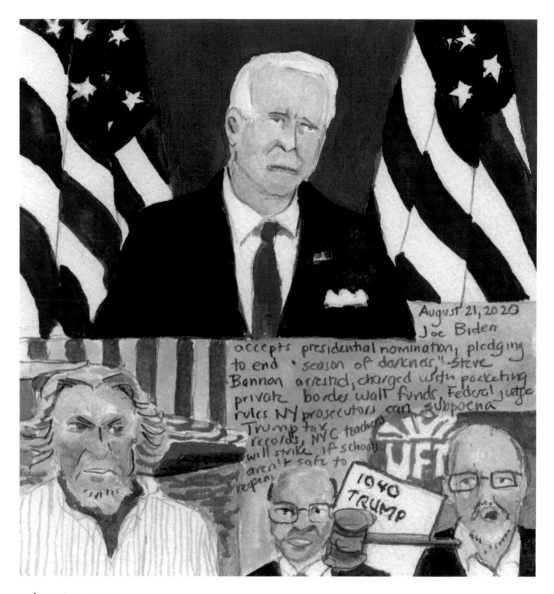

August 21, 2020

Joe Biden accepts presidential nomination, pledging to end "season of darkness"; Steve Bannon arrested, charged with pocketing private border wall funds; Federal judge rules New York prosecutors can subpoena Trump tax records; NYC teachers will strike if schools aren't safe to reopen.

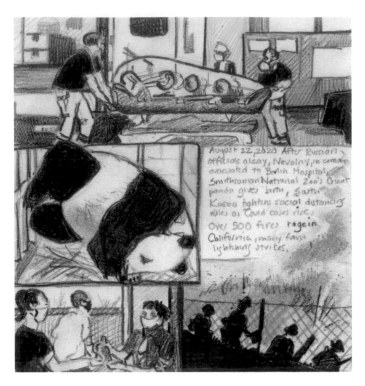

August 22, 2020

After Russian officials okay, Navalny, in coma, evacuated to Berlin hospital; Smithsonian National Zoo's giant panda gives birth; South Korea tightens social distancing rules as COVID cases rise; Over 500 fires rage in California, many from lightning strikes.

August 23, 2020

India has over 3 million cases of COVID-19, 3rd after US and Brazil; In secretly recorded audio, Trump's sister says he has "no principles" and "you can't trust him"; Portland police stand by as Proud Boys and far right flash guns and brawl with protesters; House passes bill to fund PO, protesters demonstrate in support.

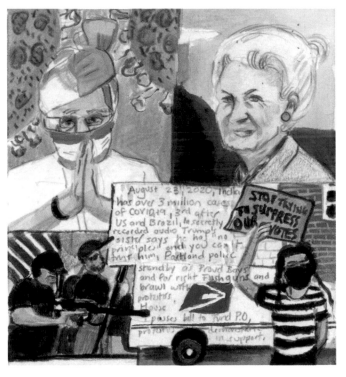

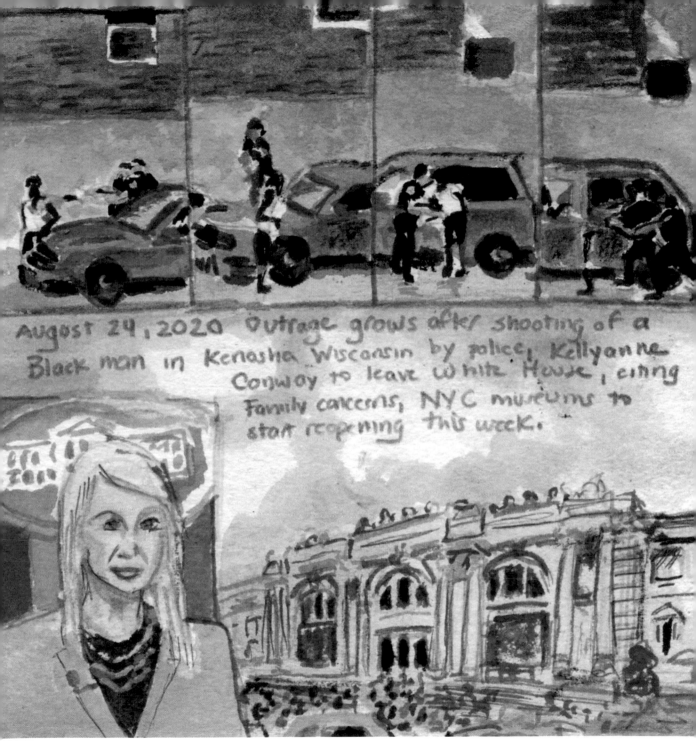

Handwritten text within image:
August 24, 2020 Outrage grows after shooting of a Black man in Kenosha Wisconsin by police, Kellyanne Conway to leave White House, citing family concerns, NYC museums to start reopening this week.

August 24, 2020

Outrage grows after shooting of a Black man in Kenosha, Wisconsin, by police; Kellyanne Conway to leave White House, citing family concerns; NYC museums to start reopening this week.

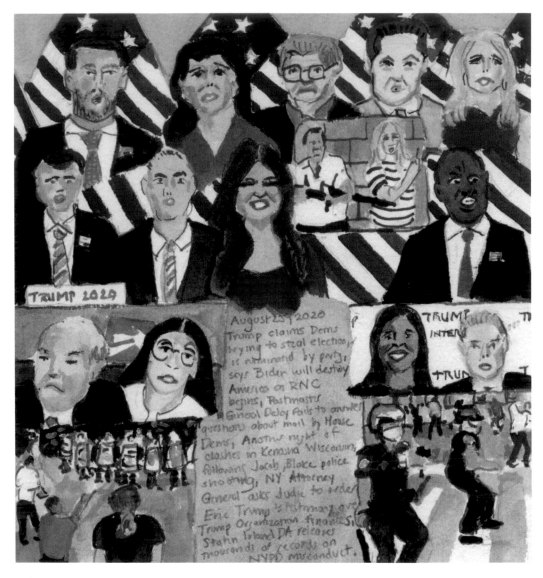

August 25, 2020

Trump claims Dems trying to steal election, is nominated by party, says Biden will destroy America as RNC begins; Postmaster General DeJoy fails to answer questions about mail by House Dems; Another night of clashes in Kenosha, Wisconsin, following Jacob Blake police shooting; NY attorney general asks judge to order Eric Trump's testimony over Trump organization finances; Staten Island DA releases thousands of records on NYPD misconduct.

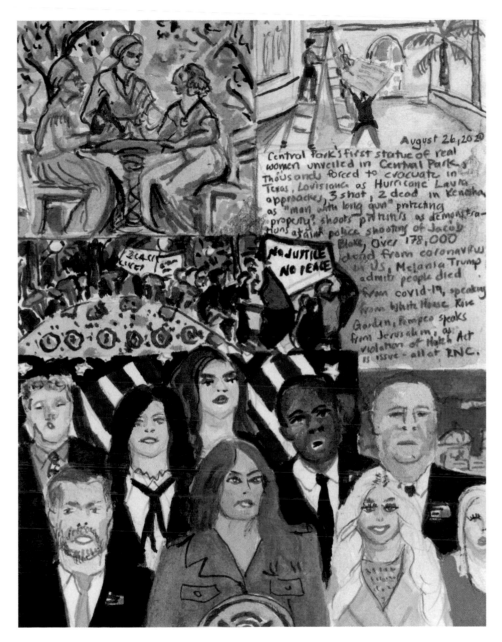

August 26, 2020

Central Park's first statue of real women unveiled in Central Park; Thousands forced to evacuate in Texas, Louisiana as Hurricane Laura approaches; 3 shot, 2 dead in Kenosha as "man with long gun" protecting property shoots protesters at demonstrations against police shooting of Jacob Blake; Over 178,000 dead from coronavirus in US; Melania Trump admits people died from COVID-19, speaking from White House Rose Garden, Pompeo speaks from Jerusalem as violation of Hatch Act is issue, all at RNC.

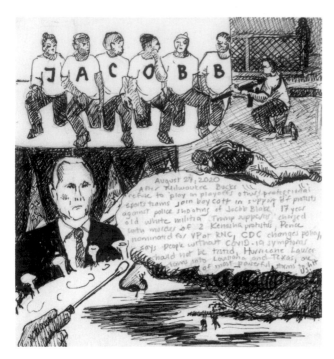

August 27, 2020

After Milwaukee Bucks refuse to play in playoffs, other professional sports teams join boycott in support of protests against police shooting of Jacob Blake; 17-year-old white militia Trump supporter charged with murder of 2 Kenosha protesters; Pence nominated for VP at RNC; CDC changes policy, says people without COVID-19 symptoms should not be tested; Hurricane Laura slams into Louisiana and Texas, one of the most powerful storms to hit US.

August 28, 2020

Using the White House as a backdrop (illegally) Trump, in front of 1000+ unmasked and not socially distanced, accepts Republican nomination; Hurricane Laura thrashes Louisiana; Japan's PM Abe steps down, citing health.

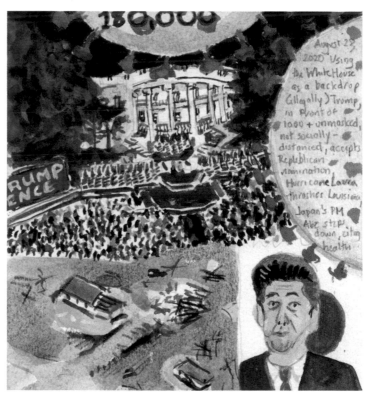

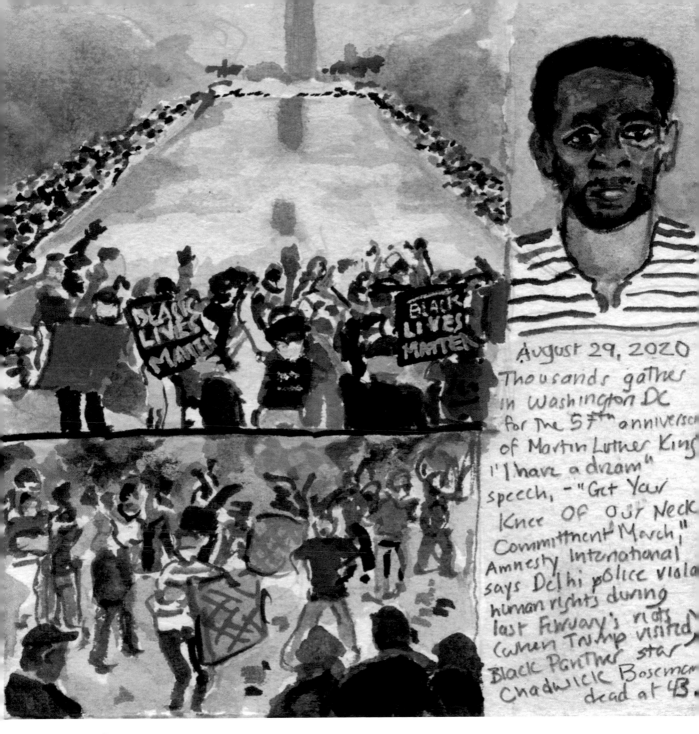

August 29, 2020

Thousands gather in Washington DC, for the 57th anniversary of Martin Luther King King's "I Have a Dream" speech—"Get Your Knee Off Our Neck Commitment March"; Amnesty International says Delhi police violated human rights during last February's riots (when Trump visited); *Black Panther* star Chadwick Boseman dead at 43.

August 30, 2020

Judge will decide whether Honduran, connected to US, will be tried for murder of environmental activist Berta Caceres; India records record number of new daily COVID cases at almost 79,000; 1 man shot and killed during gathering of Trump supporters in Portland; Director of National Intelligence cancels verbal election security briefings.

August 31, 2020

NYC Housing Authority tenants say they were duped into RNC video appearance; Tony Evers, governor of Wisconsin, asks Trump to reconsider Kenosha visit; Belarus cracks down on journalists, protests continue; 6,008,100 people in the US infected with coronavirus, at least 182,900 have died, 1 million in the last 22 days infected.

SEPTEMBER

September 1, 2020

NYC teachers' union prepares for possible strike authorization; New Trump pandemic adviser pushes controversial "herd immunity" strategy; Despite Kenosha officials' attempt to dissuade Trump visit he will go—only talking to law enforcement, Biden says he is sowing chaos and racial divide; EPA eases limits on coal plants' toxic discharges.

September 2, 2020

Sen. Markey defeats a Kennedy in MA primary; De Blasio delays NYC schools reopening 11 days, teachers still skeptical; CDC orders eviction moratorium for most through year's end; Facebook and Twitter remove Russia-backed accounts targeting left-leaning voters.

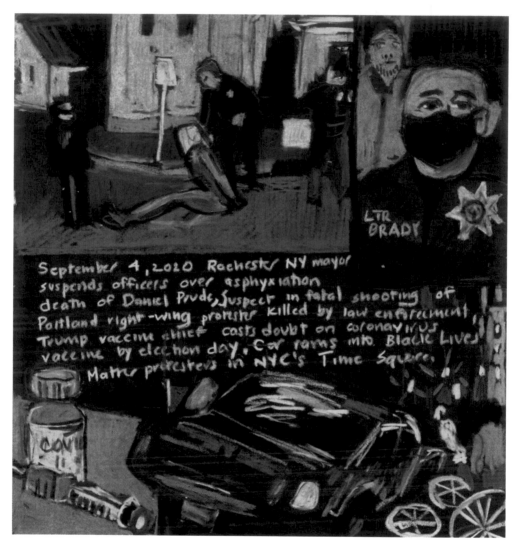

September 4, 2020

Rochester, NY, mayor suspends officers over asphyxiation death of Daniel Prude; Suspect in fatal shooting of Portland right-wing protester killed by law enforcement; Trump vaccine chief casts doubt on coronavirus vaccine by Election Day; Car rams into Black Lives Matter protesters in NYC's Times Square.

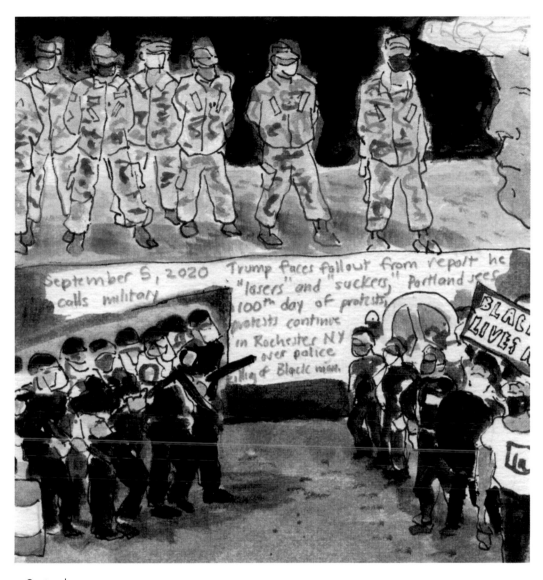

September 5, 2020

Trump faces fallout from report he calls military "losers" and "suckers"; Portland sees 100th day of protests; Protests continue in Rochester, NY, over police killing a Black man.

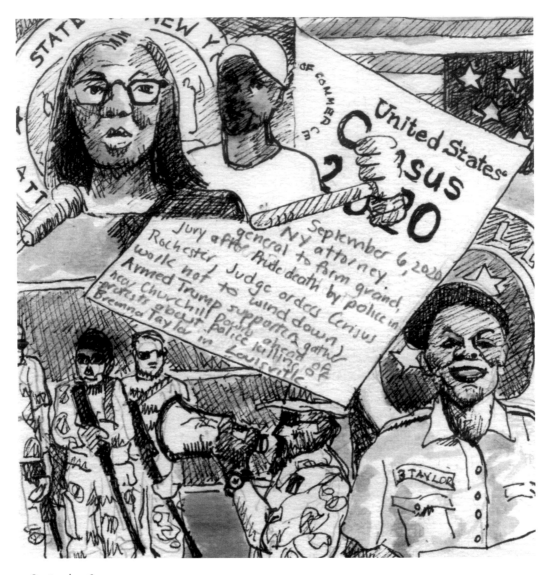

September 6, 2020

NY attorney general to form grand jury after Prude death by police in Rochester; Judge orders census work not to wind down; Armed Trump supporters gather near Churchill Downs ahead of protests about police killing of Breonna Taylor in Louisville.

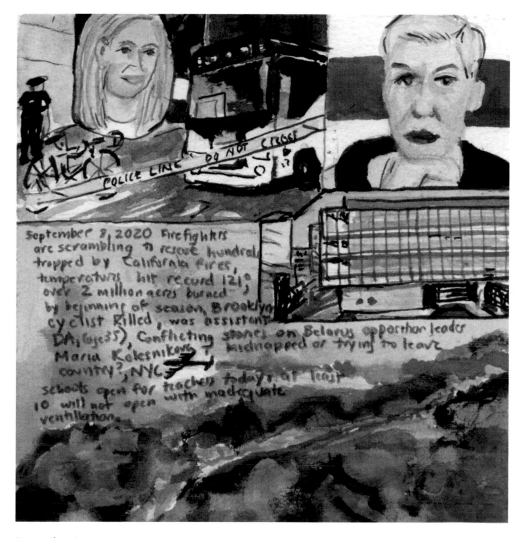

September 8, 2020

Firefighters are scrambling to rescue hundreds trapped by California fires, temperatures hit record 121°, over 2 million acres burned by beginning of season; Brooklyn cyclist killed, was assistant DA (age 35); Conflicting stories on Belarus opposition leader Maria Kolesnikova, kidnapped or trying to leave the country; NYC schools open for teachers today, at least 10 will not open with inadequate ventilation.

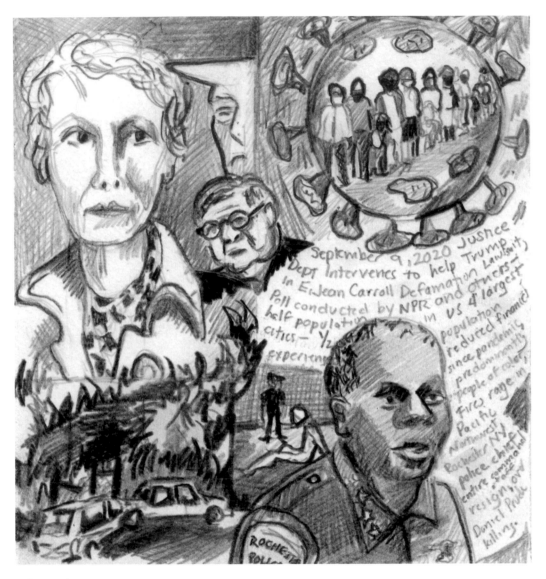

September 9, 2020

Justice Dept. intervenes to help Trump in E. Jean Carroll defamation lawsuit; Poll conducted by NPR and others—half population in US 4 largest cities experienced reduced finances since pandemic, predominantly people of color; Fires rage in Pacific Northwest; Rochester, NY, police chief and entire command staff resign over Daniel Prude killing.

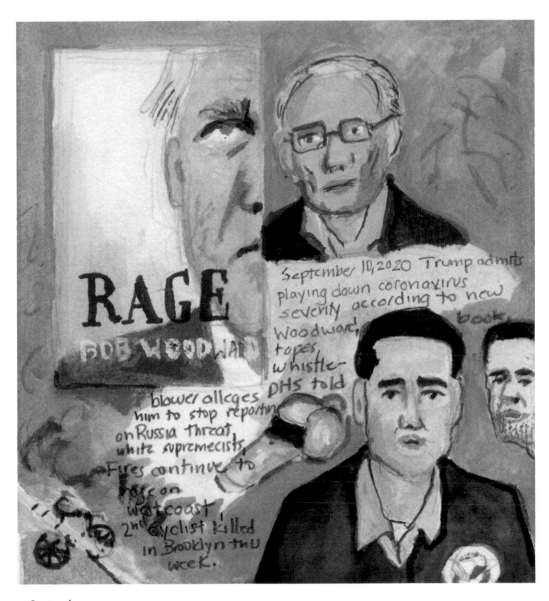

September 10, 2020

Trump admits playing down coronavirus severity according to new Woodward book, tapes; Whistle-blower alleges DHS told him to stop reporting on Russian threats, white supremacists; Fire continues to rage on West Coast; 2nd cyclist in Brooklyn killed this week.

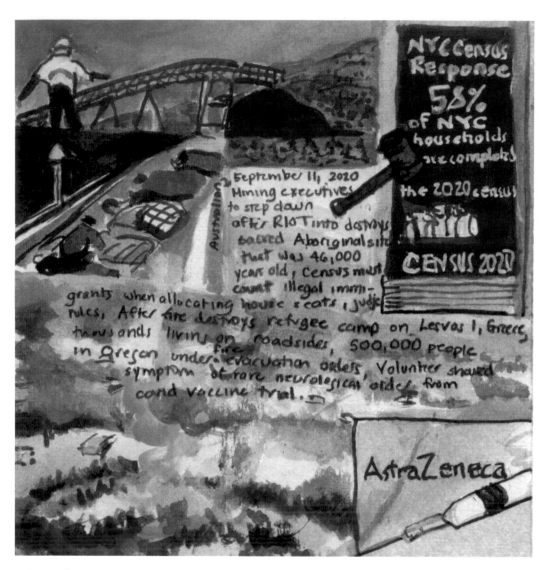

September 11, 2020

Australian mining executives to step down after Rio Tinto destroys sacred aboriginal site that was 46,000 years old; Census must count illegal immigrants when allocating house seats, judge rules; After fire destroys refugee camp on Lesvos, Greece, thousands living on roadside; 500,000 people in Oregon under fire evacuation orders; Volunteer showed symptoms of rare neurological disorder from COVID vaccine trial.

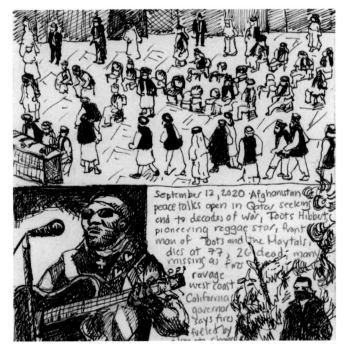

September 12, 2020

Afghanistan peace talks open in Qatar, seeking end to 2 decades of war; Toots Hibbert, pioneering reggae star, front man of Toots and the Maytals, dies at 77; 26 dead, many missing as fires ravage West Coast, California governor says fires fueled by climate change.

September 13, 2020

29,000 personnel are working to stop 97 large fires that have burned 4.7 million acres across the West, at least 29 dead, air quality is toxic.

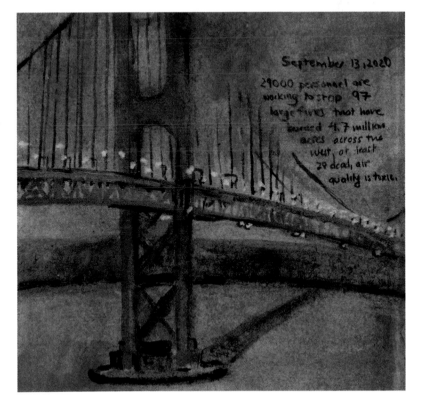

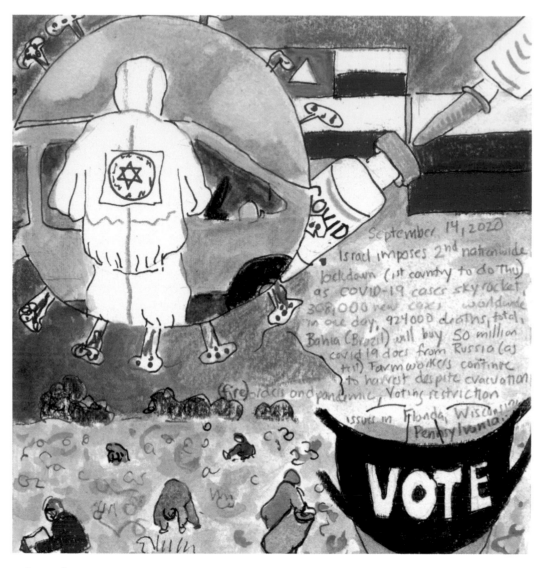

September 14, 2020

Israel imposes 2nd nationwide lockdown (1st country to do this) as COVID-19 cases skyrocket; 308,000 new cases worldwide in one day, 924,000 deaths total; Bahia, Brazil, will buy 50 million COVID-19 doses from Russia (as test); Farmworkers continue to harvest despite evacuation (fire) orders and pandemic; Voting restriction issues in Florida, Wisconsin, and Pennsylvania.

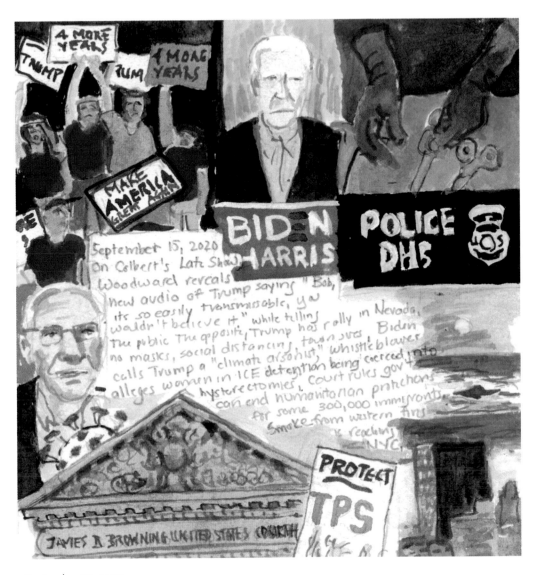

September 15, 2020
On Colbert's Late Show Woodward reveals new audio of Trump saying "Bob, its so easily transmissable, you wouldn't believe it," while telling the public The opposite, Trump has rally in Nevada, town sues; Biden no masks, social distancing, calls Trump a "climate arsonist," whistleblower alleges women in ICE detention being coerced into hysterectomies; Court rules gov't can end humanitarian protections for some 300,000 immigrants; Smoke from western fires is reaching NYC

4 MORE YEARS
TRUMP
4 MORE YEARS
MAKE AMERICA GREAT AGAIN
BIDEN HARRIS
POLICE DHS
PROTECT TPS
JAMES A. BROWNING UNITED STATES COURT

September 15, 2020

On Colbert's *Late Show*, Woodward reveals new audio of Trump saying, "Bob, it's so easily transmissible, you wouldn't believe it," while telling the public the opposite; Trump has rally in Nevada, no masks, social distancing, town sues; Biden calls Trump "a climate arsonist"; Whistleblower alleges women in ICE detention being coerced into hysterectomies; Court rules government can end humanitarian protections for some 300,000 immigrants; Smoke from Western fires is reaching NYC.

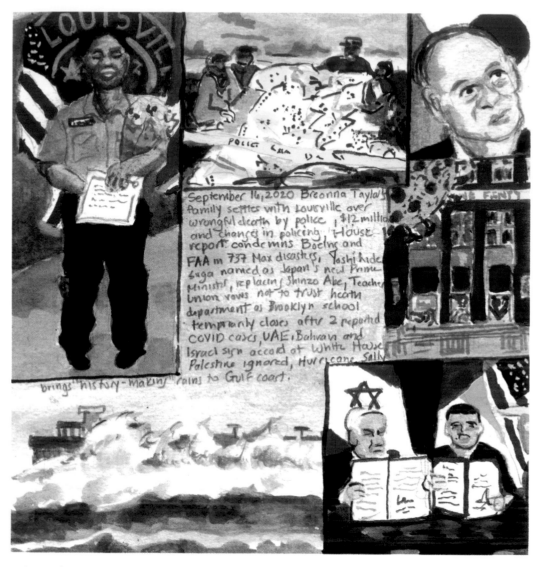

September 16, 2020

Breonna Taylor's family settles with Louisville over wrongful death by police, $12 million and changes in policing; House report condemns Boeing and FAA in 737 MAX disasters; Yoshihide Suga named as Japan's new prime minister, replacing Shinzō Abe; Teachers' union vows not to trust health department while Brooklyn school temporarily closes after 2 reported COVID-19 cases; UAE, Bahrain, and Israel sign accord at White House, Palestine ignored; Hurricane Sally brings "history-making" rains to Gulf Coast.

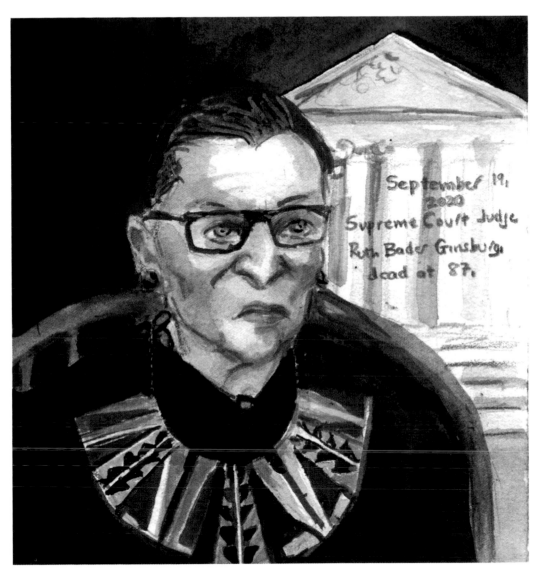

September 19, 2020

Supreme Court Judge Ruth Bader Ginsburg dead at 87.

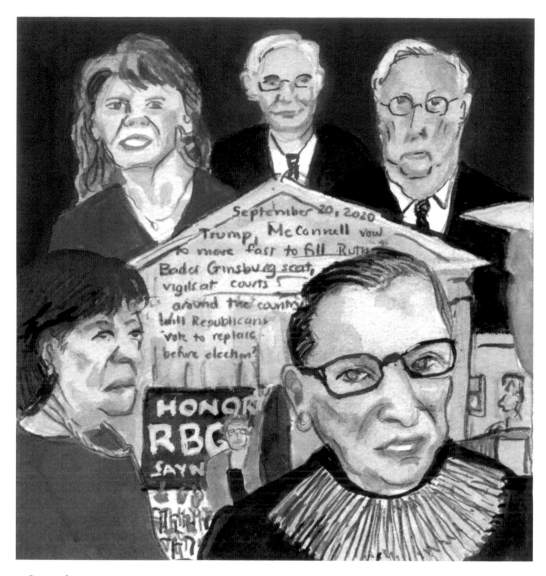

September 20, 2020

Trump, McConnell vow to move fast to fill Ruth Bader Ginsburg seat; Vigils at courts around the country; Will Republicans vote to replace before election?

September 21, 2020

Trump says he plans to announce Supreme Court pick Friday or Saturday (said to be a woman), Biden says wait till after election; BuzzFeed reports dirty money pours into world's biggest banks; In-person 3-K, pre-K, and special education starts in NYC public schools; Reported COVID deaths in the US near 200,000, numbers rising in some European countries.

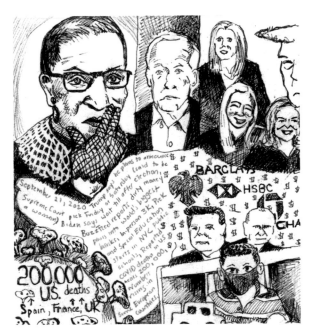

September 22, 2020

DOJ threatens to strip funds from NYC and other "anarchist cities"; CDC removes posting that says "main way the virus spreads" is through air droplets from people's mouths, 3rd confusing reversal; Boris Johnson orders UK new coronavirus restrictions; Republicans Grassley, Gardner, and Romney support voting on Trump's Supreme Court nominee.

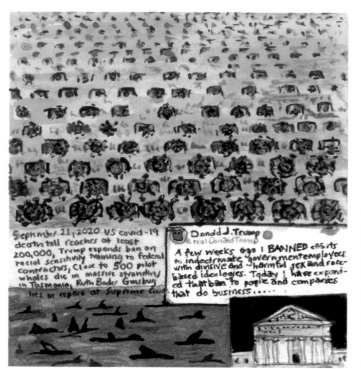

September 23, 2020

US COVID-19 death toll reaches at least 200,000; Trump expands ban on racial sensitivity training to federal contractors; Close to 500 pilot whales die in massive stranding in Tasmania; Ruth Bader Ginsburg lies in repose at Supreme Court.

September 24, 2020

Grand jury fails to charge police officers with Breonna Taylor's death, only indictment 1 officer for wanton endangerment, protests across the country, 2 police officers shot in Louisville; CDC says 20-year-olds are spreading COVID-19; Yesterday almost 1,100 deaths, 40,000 new cases; Eric Trump must testify re: family finances by October 8; Trump refuses to commit to peaceful transfer of power after election; Antarctic sea ice melt will raise sea level by 2.5 meters even with Paris climate goals; Metropolitan Opera will remain closed until at least fall 2021.

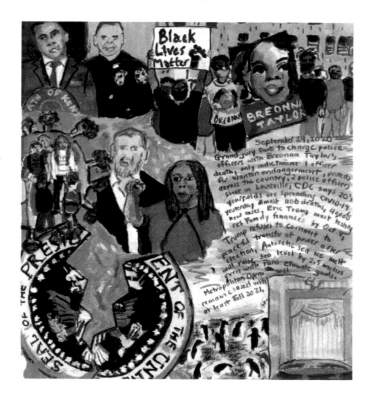

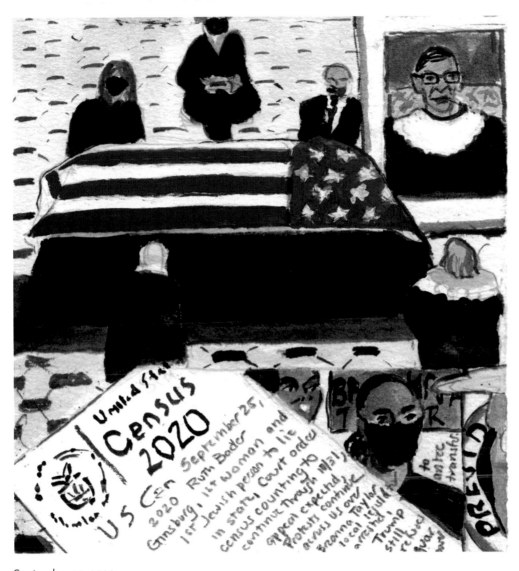

September 25, 2020

Ruth Bader Ginsburg, 1st woman and 1st Jewish person to lie in state; Court orders census counting to continue through 10/31, appeal expected; Protests continue across US over Breonna Taylor, local legislator arrested; Trump still refuses to guarantee power transfer.

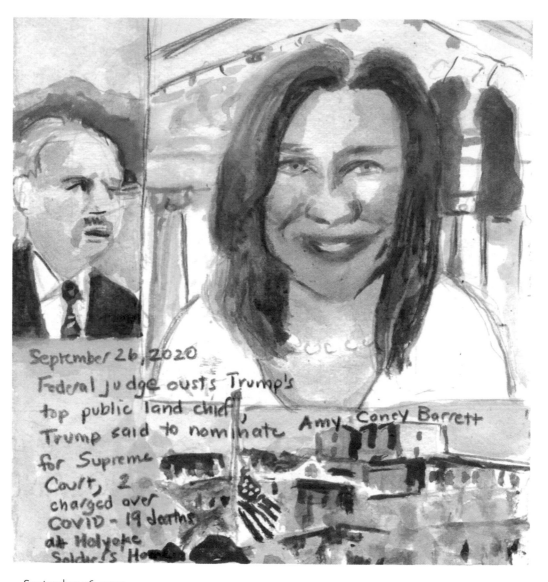

September 26, 2020

Federal judge ousts Trump's top public lands chief; Trump said to nominate Amy Coney Barrett for Supreme Court; 2 charged over COVID-19 deaths at Holyoke Soldier's Home.

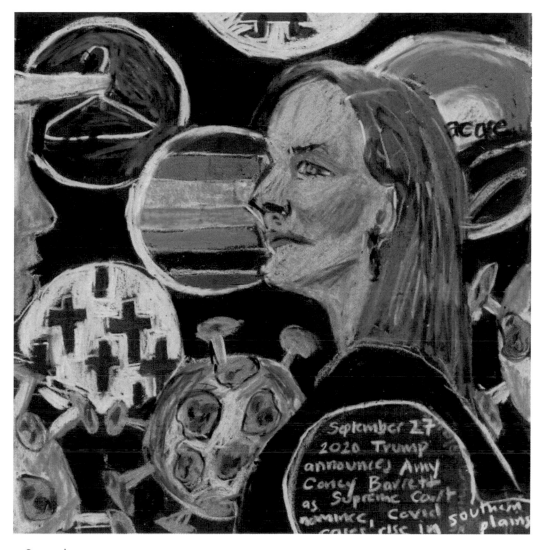

September 27, 2020

Trump announces Amy Coney Barrett as Supreme Court nominee; COVID cases rise in Southern Plains.

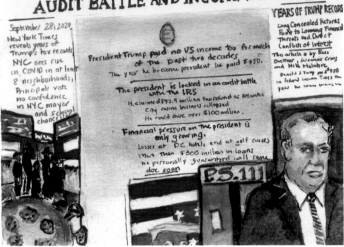

September 28, 2020

New York Times reveals years of Trump's tax records; NY sees rise in COVID in at least 8 neighborhoods; Principals vote no confidence in NYC mayor and school chancellor.

September 29, 2020

COVID-19 deaths top at least 1 million worldwide, US has 4% of population and 20% of deaths; Trump's 2016 US presidential campaign activity sought to deter 3.5 million Black Americans from voting, through Facebook; 3 dead in California fires, tens of thousands evacuated; Brad Parscale, senior Trump advisor to Trump campaign, hospitalized after call to police; In-person classes for elementary students begin in NYC public schools; More tax revelations on Trump tax nonpayment.

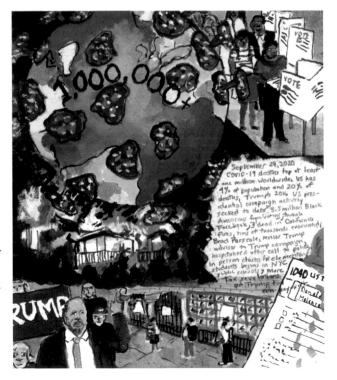

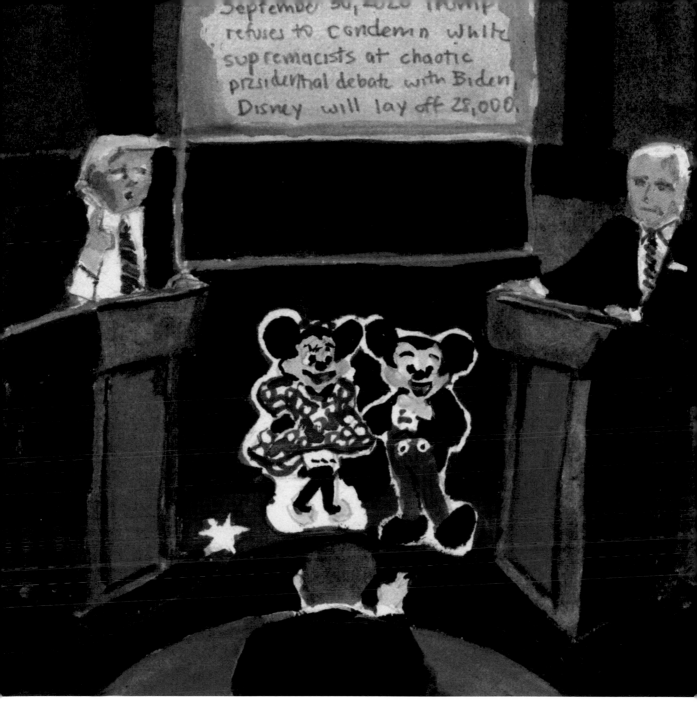

September 30, 2020

Trump refuses to condemn white supremacists at chaotic presidential debate with Biden; Disney will lay off 28,000.

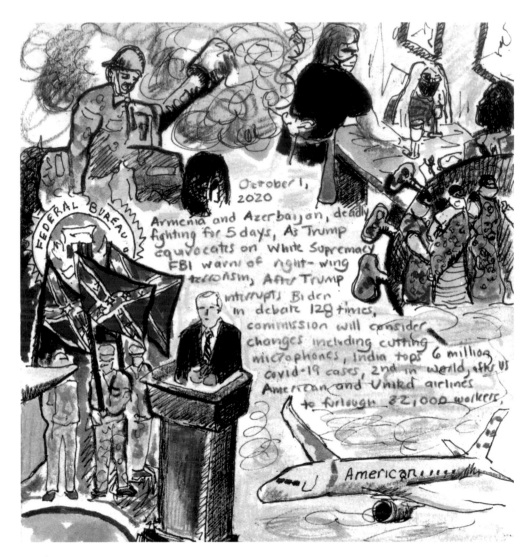

October 1, 2020

Armenia and Azerbaijan deadly fighting for 5 days; As Trump equivocates on white supremacy, FBI warns of right-wing terrorism; After Trump interrupts Biden in debate 128 times, commission will consider changes including cutting microphones; India tops 6 million COVID-19 cases, 2nd in world after US; America and United Airlines to furlough 32,000 workers.

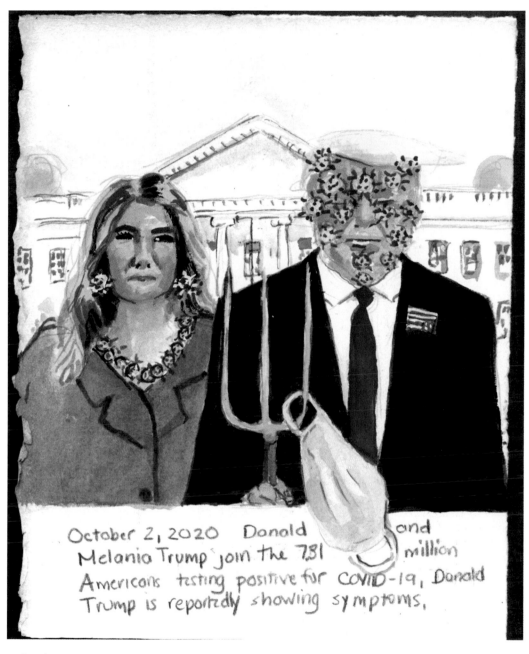

October 2, 2020

Donald and Melania Trump join 7.31 million Americans testing positive for COVID-19, Donald Trump reported to be showing symptoms.

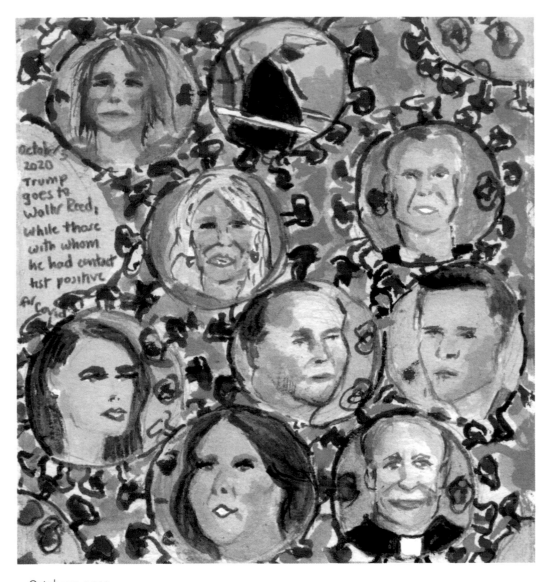

October 3, 2020

Trump goes to Walter Reed, while those with whom he had contact test positive for COVID.

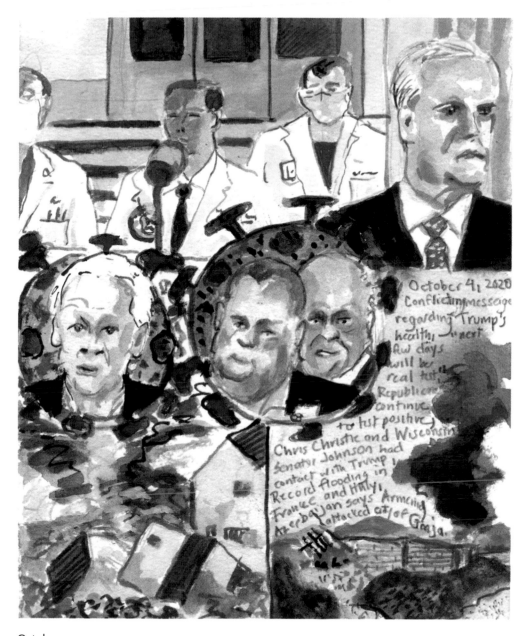

October 4, 2020

Conflicting messages regarding Trump's health, "next few days will be real test"; Republicans continue to test positive, Chris Christie and Wisconsin Senator Johnson had contact with Trump; Record flooding in France and Italy; Azerbaijan says Armenia attacked city of Ganja.

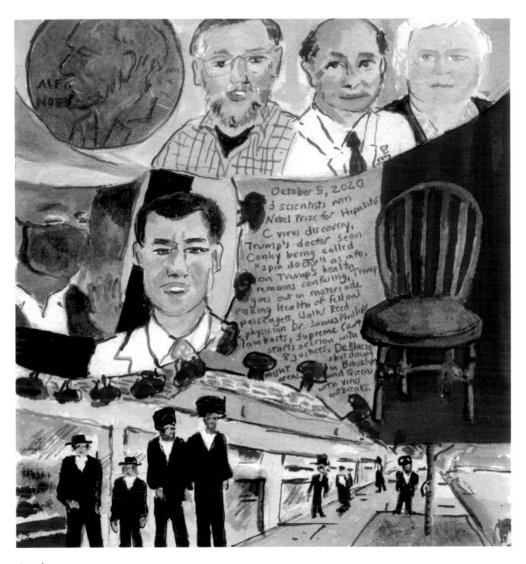

October 5, 2020

Three scientists win Nobel Prize for hepatitis C virus discovery; Trump's doctor, Sean Conley, being called "spin doctor" as info on Trump's health remains confusing; Trump goes out in motorcade risking health of fellow passengers, Walter Reed physician Dr. James Phillips lambasts; Supreme Court starts session with 8 justices; De Blasio might shut down areas in Brooklyn and Queens with virus outbreaks.

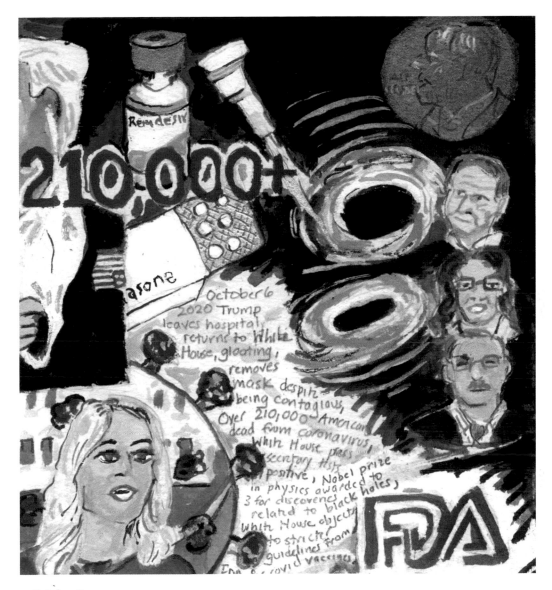

October 6, 2020

Trump leaves hospital, returns to White House, gloating, removes mask despite being contagious; Over 210,000 Americans dead from coronavirus; White House press secretary tests positive; Nobel Prize in physics awarded to 3 for discoveries related to black holes; White House objects to stricter guidelines from FDA for COVID vaccines.

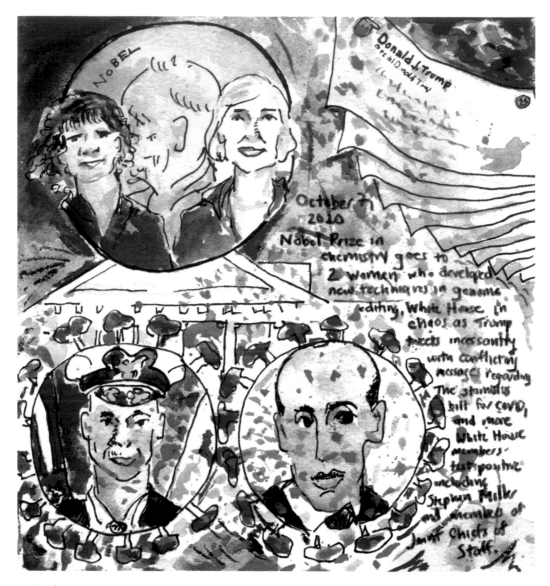

October 7, 2020

Nobel Prize in chemistry goes to 2 women who developed new techniques in genome editing; White House in chaos as Trump tweets incessantly with conflicting messages regarding the stimulus bill for COVID, and more White House members test positive, including Stephen Miller and members of the Joint Chiefs of Staff.

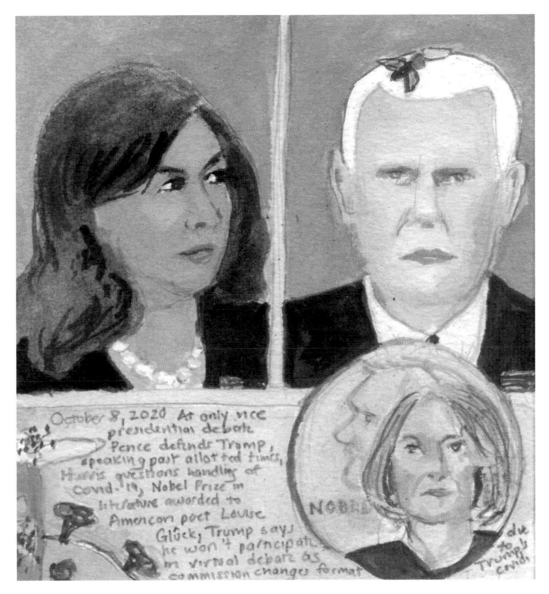

October 8, 2020

At only vice presidential debate, Pence defends Trump, speaking past allotted times, Harris questions handling of COVID-19; Nobel Prize in literature awarded to American poet Louise Glück; Trump says he won't participate in virtual debate as commission changes format due to Trump's COVID.

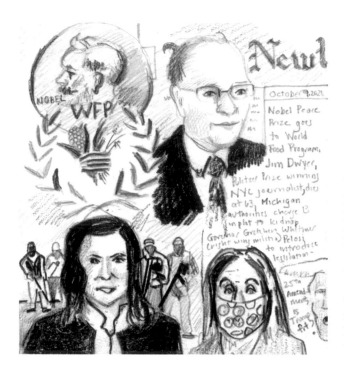

October 9, 2020

Nobel Peace Prize goes to World
Food Program; Jim Dwyer,
Pulitzer Prize–winning New
York City journalist, dies at 63;
Michigan authorities charge
13 in plot to kidnap Governor
Gretchen Whitmer (right-wing
militia); Pelosi to introduce
legislation, 25th Amendment, is
Trump fit?

October 10, 2020

Nagorno-Karabakh:
Armenia and Azerbaijan
agree to cease-fire; Judge
rules against Texas governor
limit of one drop-off site per
county for absentee ballots;
Next presidential debate
canceled over coronavirus
safety concerns; Hurricane
Delta is 25th named storm
of the season, saturates
Louisiana's already storm-
scarred coast.

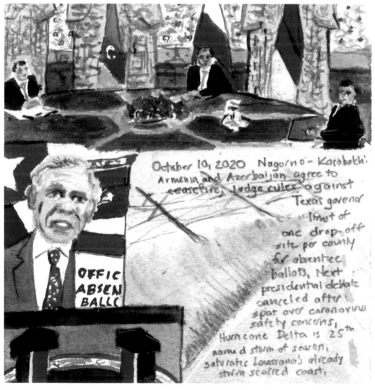

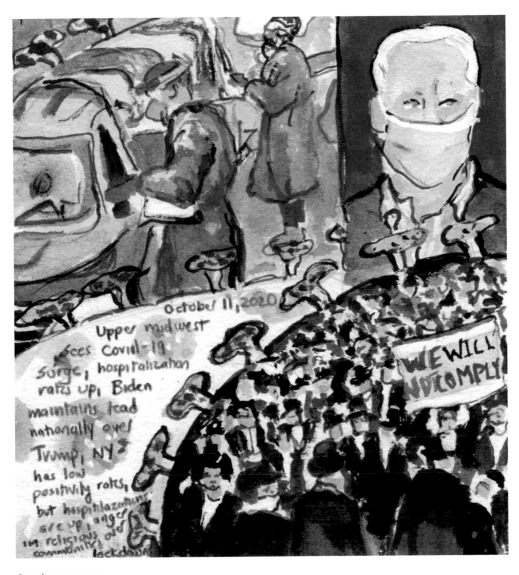

October 11, 2020

Upper Midwest sees COVID-19 surge, hospitalization rates up; Biden maintains lead nationally over Trump; NY has low positivity rates, but hospitalizations are up; Anger in religious communities over lockdowns.

October 12, 2020

Amy Coney Barrett's Supreme Court confirmation hearings begin despite the fact that 2 Senate Committee members have COVID and Committee Chairman Lindsey Graham refuses testing; Nobel Prize for economics announced; Courts stay Texas gov's directive to limit drop-off boxes; Montana COVID up 40%.

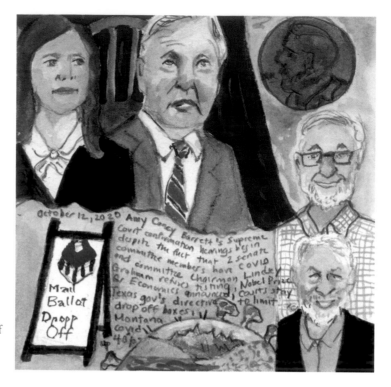

October 13, 2020

Questioning begins for Judge Amy Coney Barrett; COVID cases rising in Europe, new restrictions expected in Italy; At Trump rally Trump threatens to give people big kiss, few masks seen; GOP installs illegal, unofficial ballot drop boxes; Voters in Georgia wait 11 hours; Vaccine trial halted.

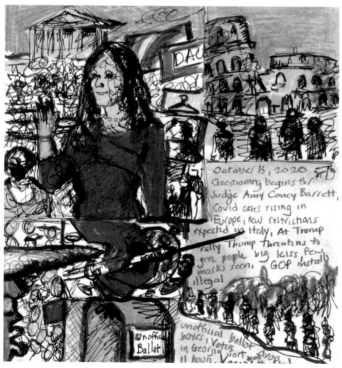

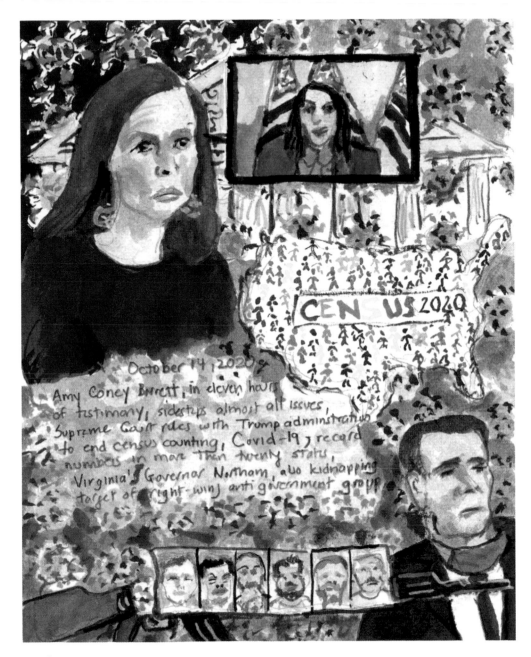

October 14, 2020

Amy Coney Barrett, in 11 hours of testimony, sidesteps almost all issues; Supreme Court rules with Trump administration to end census counting; COVID-19 record numbers in more than 20 states; Virginia's governor Northam also kidnapping target of right-wing antigovernment group.

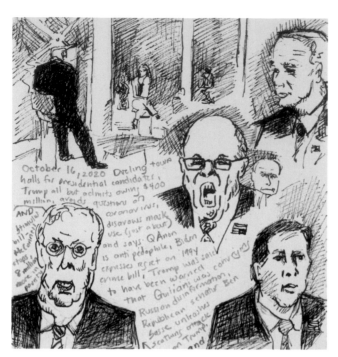

October 16, 2020

Dueling town halls for presidential candidates; Trump all but admits owing $400 million, avoids questions on coronavirus, disavows mask use (just about), and says QAnon is anti-pedophile; Biden expresses regret on 1994 crime bill; Trump was said to have been warned Giuliani was conveying Russian disinformation; Republican senator Ben Sasse unleashes scathing attack on Trump, and stimulus bill—McConnell stops, 8 million more in poverty.

October 17, 2020

New Zealand PM Jacinda Ardern wins 2nd term in landslide; US arrests Mexico's ex–defense chief, accused of helping drug cartel; Hundreds queue in Yiwu, China, for experimental COVID-19 vaccine; Armenian missile kills 13, wounds at least 50 in conflict over Nagorno-Karabakh; Supreme Court to hear case regarding unauthorized immigrants and the census.

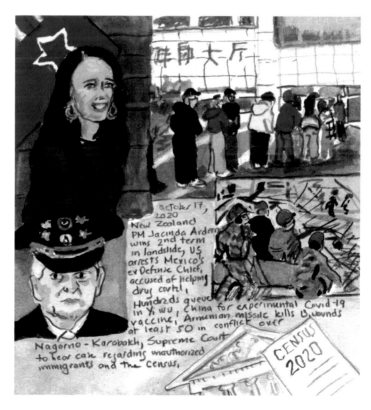

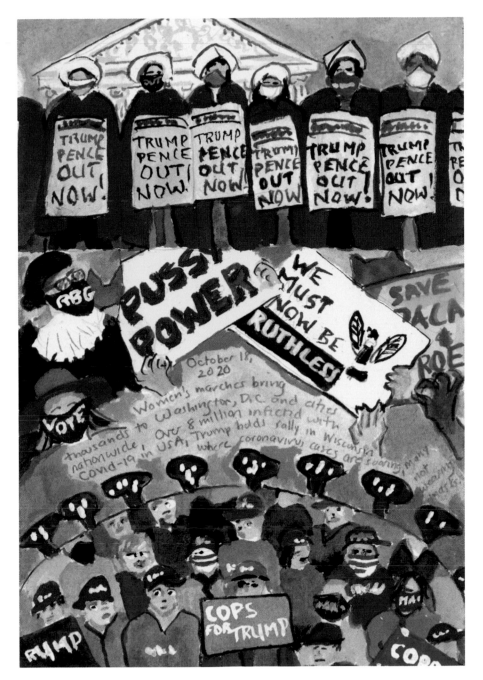

October 18, 2020

Women's marches bring thousands to Washington, DC, and cities nationwide; Over 8 million infected with COVID-19 in USA; Trump holds rally in Wisconsin, where coronavirus cases are soaring, many not wearing masks.

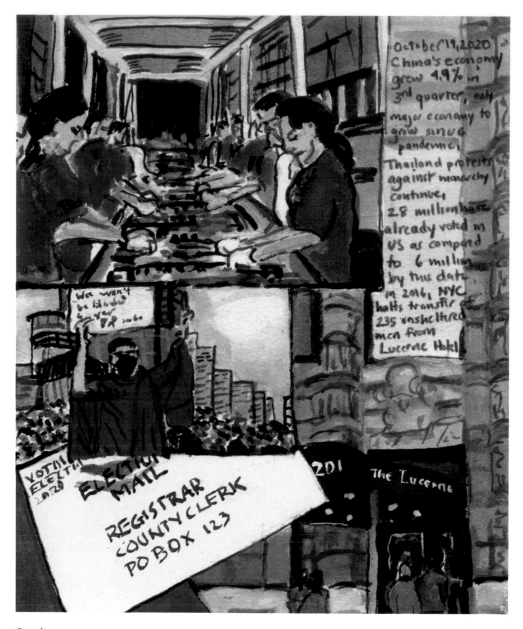

October 19, 2020

China's economy grew 4.9% in 3rd quarter, only major economy to grow since pandemic; Thailand protests against monarchy continue; 28 million have already voted in US as compared to 6 million by this date in 2016; NYC halts transfer of 235 unsheltered men from Lucerne Hotel.

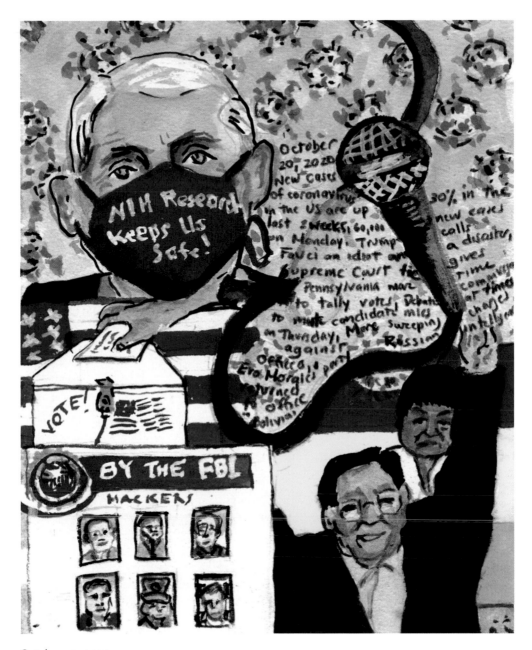

October 20, 2020

New cases of coronavirus in the US are up 30% in the last 2 weeks, 60,000 new cases on Monday; Trump calls Fauci an idiot and a disaster; Supreme Court tie gives Pennsylvania more time to tally votes; Debate Commission to mute candidates' mics at times on Thursday; More sweeping charges against Russian intelligence officers; Evo Morales's party returned to office in Bolivia.

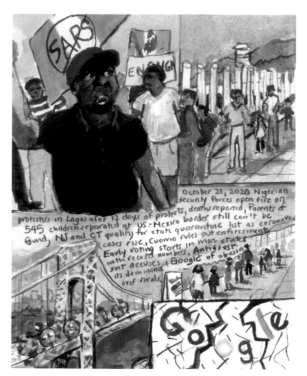

October 21, 2020

Nigerian security forces open fire on protesters in Lagos after 12 days of protest, deaths reported; Parents of 545 children separated at US-Mexico border still can't be found; NJ and CT qualify for state quarantine list as coronavirus cases rise, Cuomo rules out enforcement; Early voting starts in more states with record numbers; Antitrust suit accuses Google of abusing its dominance over rivals.

October 22, 2020

Supreme Court blocks curbside voting in Alabama; Senate Democrats to boycott Barrett's Judiciary Committee vote; US officials accuse Iran and Russia of seeking to influence elections; At least 12 peaceful protesters shot dead by Nigerian army in Lagos; Justice Department settles with Purdue Pharma, no harm to Sackler family or fortune.

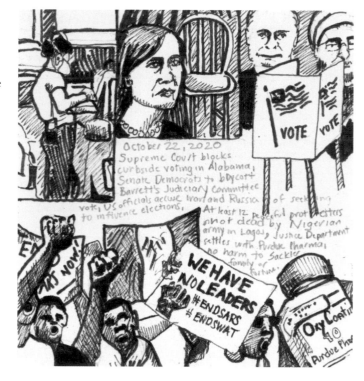

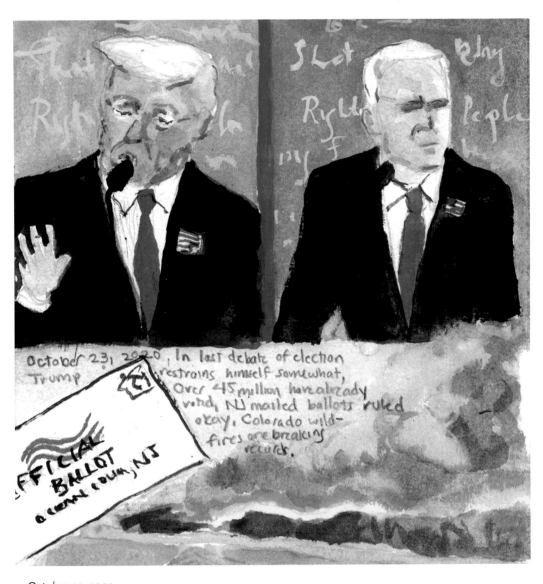

October 23, 2020

In last debate of election Trump restrains himself somewhat; Over 45 million have already voted; NJ mailed ballots ruled okay; Colorado wildfires are breaking records.

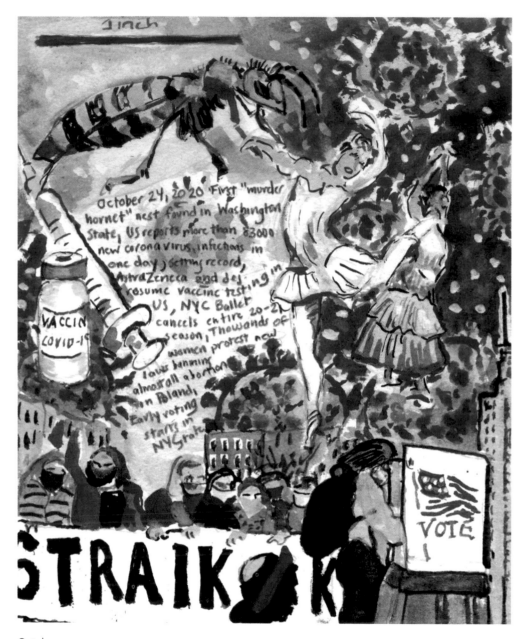

October 24, 2020

First "murder hornet" nest found in Washington State; US reports more than 83,000 new coronavirus infections in one day, setting record; AstraZeneca and J&J resume vaccine testing in US; NYC Ballet cancels entire 20–21 season; Thousands of women protest new laws banning almost all abortions in Poland; Early voting starts in NY State.

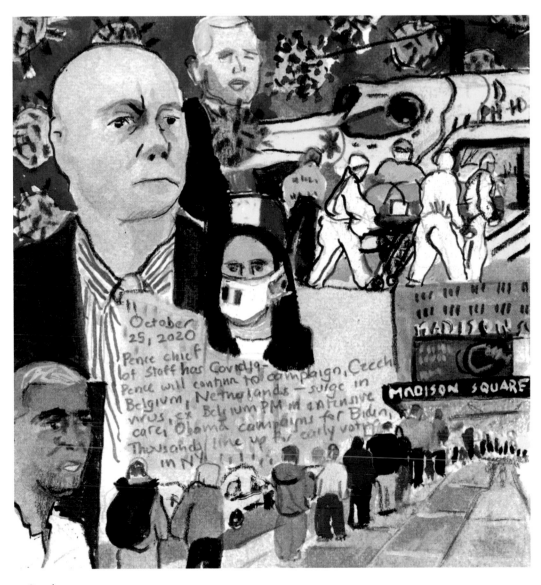

October 25, 2020

Pence chief of staff has COVID-19—Pence will continue to campaign; Czech Republic, Belgium, Netherlands surge in virus, ex–Belgium PM in intensive care; Obama campaigns for Biden; Thousands line up for early voting in NY.

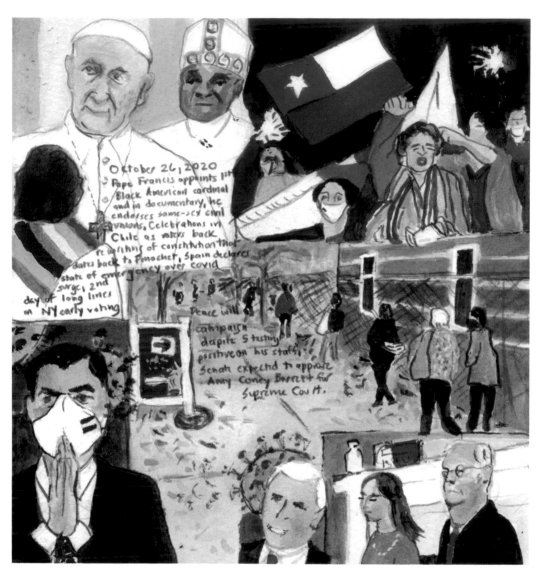

October 26, 2020

Pope Francis appoints first Black American cardinal, and in documentary he endorses same-sex civil unions; Celebrations in Chile as voters back rewriting of constitution that dates back to Pinochet; Spain declares state of emergency over COVID surge; 2nd day of long lines in NY early voting; Pence will campaign despite 5 testing positive on his staff; Senate expected to approve Amy Coney Barrett for Supreme Court.

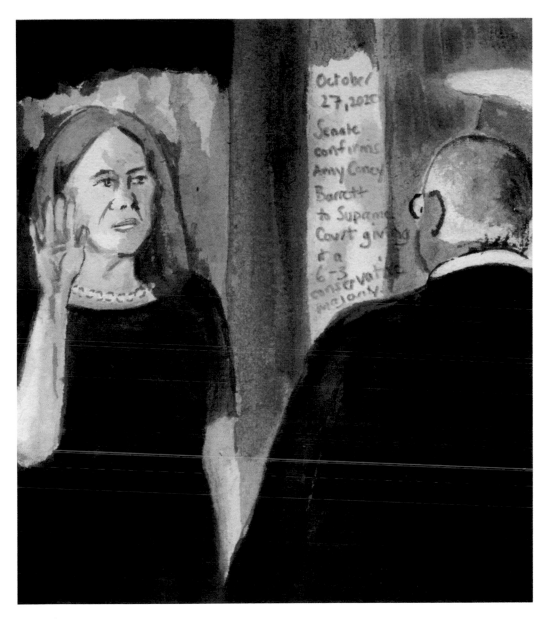

October 27, 2020

Senate confirms Amy Coney Barrett to Supreme Court, giving it a 6–3 conservative majority.

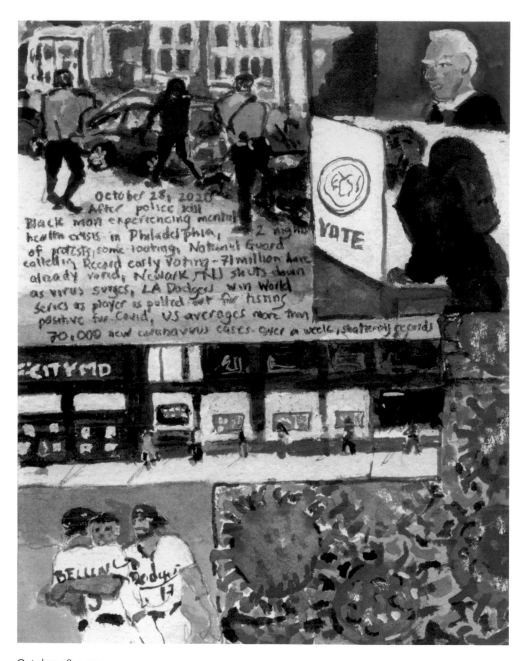

October 28, 2020

After police kill Black man experiencing mental health crisis in Philadelphia, 2 nights of protests, some looting, National Guard called in; Record early voting, 71 million have already voted; Newark, NJ, shuts down as virus surges; LA Dodgers win World Series as player is pulled off for testing positive for COVID; US averages more than 70,000 new coronavirus cases over a week, shattering records.

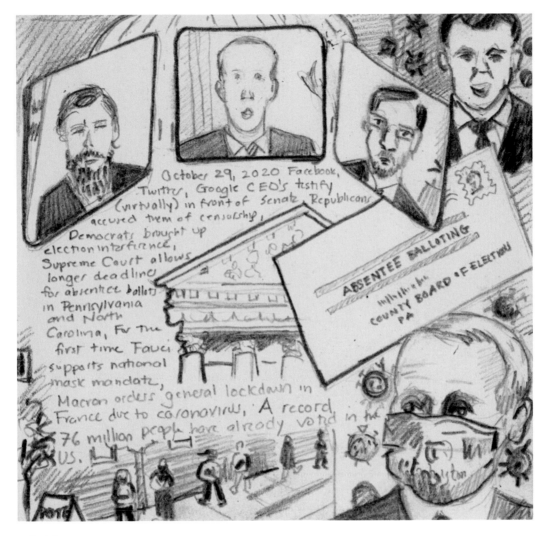

October 29, 2020

Facebook, Twitter, Google CEOs testify virtually in front of Senate, Republicans accuse them of censorship, Democrats brought up election interference; Supreme Court allows longer deadlines for absentee ballots in Pennsylvania and North Carolina; For the first time, Fauci supports national mask mandate; Macron orders general lockdown in France due to coronavirus; A record 76 million people have already voted in the US.

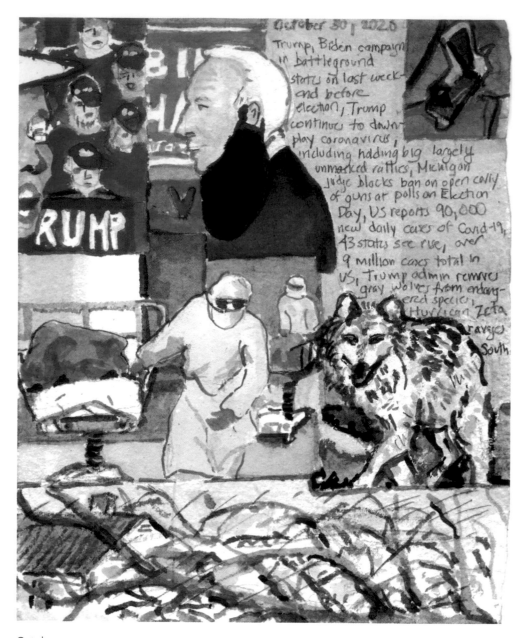

October 30, 2020

Trump, Biden campaign in battleground states on last weekend before election; Trump continues to downplay coronavirus, including holding big, largely unmasked rallies; Michigan judge blocks ban on open carry of guns at polls on Election Day; US reports 90,000 new daily cases of COVID-19, 43 states see rise, over 9 million cases total in US; Trump admin removes gray wolves from endangered species; Hurricane Zeta ravages South.

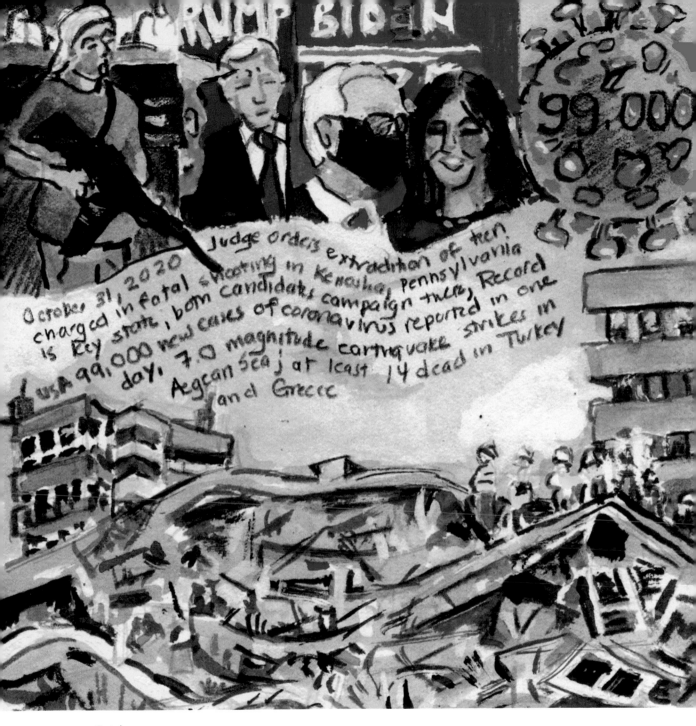

October 31, 2020

Judge orders extradition of teen charged in fatal shooting in Kenosha; Pennsylvania is key state, both candidates campaign there; Record USA 99,000 new cases of coronavirus reported in one day; 7.0 magnitude earthquake strikes in Aegean Sea, at least 14 dead in Turkey and Greece.

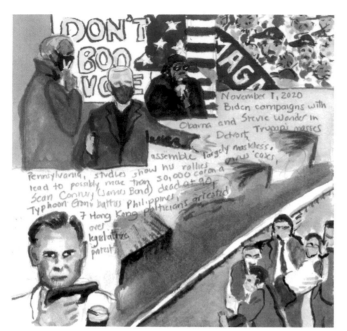

November 1, 2020

Biden campaigns with Obama and Stevie Wonder in Detroit; Trump's masses assemble largely maskless in Pennsylvania, studies show his rallies led to possibly more than 30,000 coronavirus cases; Sean Connery (James Bond) dead at 90; Typhoon Goni batters Philippines; 7 Hong Kong politicians arrested over legislative protest.

November 2, 2020

Heavily armed NYPD officers arrest 10 while quashing small anti-Trump protest in Manhattan; Trump supporters ambush Biden-Harris campaign bus in Texas, leading to cancellation of 2 rallies; Trump supporters block bridges and highways in NY area; Trump falsely claims votes shouldn't be counted after Election Day; Germany and UK go on partial coronavirus lockdown.

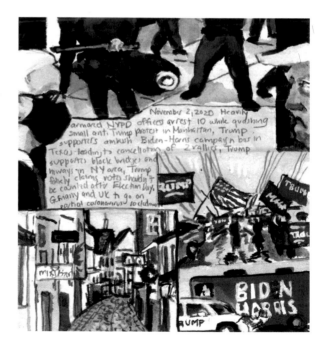

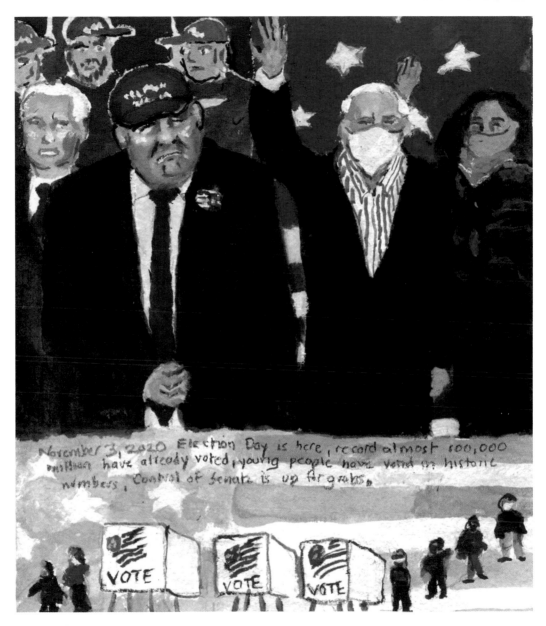

November 3, 2020

Election Day is here, record almost 100,000,000 have already voted, young people have voted in historic numbers; Control of Senate is up for grabs.

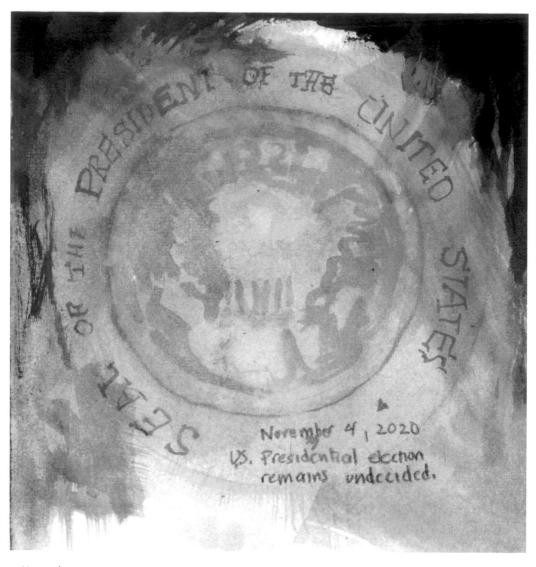

November 4, 2020

US presidential election remains undecided.

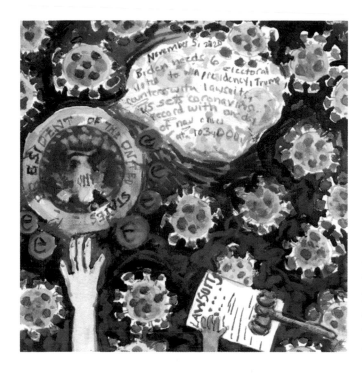

November 5, 2020

Biden needs 6 electoral
votes to win presidency,
Trump counters with
lawsuits; US sets
coronavirus record
with one day of new
cases at 103,000.

November 6, 2020

More Americans voted
in election than ever
before, vote goes as
predicted, shifting
from red to blue;
Networks cut away
from Trump's press
conference as he lies
about election, Twitter,
Facebook block his
posts; Georgia, PA,
Biden takes lead;
117,000+ new US
coronavirus cases;
Cyclist killed by truck
in Bronx.

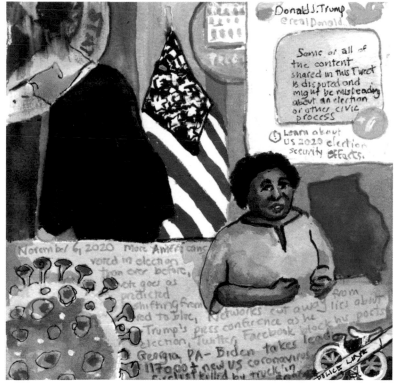

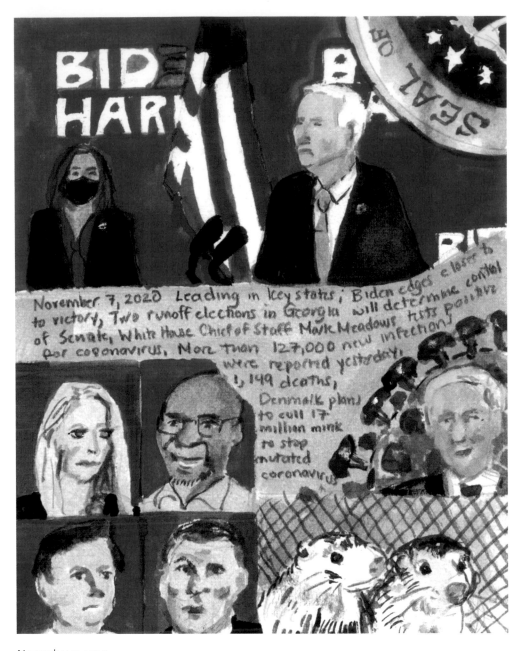

November 7, 2020

Leading in key states, Biden edges closer to victory; Two runoff elections in Georgia will determine control of Senate; White House chief of staff Mark Meadows tests positive for coronavirus; More than 127,000 new infections were reported yesterday, 1,149 deaths; Denmark plans to cull 17 million mink to stop mutated coronavirus.

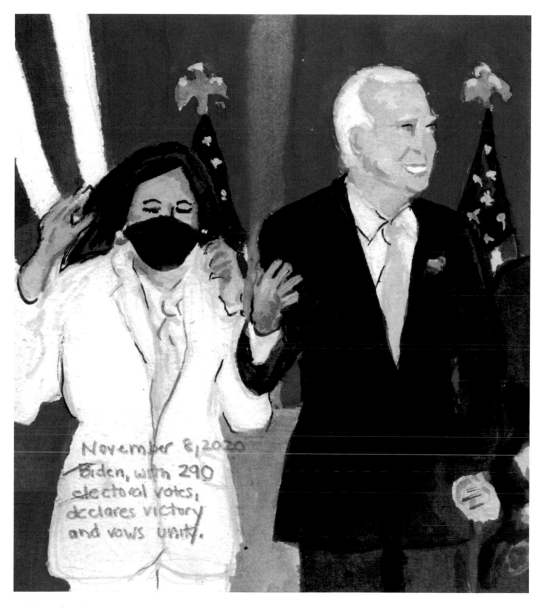

November 8, 2020

Biden, with 290 electoral votes, declares victory and vows unity.

November 9, 2020

Trump's lawyer Rudy Giuliani gives press conference outside Four Seasons Landscaping (not resort), located between Fantasy Island Adult Books and Delaware Valley Cremation Center, decrying election fraud; Alex Trebek, longtime *Jeopardy* host, dead at 80; Coronavirus 50 million cases worldwide, close to 10 million in US; President-elect Biden appoints coronavirus task force; Pfizer announces 90% effective coronavirus vaccine.

November 10, 2020

Barr hands prosecutors the authority to investigate voter fraud claims; Saeb Erekat, veteran Palestinian peace negotiator, dies from COVID-19 at age 65; Trump fires Mark Esper, defense secretary who opposed troops on US streets; Ben Carson, David Bossie, White House staff COVID-19 positive.

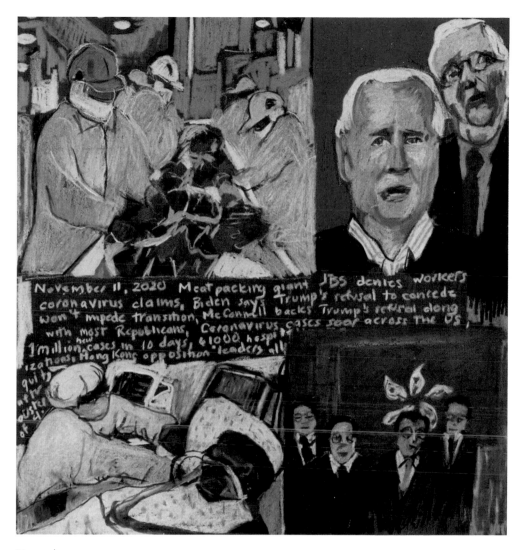

November 11, 2020

Meatpacking giant JBS denies workers coronavirus claims; Biden says Trump's refusal to concede won't impede transition; McConnell backs Trump's refusal along with most Republicans; Coronavirus cases soar across the US, 1 million new cases in 10 days, 61,000 hospitalizations; Hong Kong opposition leaders all quit after ouster of 4.

November 12, 2020

President-elect Biden names longtime advisor Robert Klain as his White House chief of staff; Foreign leaders are congratulating Biden, including Boris Johnson; Trump still refusing to concede despite no evidence of voter fraud; Georgia will recount vote by hand; Cuomo orders new COVID restrictions in New York as cases climb; 144,000 new cases in US yesterday; France most affected country in Europe.

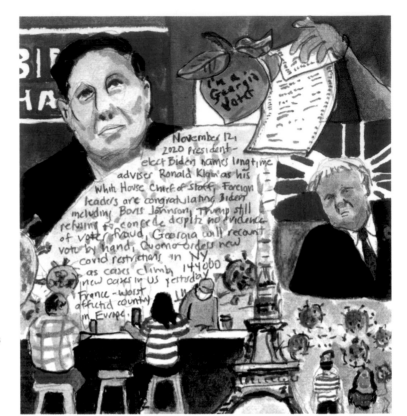

November 13, 2020

Four shipwrecks in 3 days claim lives of at least 110 migrants in the Mediterranean; Max Rose (D) concedes to Nicole Malliotakis (R) in NYC congressional seat; Biden takes Arizona, according to AP; 160,000 new COVID cases in US yesterday.

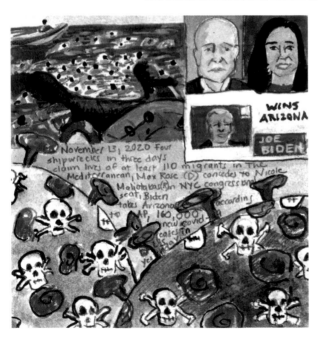

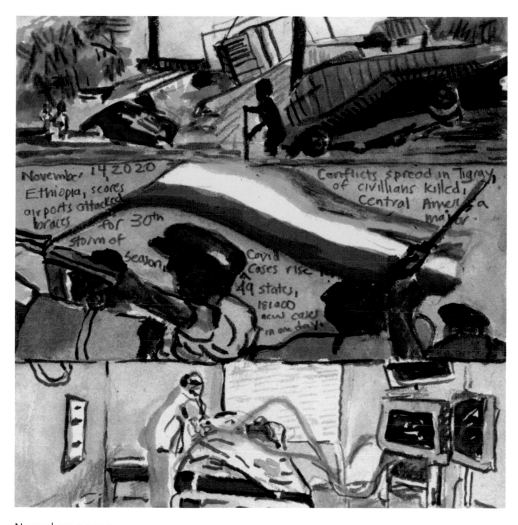

November 14, 2020

Conflicts spread in Tigray, Ethiopia, scores of civilians killed, airports attacked; Central America braces for 30th major storm of the season; COVID cases rising in 49 states, 181,000 new cases in one day.

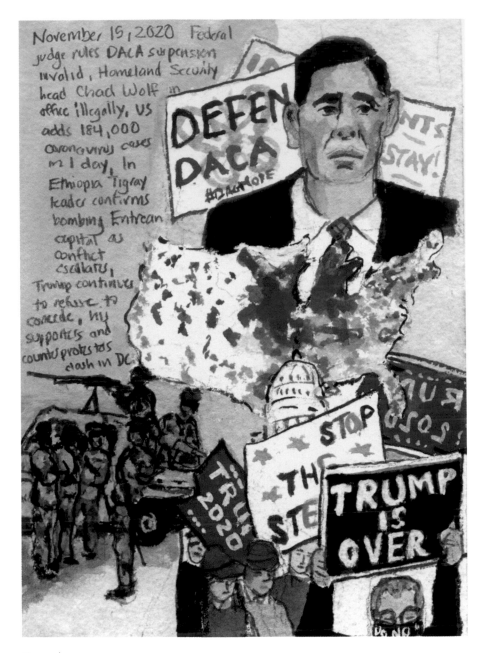

November 15, 2020

Federal judge rules DACA suspension invalid, Homeland Security head Chad Wolf in office illegally; US adds 184,000 coronavirus cases in 1 day; In Ethiopia, Tigray leader confirms bombing Eritrean capital as conflict escalates; Trump continues to refuse to concede, his supporters and counterprotesters clash in DC.

November 16, 2020

Moderna's coronavirus vaccine is 94.5% effective according to company data; States and cities tighten the restrictions as US virus caseload soars; Trump is absent from leadership on virus, still won't concede; SpaceX launches 4 astronauts to the International Space Station, first private taxi flight for NASA; Asia-Pacific countries sign one of the largest trade deals ever.

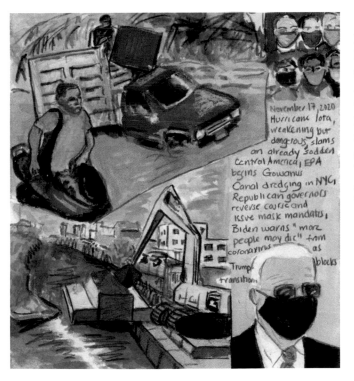

November 17, 2020

Hurricane Iota, weakening but dangerous, slams an already sodden Central America; EPA begins Gowanus Canal dredging in NYC; Republican governors reverse course and issue mask mandates; Biden warns "more people may die" from coronavirus as Trump blocks transition.

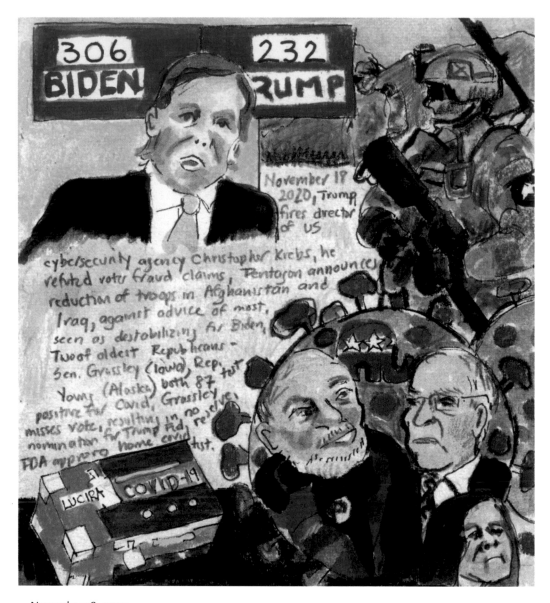

November 18, 2020

Trump fires director of US cybersecurity agency Christopher Krebs, he refuted voter fraud claims; Pentagon announces reduction of troops in Afghanistan and Iraq, against advice of most, seen as destabilizing for Biden; Two of oldest Republicans—Sen. Grassley (Iowa), Rep. Young (Alaska), both 87—test positive for COVID; Grassley misses vote, resulting in no nomination for Trump Fed. Reserve; FDA approves home COVID test.

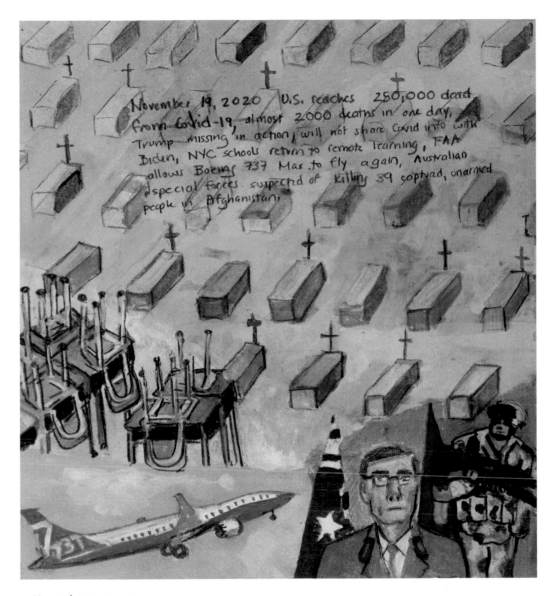

November 19, 2020

US reaches 250,000 dead from COVID-19, almost 2,000 deaths in one day; Trump is missing in action, will not share COVID info with Biden; NYC schools return to remote learning; FAA allows Boeing 737 MAX to fly again; Australian special forces suspected of killing 39 captured, unarmed people in Afghanistan.

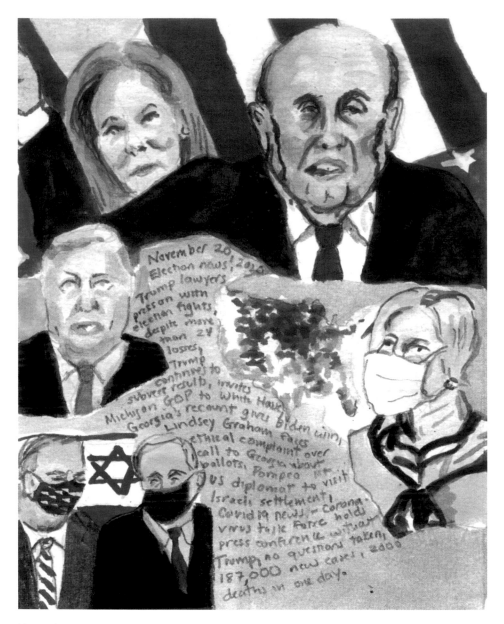

November 20, 2020

Election news: Trump lawyers press on with election fights, despite more than 24 losses; Trump continues to subvert results, invites Michigan GOP to White House; Georgia recount gives Biden win; Lindsey Graham faces ethical complaint over call to Georgia about ballots; Pompeo 1st US diplomat to visit Israeli settlement; COVID-19 news: coronavirus task force holds press conference without Trump, no questions taken; 187,000 new cases, 2,000 deaths in one day.

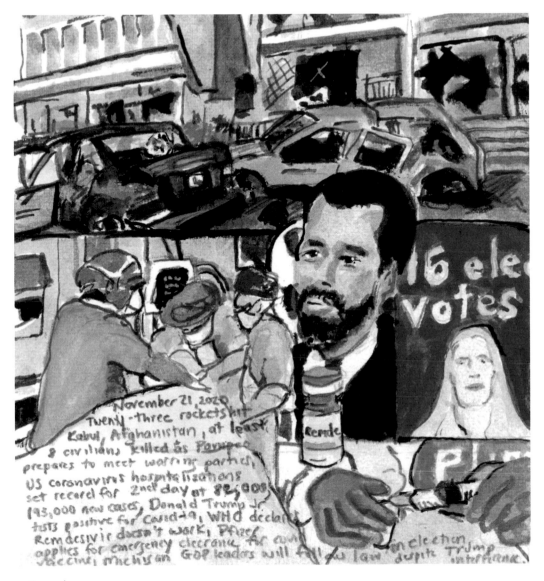

November 21, 2020

Twenty-three rockets hit Kabul, Afghanistan, at least 8 civilians killed as Pompeo prepares to meet warring parties; US coronavirus hospitalizations set record for 2nd day at 82,000, 193,000 new cases; Donald Trump Jr. tests positive for COVID-19; WHO declares remdesivir doesn't work; Pfizer applies for emergency clearance for COVID vaccine; Michigan GOP leaders will follow law in election despite Trump interference.

November 22, 2020

Federal Judge Matthew
Brann tosses out Trump's
last suit seeking to invalidate
Pennsylvania election results,
calling the attempt to invalidate
election results a tortured
"Frankenstein monster";
FDA allows emergency use of
antibody drug REGEN-COV for
COVID-19; WHO says more
cases in 4 weeks than the first
6 months; Portugal declares
COVID state of emergency.

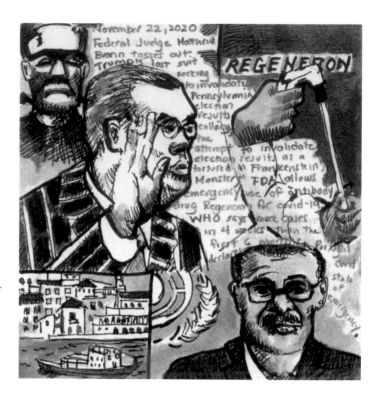

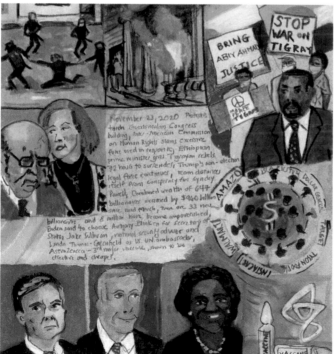

November 23, 2020

Protesters torch Guatemalan Congress
building, Inter-American Commission on
Human Rights slams excessive force used
in response; Ethiopian prime minister gives
Tigrayan rebels 72 hours to surrender;
Trump's non-election legal farce continues,
team distances itself from conspiracy fan
Sidney Powell; Combined wealth of 647
billionaires increased by $960 billion since
mid-March, there are 33 new billionaires and
8 million have become impoverished; Biden
said to choose Anthony Blinken for secretary
of state, Jake Sullivan, national security
advisor, and Linda Thomas-Greenfield as US
UN ambassador; AstraZeneca, 3rd major
vaccine, shown to be effective and cheaper.

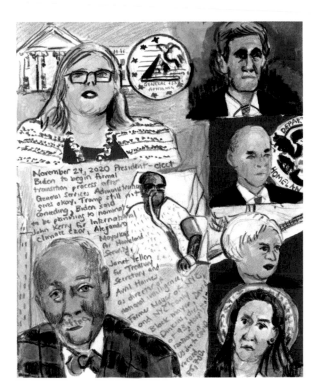

November 24, 2020

President-elect Biden to begin formal transition process after General Services Administration gives okay, Trump still not conceding; Biden said to be planning to nominate John Kerry for international climate czar, Alejandro Mayorkas for Homeland Security, Janet Yellen for treasury secretary, and Avril Haines as director of national intelligence; Former mayor of NYC and NYC's only Black mayor, David Dinkins, dead at 93; Hospitalizations in US due to COVID-19 record 85,700.

November 25, 2020

Biden introduces Cabinet, and can receive intelligence briefings as transition begins; Scotland is the first country to make women's sanitary products free; Facing criticism, Dianne Feinstein steps down as top Democrat on judiciary panel; Purdue Pharma pleads guilty on drug felony charges, but Sackler family no criminal charges; 173,000 new COVID-19 cases, 21,000 deaths in the US, but many Americans still travel over Thanksgiving holiday.

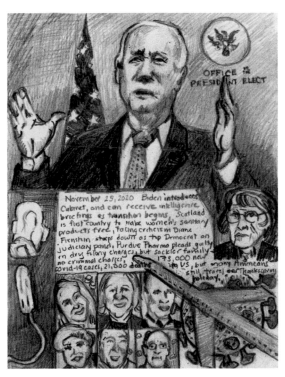

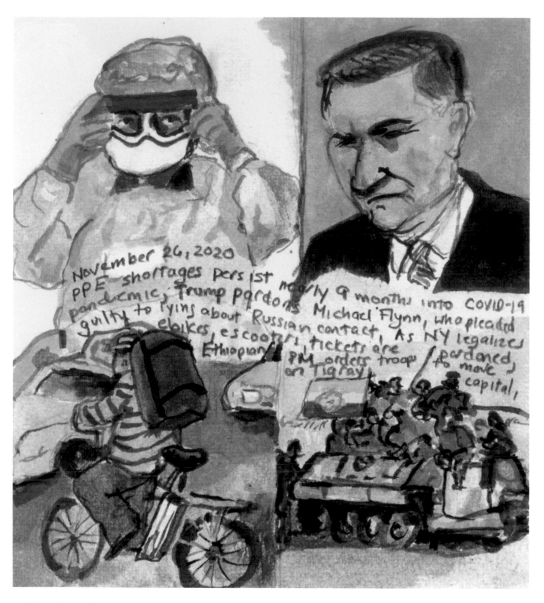

November 26, 2020

PPE shortages persist nearly 9 months into COVID-19 pandemic; Trump pardons Michael Flynn, who pleaded guilty to lying about Russian contact; As NY legalizes ebikes, escooters, tickets are pardoned; Ethiopian PM orders troops to move on Tigray capital.

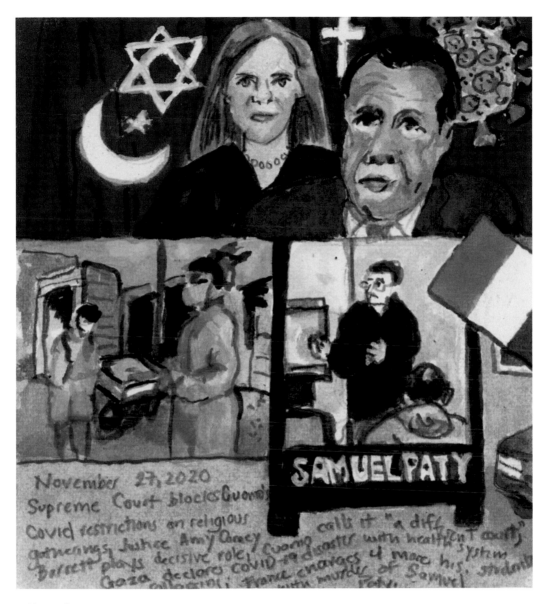

November 27, 2020

Supreme Court blocks Cuomo's restrictions on religious gatherings, Justice Amy Coney Barrett plays decisive role, Cuomo calls it "a different court"; Gaza declares COVID-19 disaster with health system collapsing; France charges 4 more high school students with murder of Samuel Paty.

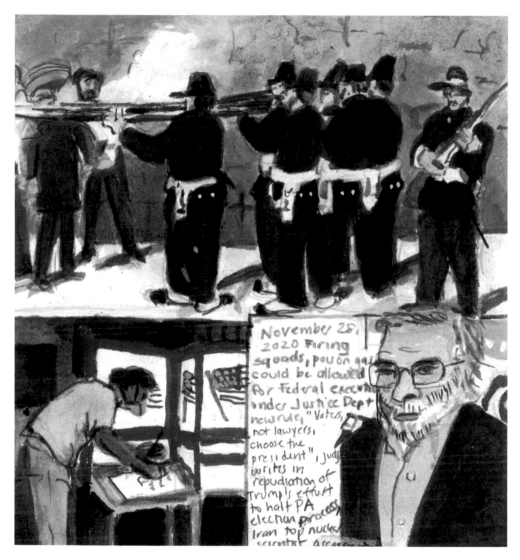

November 28, 2020

Firing squad, poison gas could be allowed for federal executions under Justice Dept. new rule; "Voters, not lawyers, choose the president," judge writes in repudiation of Trump's effort to halt PA election process; Iran top nuclear scientist assassinated.

November 29, 2020

Protests over security bill in France draw tens of thousands, French decry bill that would restrict sharing images of police officers and could curb press freedom; In US, 266,000 deaths from COVID-19, 4 million new cases in November, more than twice October #; Pennsylvania Supreme Court throws out Republican bid to eject 2.5 million mail-in votes; At least 34 dead in 2 separate suicide bombings in Afghanistan.

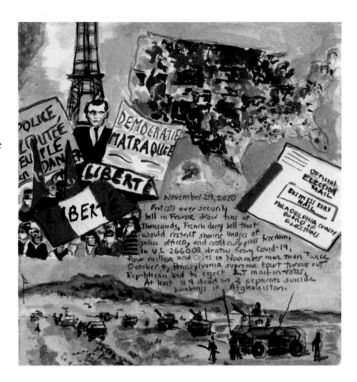

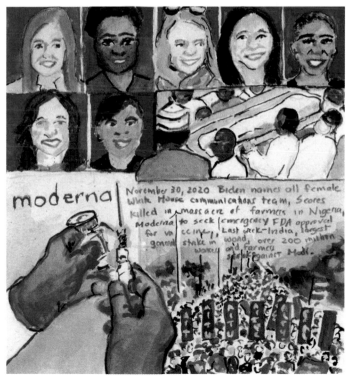

November 30, 2020

Biden names all-female White House communications team; Scores killed in massacre of farmers in Nigeria; Moderna to seek emergency FDA approval for vaccine; Last week—India, largest general strike in world, over 200 million workers and farmers strike against Modi.

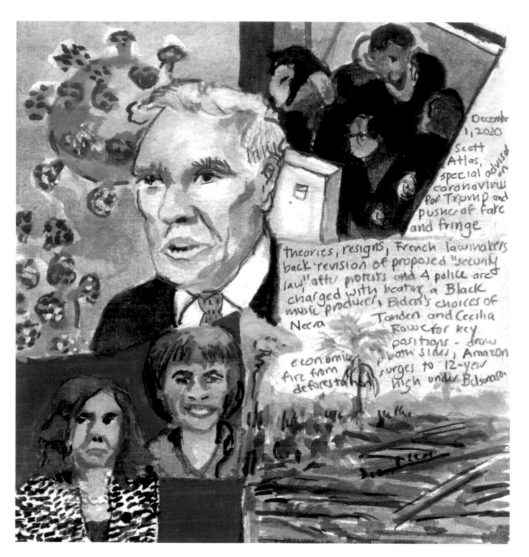

December 1, 2020

Scott Atlas, special adviser on coronavirus for Trump and pusher of fake and fringe theories, resigns; French lawmakers back revision of proposed "security law" after protests and 4 police are charged with beating of Black music producer; Biden's choices of Neera Tanden and Cecilia Rouse for key economic positions draw fire from both sides; Amazon deforestation surges to 12-year high under Bolsonaro.

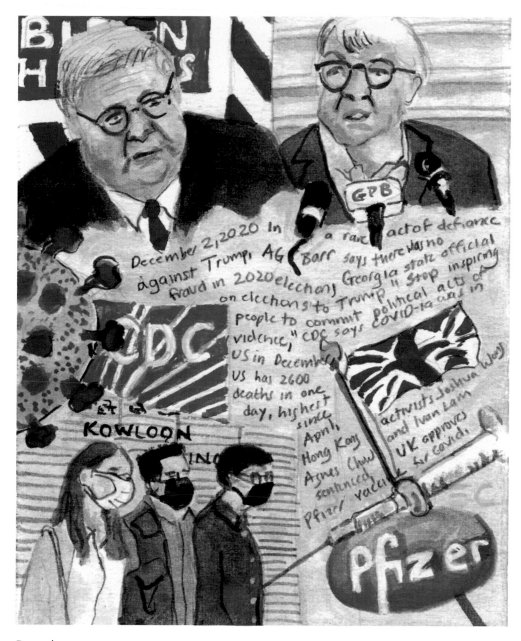

December 2, 2020

In a rare act of defiance against Trump, AG Barr says there was no fraud in 2020 election; Georgia state official on elections to Trump, "Stop inspiring people to commit political acts of violence"; CDC says COVID-19 was in US in December; US has 2,600 deaths in one day, highest since April; Hong Kong activists Joshua Wong, Agnes Chow, and Ivan Lam sentenced; UK approves Pfizer vaccine for COVID.

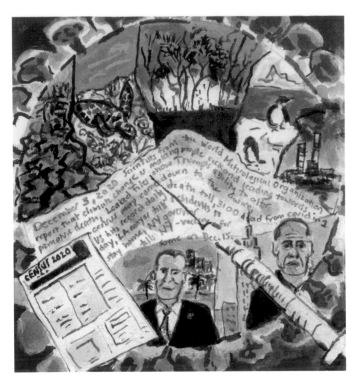

December 3, 2020

Scientists from the World Meteorological Organization report that climate change is making people sick and leading towards premature death; Leaked files show Trump's ability to alter census may come down to the wire; US hits record daily death toll, 3,100 in one day; LA mayor tells residents to stay home; New York governor tells NY vaccine for some on Dec. 15.

December 4, 2020

Biden asks Dr. Fauci to join his team, will urge 100 days of mask wearing; 213,000 new cases of COVID-19 yesterday, 2 deaths per minute; ICE detainees, 20th day of hunger strike at Bergen County Jail; US will auction drilling rights in Arctic January 6.

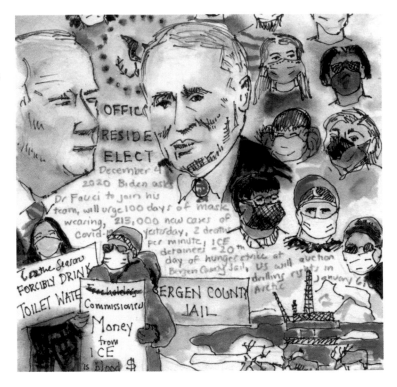

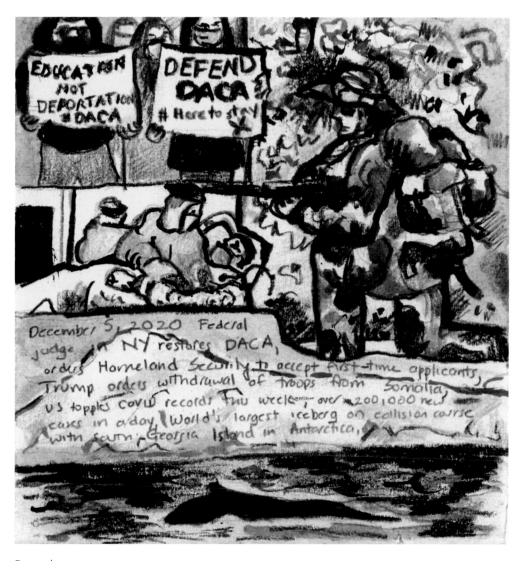

December 5, 2020

Federal judge in NY restores DACA, orders Homeland Security to accept first-time applicants; Trump orders withdrawal of troops from Somalia; US tops COVID records this week, over 200,000 new cases in one day; World's largest iceberg on collision course with South Georgia Island in Antarctica.

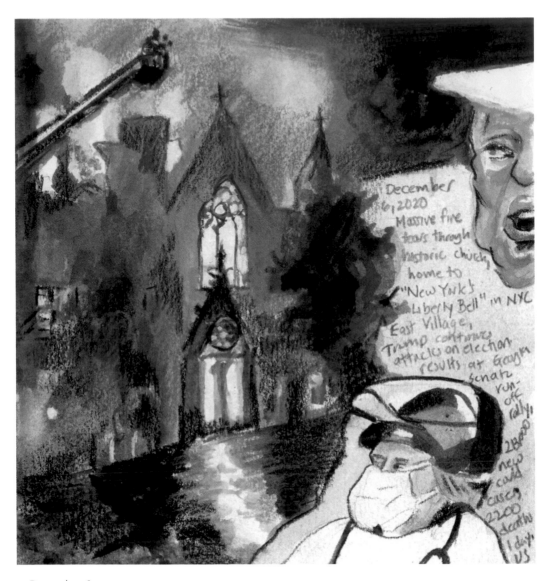

December 6, 2020

Massive fire tears through historic church, home to "New York's Liberty Bell," in NYC East Village; Trump continues attacks on election results at Georgia Senate runoff rally; 213,000 new COVID cases, 2,200 deaths in 1 day in US.

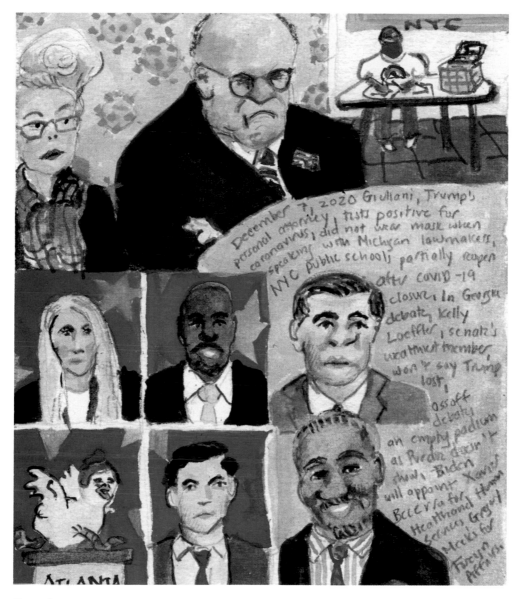

December 7, 2020

Giuliani, Trump's personal attorney, tests positive for coronavirus, did not wear mask when speaking with Michigan lawmakers; NYC public schools partially reopen after COVID-19 closure; In Georgia debate, Kelly Loeffler, Senate's wealthiest member, won't say Trump lost; Ossoff debates an empty podium, as Perdue doesn't show; Biden will appoint Xavier Becerra for Health and Human Services, Gregory Meeks for Foreign Affairs.

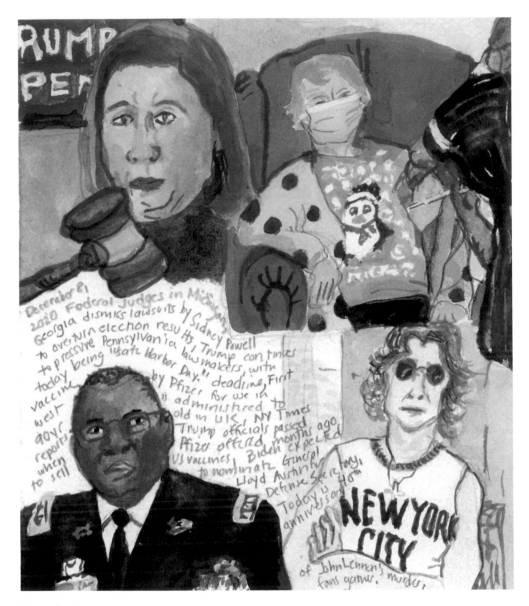

The text within the illustration reads:

December 8, 2020 Federal Judges in Michigan, Georgia dismiss lawsuits by Sidney Powell to overturn election results, Trump continues to pressure Pennsylvania lawmakers, with today being "Safe Harbor Day" deadline, First vaccine by Pfizer for use in west is administered to 90 yr old in UK, NY Times reports when Trump officials passed to sell Pfizer offered months ago US vaccines, Biden expected to nominate General Lloyd Austin for Defense Secretary, Today is 40th anniversary of John Lennon's murder, fans gather.

December 8, 2020

Federal judges in Michigan, Georgia dismiss lawsuits by Sidney Powell to overturn election results, Trump continues to pressure Pennsylvania lawmakers with today being "Safe Harbor Day" deadline; First vaccine by Pfizer for use in West is administered to 90-year-old in UK; *NY Times* reports Trump officials passed when Pfizer offered months ago to sell US vaccines; Biden expected to nominate General Lloyd Austin for defense secretary; Today is 40th anniversary of John Lennon's murder, fans gather.

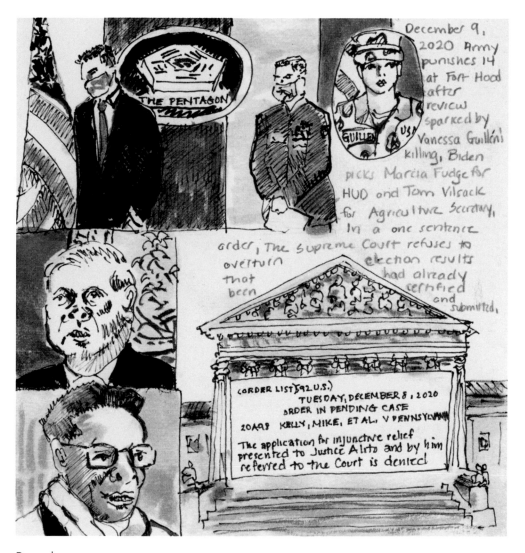

December 9, 2020

Army punishes 14 at Fort Hood after review sparked by Vanessa Guillén's killing; Biden picks Marcia Fudge for HUD and Tom Vilsack for agriculture secretary; In a one-sentence order, the Supreme Court refuses to overturn election results that had already been certified and submitted.

December 10, 2020

18 Republican attorneys general back Trump in election lawsuit, Ted Cruz would argue election case if it reached Supreme Court; 3,124 deaths, 107,000 hospitalized from COVID-19 in US, breaking all records; House extends federal funding one week, still no COVID relief funds; NY's $226 billion pension fund is dropping fossil fuel stocks; Biden will nominate Katherine Tai for top trade official; Hunter Biden under federal investigation for "tax affairs"; NOAA reports Arctic is warming 2 to 3 times faster than rest of planet; Trump will complete massive arms deal to UAE after Senate fails to block; Minneapolis will cut millions from police budget.

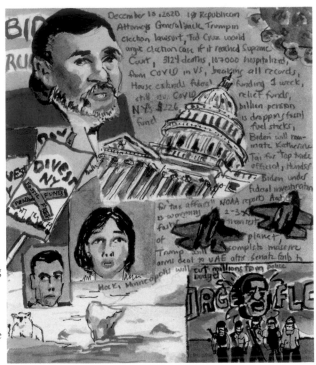

December 11, 2020

Biden taps Susan Rice to lead White House Domestic Policy Council, Denis McDonough as VA secretary; Morocco normalizes ties with Israel as Trump recognizes Morocco's claims over disputed Western Sahara; US unemployment claims rise to highest level since September; Vaccine may be one day away; Justice Department executes man who committed crime at age 18.

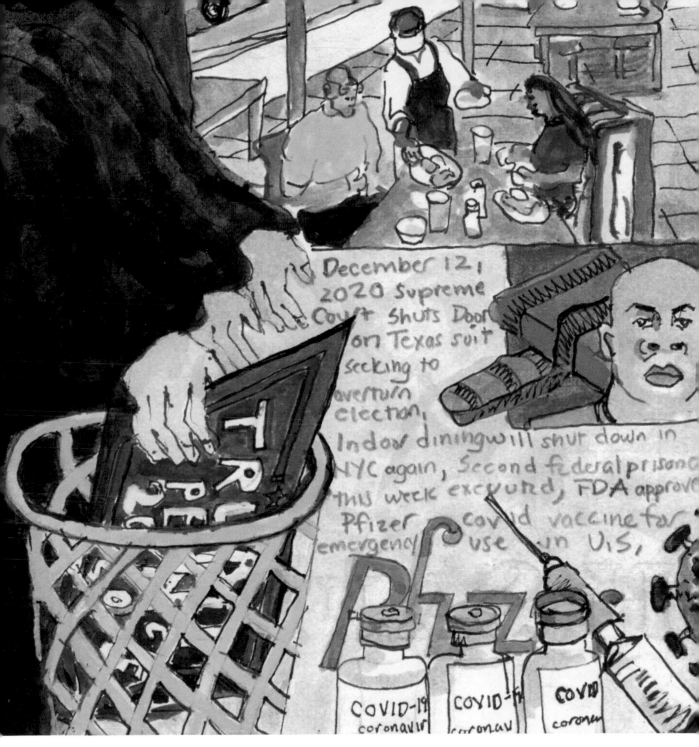

December 12, 2020

Supreme Court shuts door on Texas suit seeking to overturn election; Indoor dining will shut down in NYC again; Second federal prisoner this week executed; FDA approves Pfizer vaccine for emergency use in US.

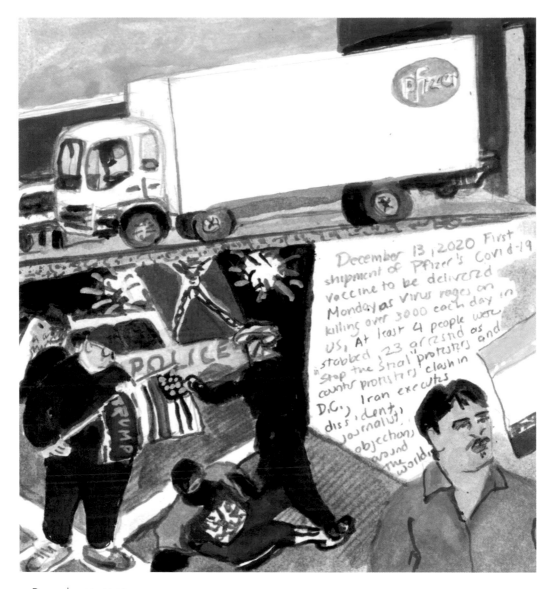

December 13, 2020

First shipment of Pfizer's COVID-19 vaccine to be delivered Monday as virus rages on, killing over 3,000 each day in US; At least 4 people were stabbed, 23 arrested as "Stop the Steal" protesters and counterprotesters clash in DC; Iran executes dissident journalist, objections around the world.

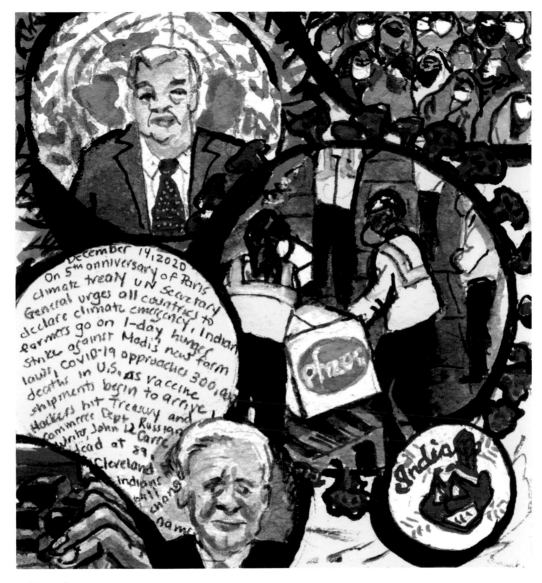

December 14, 2020

On 5th anniversary of Paris climate treaty UN secretary-general urges all countries to declare climate emergency; Indian farmers go on 1-day hunger strike against Modi's new farm laws; COVID-19 approaches 300,000 deaths in US as vaccine shipments begin to arrive; Hackers hit treasury and commerce departments; Writer John le Carré dead at 89; Cleveland Indians will change name.

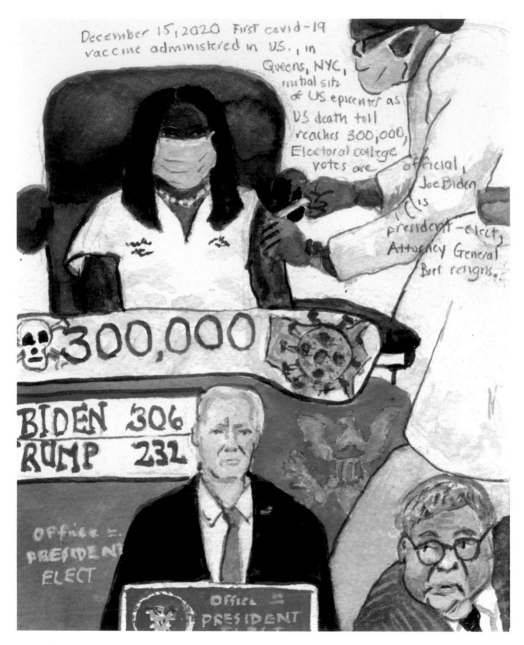

December 15, 2020

First COVID-19 vaccine administered in US, in Queens, NYC, initial site of US epicenter, as US death toll reaches 300,000; Electoral college votes are official, Joe Biden is president-elect; Attorney General Barr resigns.

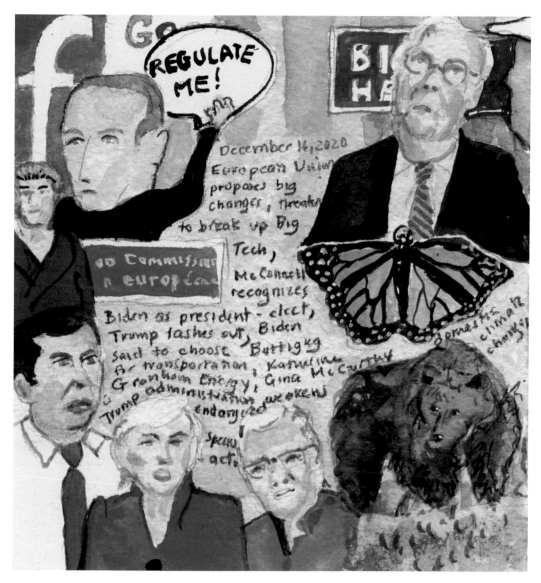

December 16, 2020

European Union proposes big changes, threatens to break up Big Tech; McConnell recognizes Biden as president-elect, Trump lashes out; Biden said to choose Buttigieg for Transportation and Jennifer Granholm for Energy, Gina McCarthy, Domestic Climate Change; Trump administration weakens Endangered Species Act.

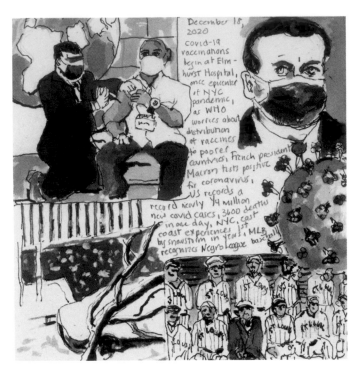

December 17, 2020

COVID-19 vaccinations begin at Elmhurst Hospital, once epicenter of NYC pandemic; WHO worries about distribution of vaccines to poorer countries; French president Macron tests positive for coronavirus; US records a record nearly 1/4 million new COVID cases, 3,600 deaths in one day; NYC, East Coast experiences 1st big snowstorm in years; MLB recognizes Negro League baseball.

December 18, 2020

Congress rushes to reach deal on $900B in COVID relief and avoid government shutdown; Pence publicly receives COVID vaccine; Biden picks Native American Deb Haaland as interior secretary, Michael Regan to lead EPA; 344 kidnapped Nigerian boys have been freed; Suspected Russian hack is much worse than first feared.

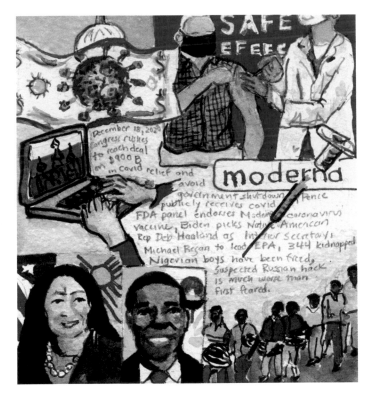

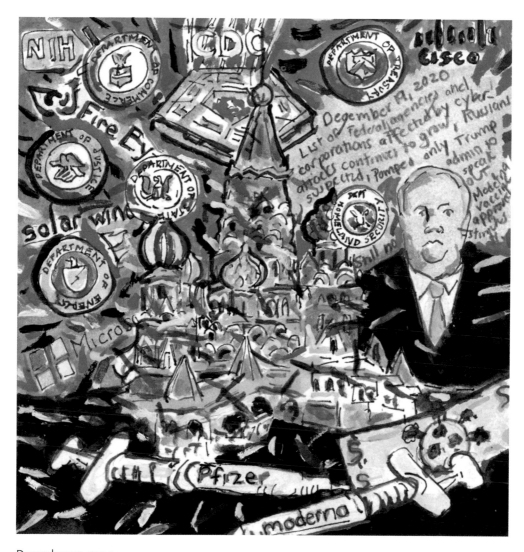

December 19, 2020

List of federal agencies and corporations affected by cyberattacks continues to grow, Russia suspected, Pompeo only Trump admin to speak up; Moderna vaccine approved; Still no stimulus money.

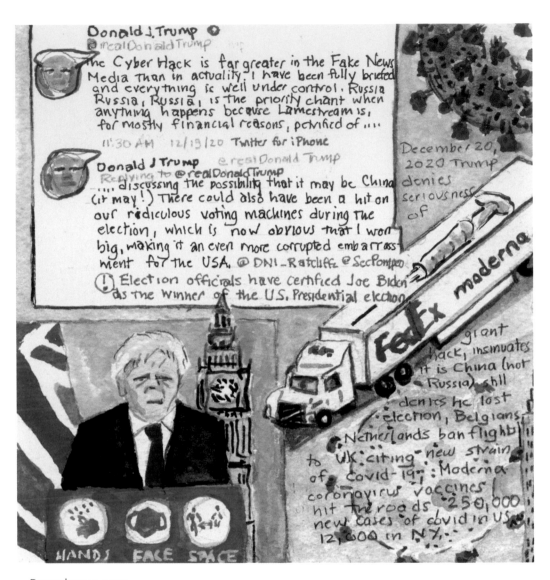

December 20, 2020

Trump denies seriousness of giant hack, insinuates it is China (not Russia), still denies he lost election; Belgium, Netherlands ban flights to UK, citing new strain of COVID-19; Moderna coronavirus vaccines hit the road; 250,000 new cases of COVID in US, 12,000 in NY.

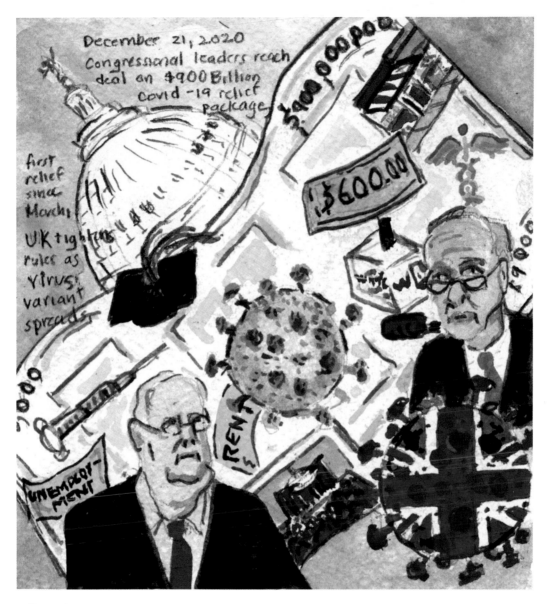

December 21, 2020

Congressional leaders reach deal on $900 billion COVID-19 relief package, first relief since March; UK tightens rules as virus variant spreads.

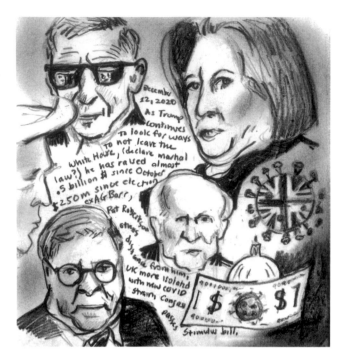

December 22, 2020

As Trump continues to look for ways to not leave the White House (declare martial law?), he has raised almost $0.5 billion since October, $250 million since election day, ex-AG Barr, Pat Robertson, others distance from him; UK more isolated with new COVID strain; Congress passes stimulus bill.

December 23, 2020

CA Governor Newsom picks Alex Padilla for Kamala Harris's Senate seat; Biden to choose Miguel Cardona as education secretary; Department of Justice sues Walmart over opioids; Trump goes on a rampage with 15 pardons including for Blackwater contractors who killed Iraqi civilians, 2 who lied about Russia to Mueller, 3 corrupt Republican congressmen, and 2 border guards convicted of killing innocent man, threatens to veto stimulus bill.

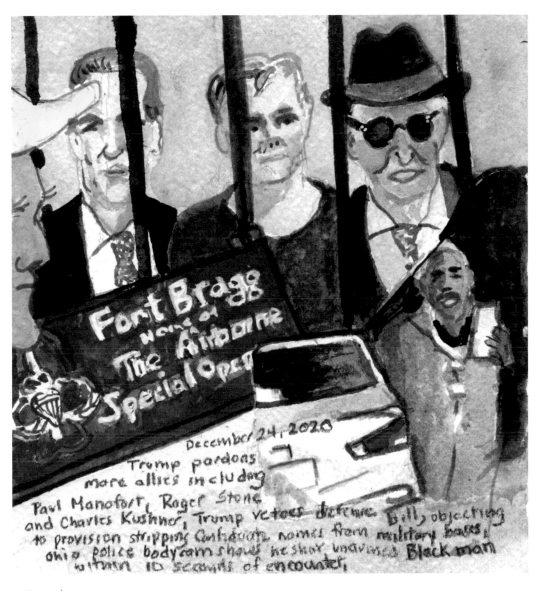

December 24, 2020

Trump pardons more allies, including Paul Manafort, Roger Stone, and Charles Kushner; Trump vetoes defense bill, objecting to provision stripping Confederate names from military bases; Ohio police bodycam shows he shot unarmed Black man within 10 seconds of encounter.

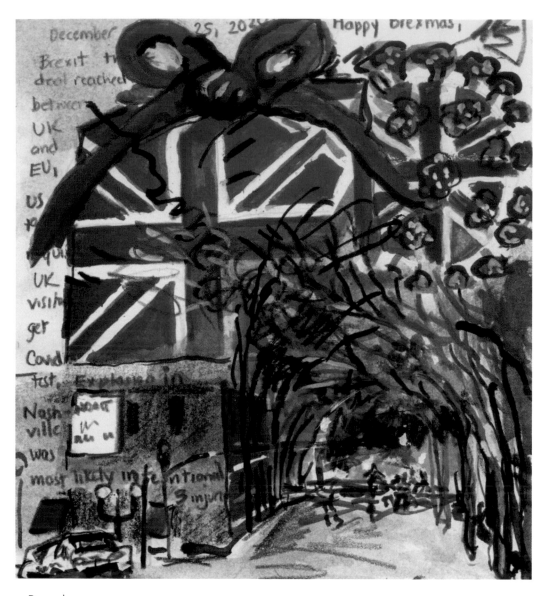

December 25, 2020

Happy Brexmas, Brexit trade deal reached between UK and EU; US to require UK visitors get COVID test; Explosion in Nashville was most likely intentional, 5 injured.

December 26, 2020

Trump still refusing to sign stimulus bill as jobless benefits for 14 million are about to expire; Judge delays execution of only woman on US death row; COVID cases in California reach 2 million, in LA County 1 person dies every 10 minutes; Still no evidence as to who is responsible for Nashville bombing.

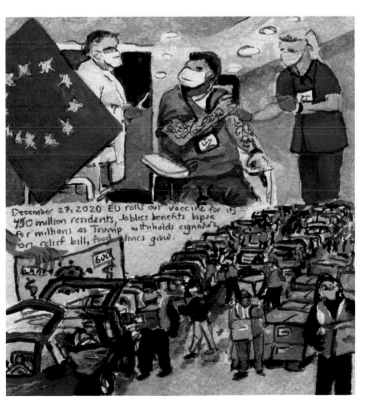

December 27, 2020

EU rolls out vaccine for its 450 million residents; Jobless benefits lapse for millions as Trump withholds signature on relief bill, food lines grow.

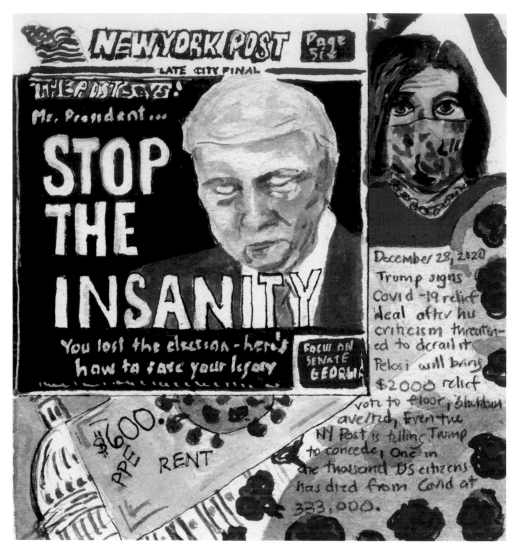

December 28, 2020

Trump signs COVID-19 relief deal after his criticism threatens to derail it; Pelosi will bring $2,000 relief vote to floor, shutdown averted; Even the *NY Post* is telling Trump to concede; One in one thousand US citizens has died from COVID at 333,000.

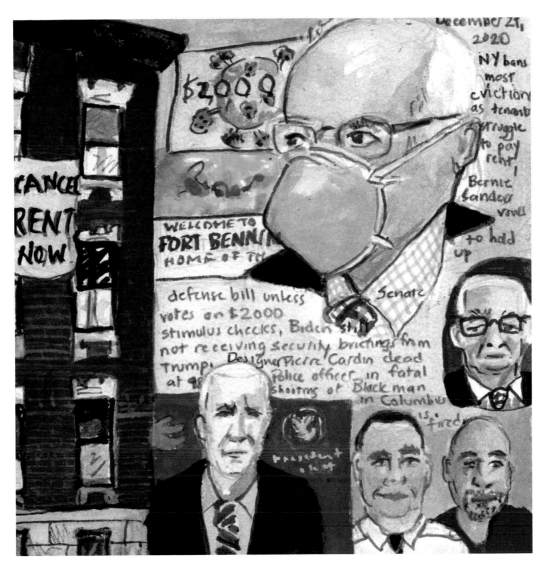

December 29, 2020

New York bans most evictions as tenants struggle to pay rent; Bernie Sanders vows to hold up defense bill unless Senate votes on $2,000 stimulus checks; Biden still not receiving security briefings from Trump; Designer Pierre Cardin dead at 98; Police officer in fatal shooting of Black man in Columbus is fired.

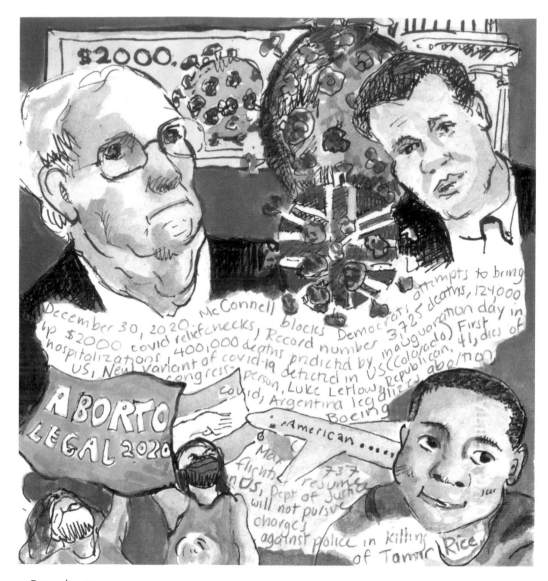

December 30, 2020

McConnell blocks Democrats' attempts to bring up $2,000 COVID relief checks; Record number 3,725 deaths, 124,000 hospitalizations, 400,000 deaths predicted by Inauguration Day in US; New variant of COVID-19 detected in US (Colorado); First congressperson, Luke Letlow, Republican, 41, dies of COVID; Argentina legalizes abortion; Boeing MAX 737 flights resume in US; Dept. of Justice will not pursue charges against police in killing of Tamir Rice.

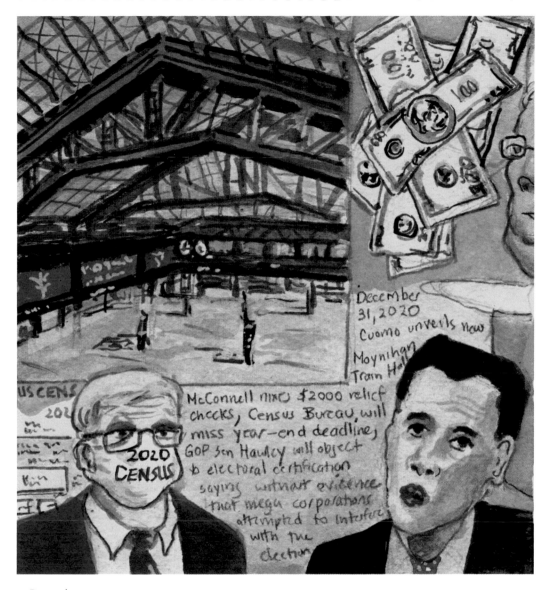

Within the illustration: December 31, 2020 Cuomo unveils new Moynihan Train Hall

McConnell nixes $2000 relief checks, Census Bureau will miss year-end deadline, GOP Sen Hawley will object to electoral certification saying without evidence that mega corporations attempted to interfere with the election

2020 CENSUS

December 31, 2020

Cuomo unveils new Moynihan Train Hall; McConnell nixes $2,000 relief checks; Census Bureau will miss year-end deadline; GOP Sen. Hawley will object to electoral certification, says without evidence that megacorporations attempted to interfere with the election.

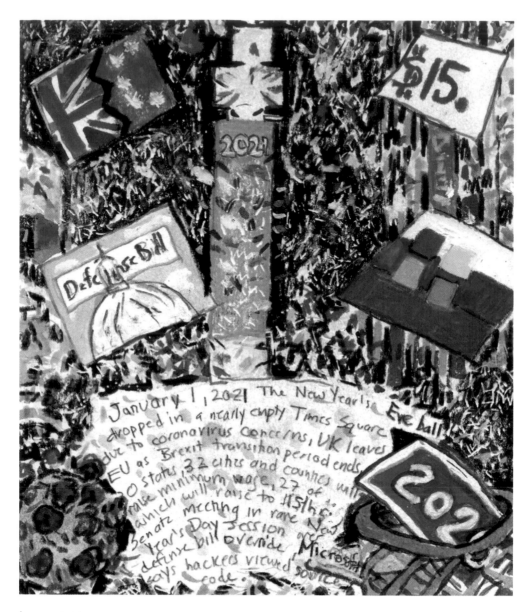

January 1, 2021

The New Year's Eve ball dropped in a nearly empty Times Square due to coronavirus concerns; UK leaves EU as Brexit transition period ends; 20 states, 32 cities and counties will raise minimum wage, 27 of which will raise to $15/hour; Senate meeting in rare New Year's Day session over defense bill override; Microsoft says hackers viewed source code.

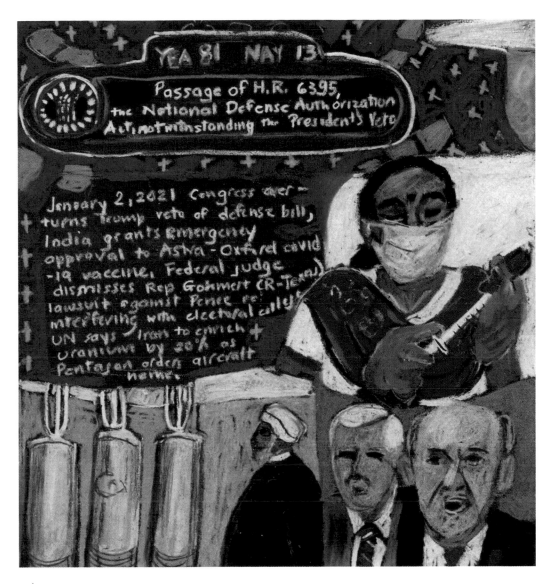

January 2, 2021

Congress overturns Trump veto of defense bill; India grants emergency approval to Oxford-Astra-Zeneca COVID-19 vaccine; Federal judge dismisses Rep. Gohmert (R-TX) lawsuit against Pence re: interfering with Electoral College; UN says Iran to enrich uranium by 20% as Pentagon orders aircraft home.

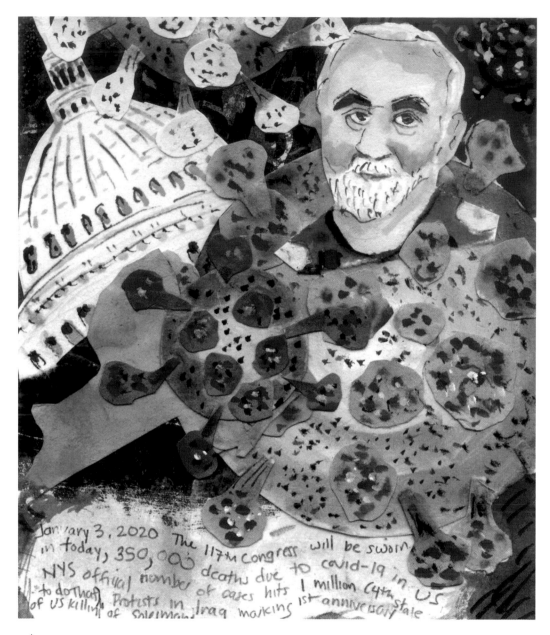

January 3, 2021

The 117th Congress will be sworn in today; 350,000 deaths due to COVID-19 in US; NY State official number of cases hits 1 million (4th state to do that); Protests in Iraq marking 1st anniversary of US killing of Soleimani.

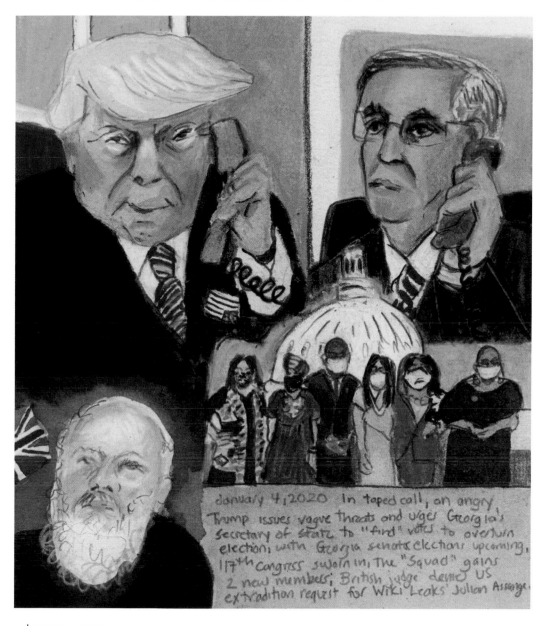

Within the illustration, handwritten text reads:

January 4, 2020 In taped call, an angry
Trump issues vague threats and urges Georgia's
secretary of state to "find" votes to overturn
elections with Georgia senate elections upcoming,
117th Congress sworn in, The "Squad" gains
2 new members; British judge denies US
extradition request for WikiLeaks' Julian Assange.

January 4, 2021

In taped call, an angry Trump issues vague threats and urges Georgia secretary of state to "find" votes to overturn the election, with Georgia senator elections upcoming; 117th Congress sworn in, the "Squad" gains 2 members; British judge denies US extradition request for WikiLeaks's Julian Assange.

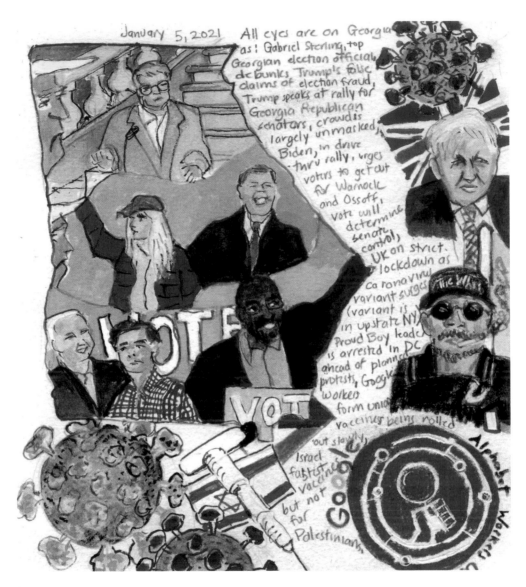

January 5, 2021

All eyes are on Georgia as: Gabriel Sterling, top Georgia election official, debunks Trump's false claims of election fraud; Trump speaks at rally for Georgia Republican senators, crowd is largely unmasked; Biden, in drive-through rally, urges voters to get out for Warnock and Ossoff, vote will determine Senate control; UK on strict lockdown as coronavirus variant surges (variant is in upstate NY); Proud Boy leader is arrested in DC ahead of planned protests; Google workers form union; Vaccines being rolled out slowly; Israel fastest vaccines, but not for Palestinians.

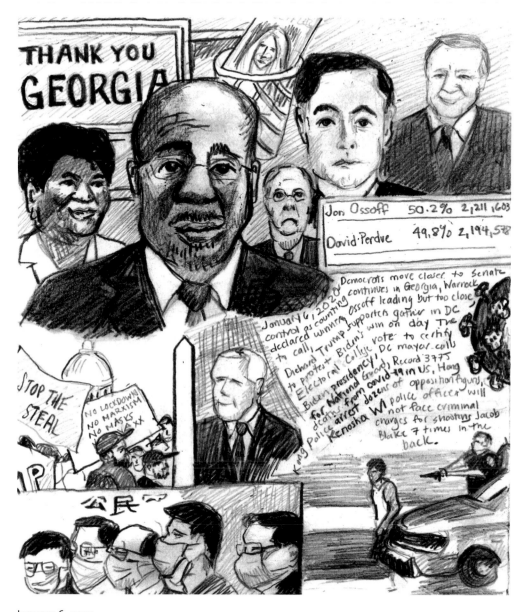

January 6, 2021

Democrats move closer to Senate control as counting continues in Georgia; Warnock declared winner, Ossoff leading but too close to call; Diehard Trump supporters gather in DC to protest Biden's win on day the Electoral College votes to certify Biden presidency, DC mayor calls for National Guard; Record 3,775 deaths from COVID-19 in US; Hong Kong police arrest dozens of opposition figures; Kenosha, WI, police officer will not face criminal charges for shooting Jacob Blake 7 times in the back.

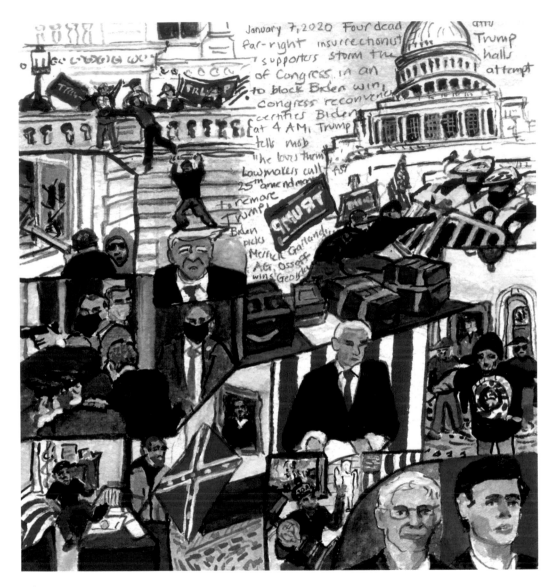

January 7, 2021

Four dead after far-right insurrectionist Trump supporters storm the halls of Congress in an attempt to block Biden win; Congress reconvenes, certifies Biden at 4 a.m.; Trump tells mob he loves them; Lawmakers call for 25th Amendment to remove Trump; Biden picks Merrick Garland for AG; Ossoff wins Georgia.

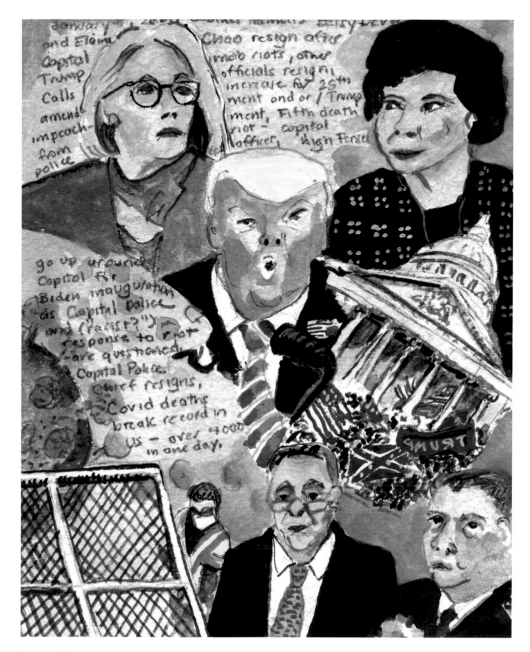

January 8, 2021

Cabinet members Betsy DeVos and Elaine Chao resign after Capitol mob riots, other officials resign; Calls increase for 25th Amendment and/or Trump impeachment; Fifth death from riot—Capitol police officer; High fences go up around Capitol for Biden inauguration as Capitol police and ("racist?") response to riot questioned; Capitol police chief resigns; COVID deaths break record, over 4,000 deaths in one day.

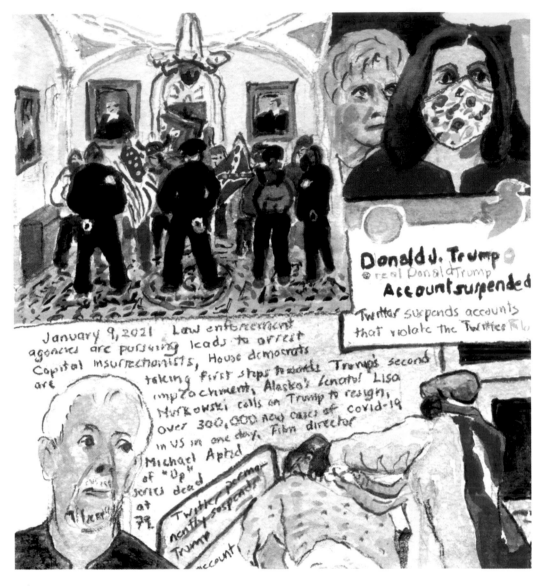

January 9, 2021

Law enforcement agencies are pursuing leads to arrest Capitol insurrectionists; House Democrats are taking first steps towards Trump's 2nd impeachment, Alaska's Senator Lisa Murkowski calls on Trump to resign; Over 300,000 new cases of COVID-19 in US in one day; Film director Michael Apted, of "Up" series, dead at 79; Twitter permanently suspends Trump's Twitter account.

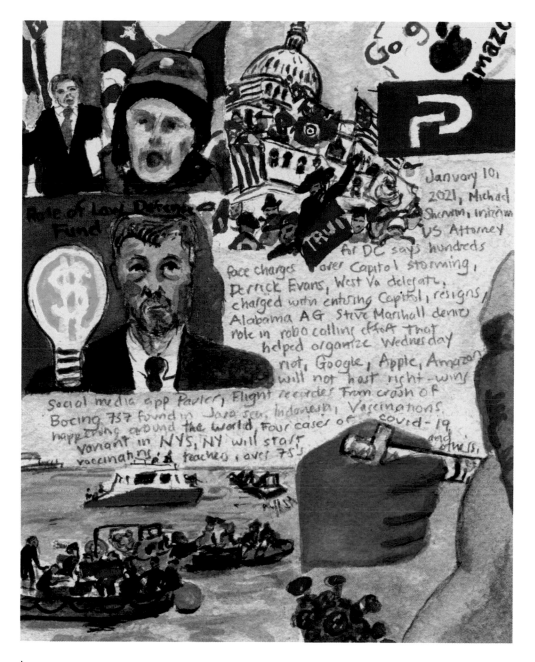

January 10, 2021

Michael Sherwin, interim US Attorney for DC, says hundreds face charges over Capitol storming; Derrick Evans, West VA delegate, charged with entering Capitol, resigns; Alabama AG Steve Marshall denies role in robocalling effort that helped organize Wednesday riot; Google, Apple, Amazon will not host right-wing social media app Parler; Flight recorder from crash of Boeing 737 found in Java Sea, Indonesia; Vaccinations happening around the world; Four cases of COVID-19 variant in NY State; NY will start vaccinating teachers, over-75s, and others.

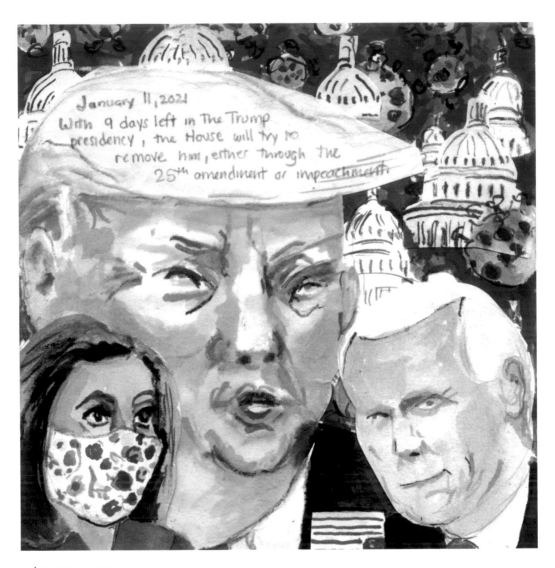

January 11, 2021

With 9 days left in the Trump presidency, the House will try to remove him, either through the 25th Amendment or impeachment.

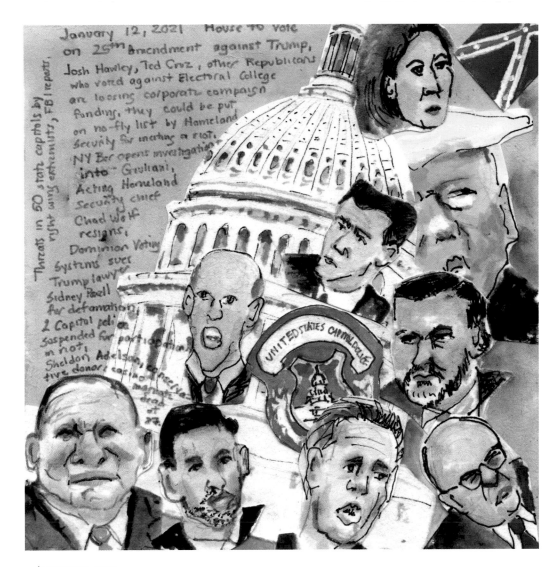

January 12, 2021

House to vote on 25th Amendment against Trump; Josh Hawley, Ted Cruz, other Republicans who voted against Electoral College are losing corporate campaign funding, they could be put on no-fly list by Homeland Security for inciting a riot; New York bar opens investigations into Giuliani; Acting Homeland Security Chief Chad Wolf resigns; Dominion Voting System sues Trump lawyer Sidney Powell for defamation; 2 Capitol police suspended for participation in riot; Sheldon Adelson, conservative donor, casino magnate, dead at 87; Threats in 50 state capitals by right-wing extremists, FBI reports.

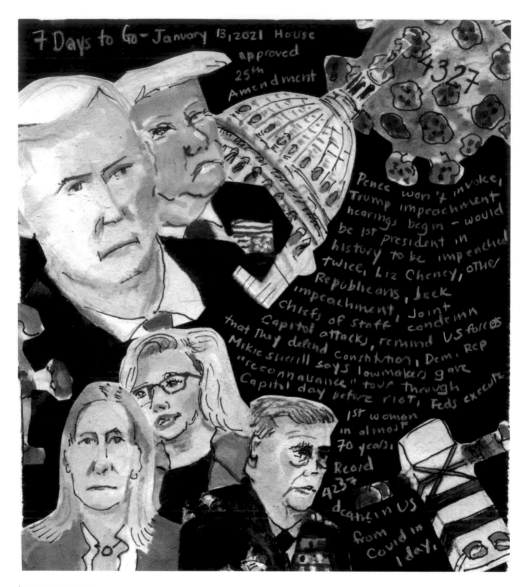

January 13, 2021

House approves 25th Amendment, Pence won't invoke; Trump impeachment hearings begin—would be first president in history to be impeached twice, Liz Cheney, other Republicans back impeachment; Joint Chiefs of Staff condemn Capitol attack, remind US forces that they defend the Constitution; Dem. Rep. Mikie Sherrill says lawmakers gave "reconnaissance" tour through Capitol day before riot; Feds execute 1st woman in almost 70 years; Record 4,237 deaths in US from COVID in one day.

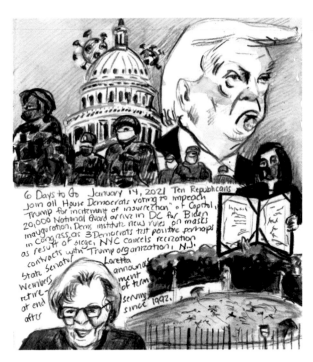

January 14, 2021

10 Republicans join all House Democrats voting to impeach Trump for incitement of insurrection at Capitol; 20,000 National Guard arrive in DC for Biden inauguration; Dems institute new rules on masks in Congress and 3 Democrats test positive, perhaps as result of siege; NYC cancels recreation contracts with Trump organization; NJ state senator Loretta Weinberger announces retirement at end of term after serving since 1992.

January 15, 2021

FBI Director Christopher Wray briefs Pence on security as all 50 state capitals are threatened and over 200 riot suspects identified; New York Attorney General Tish James sues NYPD, de Blasio over use of excessive force during BLM protests; 2020 was warmest year in recorded history; Ex–Michigan Gov. Rick Snyder and 8 others charged in Flint water crisis; Biden unveils $1.9 trillion COVID relief plan; US officials promised 20 million vaccinated by 2020, less than half have been vaccinated.

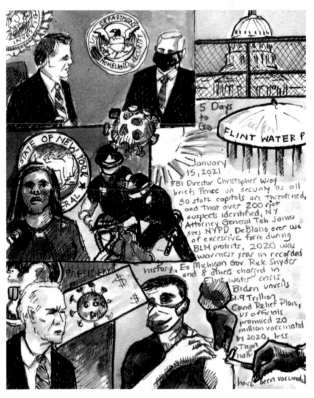

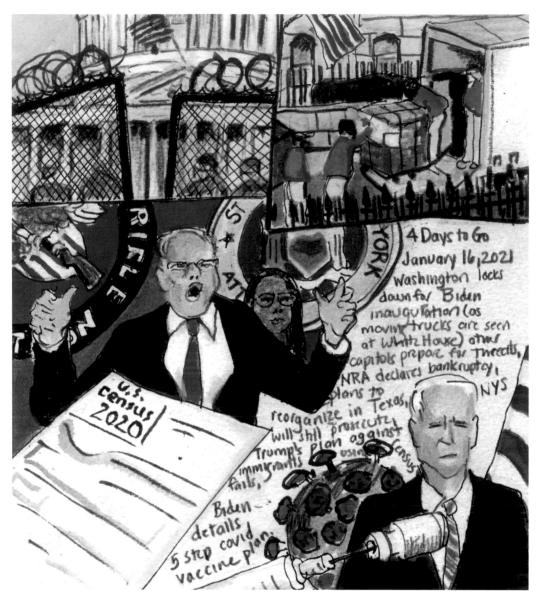

January 16, 2021

Washington locks down for Biden inauguration (as moving trucks are seen at White House), other capitals prepare for threats; NRA declares bankruptcy, plans to reorganize in Texas; NY State will still prosecute; Trump's plan against immigrants using census fails; Biden details 5-step COVID vaccine plan.

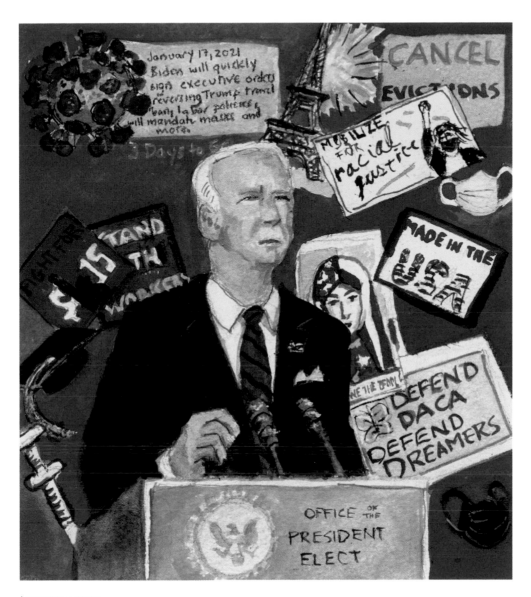

January 17, 2021

Biden will quickly sign executive orders reversing Trump's travel ban, labor policies, will mandate masks and more.

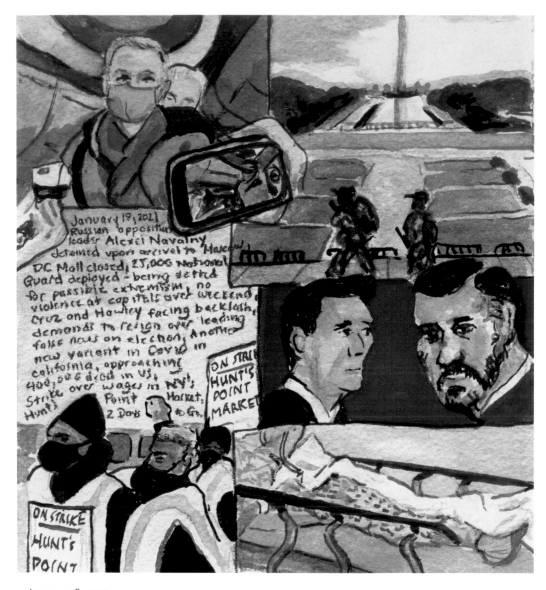

January 18, 2021

Russian opposition leader Alexei Navalny detained upon arrival to Moscow; DC Mall closed; 25,000 National Guard deployed—being vetted for possible extremism, no violence at capitals over weekend; Cruz, Hawley face backlash, demands to resign over leading false news on election; Another new variant of COVID in California, approaching 400,000 deaths in US; Strike over wages in NY's Hunts Point Market.

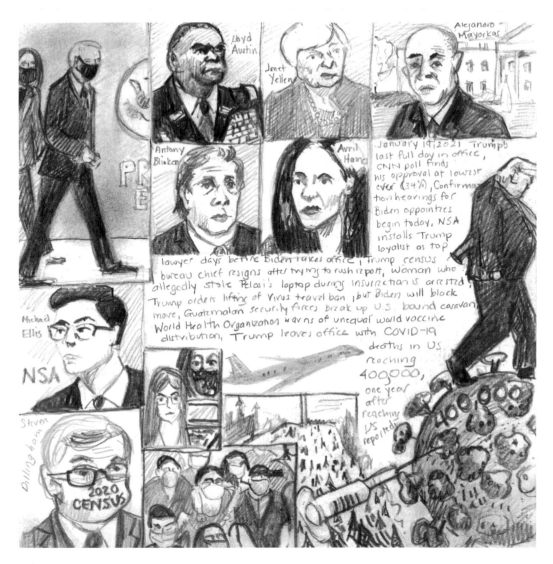

January 19, 2021

Trump's last full day in office, CNN poll finds his approval at lowest ever (34%); Confirmation hearings for Biden appointees begin today; NSA installs Trump loyalist as top lawyer days before Biden takes office; Trump Census Bureau chief resigns after trying to rush report; Woman who allegedly stole Pelosi's laptop during insurrection is arrested; Trump orders lifting of virus travel ban, but Biden will block move; Guatemalan security forces break up US-bound caravan; World Health Organization warns of unequal world vaccine distribution; Trump leaves office with COVID-19 deaths in US reaching 400,000 one year after reaching US reported.

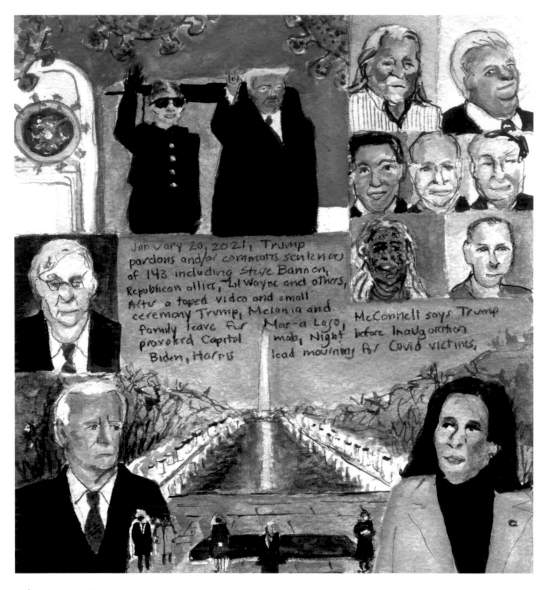

January 20, 2021

Trump pardons and/or commutes sentences of 143, including Steve Bannon, Republican allies, Lil Wayne, and others; After a taped video and small ceremony Trump, Melania, and family leave for Mar-a-Lago; McConnell says Trump provoked Capitol mobs; Night before inauguration, Biden, Harris lead mourning for COVID victims.

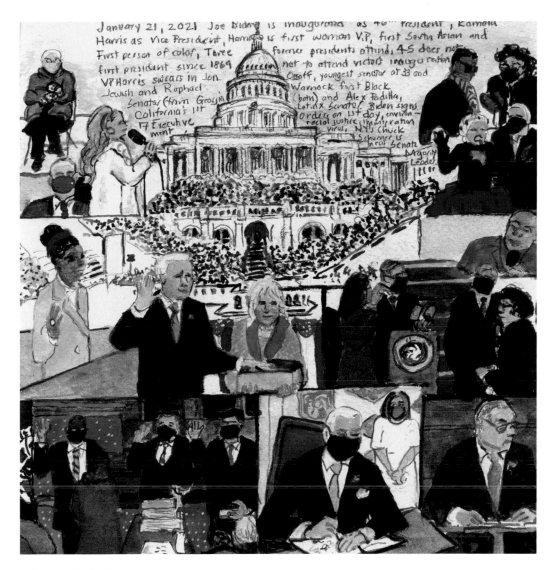

January 21, 2021

Joe Biden is inaugurated as 46th president, Kamala Harris as vice president, Harris is 1st woman VP, 1st South Asian, and 1st person of color; 3 former presidents attend, 45 does not, 1st president since 1869 not to attend victor's inauguration; VP Harris swears in John Ossoff, youngest senator at 33 and Jewish, and Raphael Warnock, 1st Black senator (from Georgia, both), and Alex Padilla, California's first Latinx senator; Biden signs 17 executive orders on 1st day—environment, racial justice, immigration, virus; NY's Chuck Schumer is new Senate majority leader.

ACKNOWLEDGMENTS

I would like to thank those who made *A Diary of the Plague Year: An Illustrated Chronicle of 2020* possible and also take this opportunity to acknowledge the many people who encouraged me over the five years I spent working on the *Diary of a Radio Junkie* project, culminating in this book.

A Diary of the Plague Year would not exist if Riva Hocherman at Metropolitan Books had not approached me, out of the blue, with the question, "Is this a project a book yet, and if not, could we talk?" We did talk, and this book is the outcome. Working with Riva was a pleasure and an education at every stage. From her earliest conception of the project to her oversight of every last detail of the design and text, the experience was revelatory, resulting in something so far from my rudimentary notion of what was possible. I feel fortunate to know Riva and can never thank her enough.

Duvall Osteen, my fabulous agent at Aragi Inc., helped me from the start with writing a proposal (a totally new venture for this studio artist) and then guiding me through the many steps right to the finish. I am grateful for her energy, editing, and intelligence and for her friendship. And a big thank you to Mona Khalidi for bringing the *Radio Junkie* project to Riva's attention.

I would like to thank everyone at Metropolitan Books including Catherine Casalino, Kelly Too, Hannah Campbell, Brian Lax, and Carolyn O'Keefe.

I would never have reached the fifth year of my *Radio Junkie* project without the help of so many people. Mark Getlein has edited and talked me through so many projects, and it was he who came up with the "Radio Junkie" moniker. He is a wonderful editor, writer, and friend. Thirty years plus of at least weekly phone conversations with artist Peter Gallo have kept me thinking, laughing, and somewhat sane through many insane times and especially through the last five years.

I so appreciate the hard work and support of two people who chose to exhibit this work in 2019—it was a massive undertaking installing and uninstalling more than a thousand small drawings. Thank you to the amazing Jeanne Flanagan, her husband, Paul, and the students who labored for many hours to cover the wall in the Esther Massry Gallery at the College of Saint Rose in Albany. Eva Frosch showed this work in her gallery (then Frosch & Portmann, now Frosch & Co.) in New York, and I am grateful for her encouragement and labor as well as that of her staff and all the friends who helped hang the show.

I feel very fortunate to have been able to spend time at MacDowell, where the ability to concentrate and focus can't be matched. Thank you, MacDowell, and all of

your wonderful people who make it such a valuable and important place for work and respite.

Thank you Paul Reyes for your kind, thoughtful, and astute essay about the *Radio Junkie* project in the *Virginia Quarterly Review* (and thank you to the staff there as well). I also want to thank Julia Thomas at *Democracy Now* for her earlier article in the *Indypendent*.

Thank you to Reinier Gerritsen and Sue Brisk for generously photographing me and my work.

I convey my appreciation to my extended family and to my friends for their support and encouragement over these demanding years.

Thank you to the guest artists who filled in for me when circumstances made the daily drawing impossible.

I want to thank Dr. Elizabeth Poynor for being the thorough, generous, and compassionate doctor that she is.

Last, I want to express my tremendous gratitude to all the journalists who keep us informed through good times and bad. Too many of them have lost their lives, too many have been silenced, and their situation continues to deteriorate. I am grateful to those who provided me with headlines, many of them reporters from National Public Radio. I would love to name them all but they are far too numerous. I will thank Amy Goodman and Juan González at *Democracy Now*. I have special appreciation for all of the reporters at WNYC, my local public radio station, who I continue to listen to as I draw and paint every day in my studio.

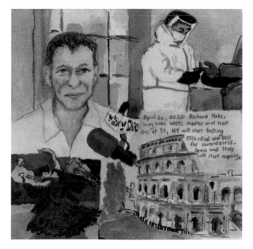

April 26, 2020

Richard Hake, longtime WNYC reporter and host, dies at 51; NY will start testing essential workers for coronavirus; Spain and Italy will start to reopen.

ABOUT THE AUTHOR

Elise Engler is a visual artist who has had her work shown in galleries across the United States and Europe. *A Diary of the Plague Year* is her first book. The recipient of a New York Foundation for the Arts fellowship in drawing and an Adolph and Esther Gottlieb Foundation grant in painting, Engler has also received two MacDowell residencies and a fellowship at Civitella Ranieri in Umbria, Italy. Her work has been written about in *Art in America*, the *New Yorker*, and the *New York Times*, among other publications. Engler teaches at the City College of the City University of New York, the School of Visual Arts, and for the Battery Park City Authority. She lives in New York.